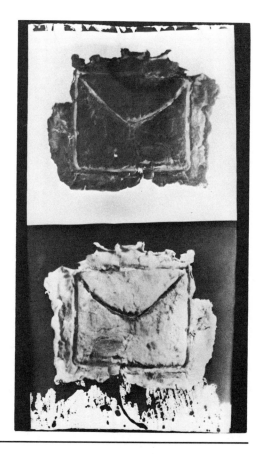

THE NEW PHOTOGRAPHY

CATHARINE REEVE
AND
MARILYN SWARD

THE NEW

A GUIDE TO NEW IMAGES, PROCESSE

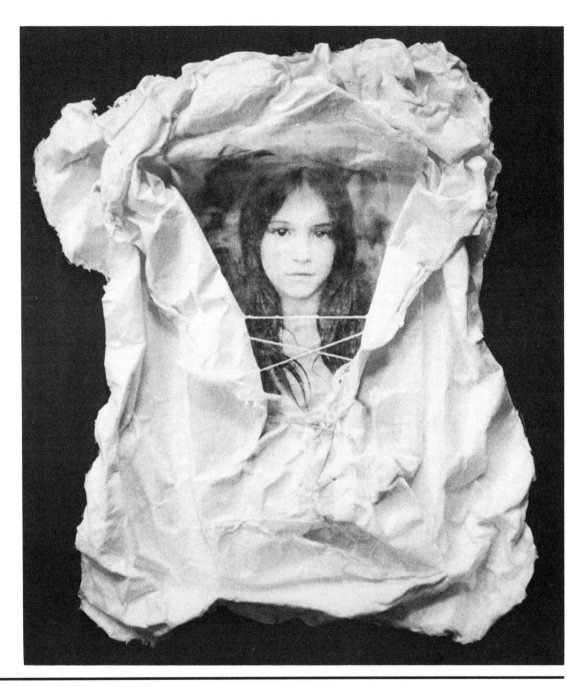

PHOTOGRAPHY

AND DISPLAY TECHNIQUES FOR PHOTOGRAPHERS

A DA CAPO PAPERBACK

Library of Congress Cataloging in Publication Data

Reeve, Catharine.
 The new photography.

 (A Da Capo paperback)
 Reprint. Originally published: Englewood Cliffs,
N.J.:
Prentice-Hall, c1984.
 Bibliography: p.
 Includes index.
 1. Photography, Artistic. I. Sward, Marilyn.
II. Title.
TR642.R44 1986 770 87-525
ISBN 0-306-80295-3 (pbk.)

Editorial/production supervision: Judy Nyren
Book design: Alice Mauro

All photographs are by Catharine Reeve unless otherwise noted.
Photographs by Marilyn Sward: pp. 23, 36, 48, 60, 77, 93, 96, 97, 102, 103,
104, 126, 129, 131, 135, 203, 210

This Da Capo Press paperback edition of *The New Photography*
is an unabridged republication of the edition published
in Englewood Cliffs, New Jersey in 1984. It is reprinted
by arrangement with the authors.

Published by Da Capo Press, Inc.
A Subsidiary of Plenum Publishing Corporation
233 Spring Street, New York, N.Y. 10013

This book is dedicated with love to our families:
Stephen, David, and Philip Ganote
and
Stephen, Eric, and Heather Sward

Contents

For the generous gifts of their time and resources, our deep affection and appreciation to Barbara Crane and Caryl Till, without whom this project could not have been completed.

We want to especially thank our book agent, Jane Jordan Browne, our editor, Mary Kennan, production editor, Fred Dahl, and their assistants for their patient belief in this endeavor.

We are indebted to many other people for assistance and support in the preparation of this book. Among them, we extend our special thanks to: Harold and Maria Allen, Lewis Alquist, Van Deren Coke, Noël Cornely, Lois Cowen, H. S. Dakin, Kris Davis, Eric Dean, Alden Dow, Kathy Wade DuFour, Marlene Everingham, Jeffrey Gilbert, Connie Gilchrist, Michael Goss, Kathy Hardgrove, Sherry Healy, Robert Heinecken, Theodore Hogan, Tung H. Jeong, Douglas Kenyon, Ruth Kohler, Elaine Koretsky, Yoko Kuzume, Alice Lassiter, Jack Leblebjian, Sue Lindstrom, Lee McDonald, Barbara Lazarus Metz, Odell T. Minick, Margaretta K. Mitchell, Barbara Morgan, Judith O'Dell, JoAnn Ofenloch, Rhoda Oif, Joshua Mann Paillet, Lynne J. Petty, Dorothy Riedl, Jeanne Reilly, Anne Schultz, Carmella Sejdak, Douglas Severson, Sonia Landy Sheridan, Carol Siegel, Linda Sorkin, Karen Stahlecker, Judith Harold Steinhauser, Stephen Sward, Joyce Takefman, Polly Thomas, Mary Jo Toles, Gerald F. Touzinsky, David Travis, David Trelford, and Robert Weinberg.

CONTRIBUTING ARTISTS

Mary Ahrendt, Harold Allen, Charles Arnold, Jr., Jan Arnow, Vera Berdich, Michael Braake, Gillian Brown, Paul Calhoun, Louva Calhoun, Jno Cook, Barbara Crane, Garie W. Crawford, Luciano Franchi de Alfaro III, François Deschamps, Rita DeWitt, Mary Dougherty, T. C. Eckersley, Fred Endsley, Linda Gammel, Linda Girvin, Misha Gordin, John Grimes, Trudy S. Guinee, G. E. Gundlach, Betty Hahn, Robert Heinecken, Martha Holt, Christopher James, Dr. Tung H. Jeong, Harold Jones, Gertrude Käsebier, Michael Keogh, Kay Kenny, Helmmo Kindermann, Bela Kolářová, Ellen Land-Weber, Philip Lange, Frank Lavelle, Grayson Marshall, Gerald A. Matlick, Russell McKnight, Barbara Lazarus Metz, Martha Madigan, Buck Mills, Margaretta K. Mitchell, Norman Mizel, Barbara Morgan, Judith L. Natal, Joyce Neimanas, Yasuzo Nojima, Elaine O'Neil, Katherine Pappas Parks, Kathryn Paul, Sheila Pinkel, Tom Porett, Vicki Lee Ragan, Jacqueline Rapp, Robert Rauschenberg, Nancy Rexroth, François Robert, Gregory Rukavina, Jack Sal, Mark Sawyer, Eva Shaderowfsky, Sonia Landy Sheridan, Kenneth Shorr, Adam Siegel, Keith Smith, Judith Harold Steinhauser, Alfred Stieglitz, William Henry Fox Talbot, Joyce Tenneson, Peter Thompson, Ruth Thorne-Thomsen, Mary Jo Toles, Carl Toth, Laslo Vespremi, Margaret Wharton, Roger Arrandale Williams

Acknowledgments

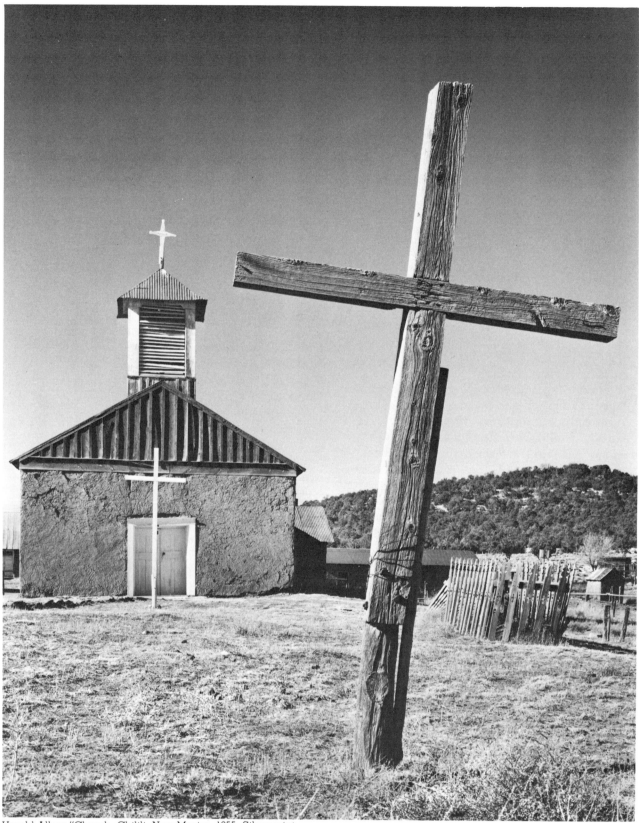

Harold Allen: "Church. Chilili, New Mexico. 1955. Silver print.

Why does a dance give delight? How did Homer, confronting something as gross as the Trojan War, fashion it into poetry which became a guide for the aesthetics of the whole Greek civilization? Why does an original idea in science and in art pop up from the unconscious at any given moment? Rollo May, *The Courage to Create*

Artistic vision is a gift of insight to be lived and shared. It may manifest itself in a commodity and may be interpreted through a vehicle, but ultimately it rests within.

When we first conceived this book, our primary concern was to share information on what we considered a most exciting combination of art forms. As we studied the range of alternative processes and the work available in this area, we began to see a need to explore as well the aesthetics of the imagery we found. The critical standards for straight photography did not fit this new imagery.

In the months that followed, we contacted and interviewed people in widely separated areas of photography. From all of them, we learned. We became aware that the artists with whom we talked were moving to evaluate meaning on a larger scale, moving away from "object-ness" and the concept of art as a commodity. They generate images away from subjects into an abstraction of realities. Where did the alternative imagery we see today come from, and why does it uniquely fill these artists' needs?

We asked our friend Harold Allen to respond to this question. Harold is a photographer who for a generation as a teacher and former head of photography at the School of the Art Institute of Chicago influenced the lives and careers of many of the artists in this book. His humanistic philosophy and aesthetic concerns have been important to us, as have his quick humor and warm heart. We are grateful for the hours we spent with him and his wife Maria discussing the material in this book. With the following introduction, Harold Allen begins our exploration of the alternative image in photography.

In the late 1930s, when I first discovered the camera, there were still a few old-timers around who called themselves photographers, yet made prints that only an etcher could love. In righteous rebellion, we bright and moral young people could see no good in any photography but straight and narrow. Since then, I have survived to see the perennial circle complete itself. Though straight photography now is, generously, still tolerated, we are experiencing an enthusiastic revival of long-discarded methods—strangely producing images that look nothing like those these same processes used to yield. And, of course, new things are constantly being tried, undreamed-of wonders dreamed.

The question naturally arises: Why do we need or want "alternative imagery" in a process as fascinating, beautiful, and varied as photography? Of many answers, I will mention three.

From its beginning, photography has been divergent, and has evolved constantly. Daguerre's world-shaking images on silver-plated copper—forever positive, reversed, and unreproducible, like jewels protected in beautiful cases—were wildly different from Talbot's negative/positive, indefinitely reproducible, inexpensive paper prints that

Introduction

were more at home in books. Yet these were the original processes, unrelated twins, both announced in 1839. They used different materials, different chemicals, tended to record different kinds of subjects, were put to different uses, and, of course, looked different. Only a decade later, stereo photography, introduced as a scientific wonder, became for eighty years a parlor amusement, was an important interpreter of reconnaissance photographs during World War II, and now, in a sophisticated varient process, survives as amusing 3-D post cards. Ambrotypes, tintypes, wet plates, dry plates, glass and plastic film bases, paper and plastic print bases, roll film, color, panchromatic emulsions, high-speed film, cinema, instant images, dry processing—not to mention the vast and expanding realms of computers, holograms, video, and generative systems—all and much more have been "alternatives."

As the world's dwindling supply of silver becomes increasingly and irretrievably sealed in traditional silver-coated films and papers, it is not only desirable but essential to find alternative materials and methods. Even if we wished it, we can hardly expect these new processes to yield exact duplicates of what we already have. So what? Some new method may be to photography what photography was to drawing.

Since both science and art—photography is their fusion—cannot occur without personal sensitivity, talent, skill, and taste, no artist or scientist is ever content to do only what has been done before; rather, we find excitement in discovering new continents and in creating things previously undreamed.

Perhaps the scientist gains his greatest interest—and honor—in finding and exploring new processes, while the artist, though sharing this interest, must also expand esthetic boundaries. It is the artist's vision, his ability to see what is good and usable in any process, old or new, that helps the artist determine how to use it well—or see what it has to offer for the future. This same vision will help the artist realize that what worked esthetically for the old may not, without change, be appropriate visually for the new. Yet the artist has a heartening advantage in that new materials and processes hold promise of visual/esthetic opportunities unknown before—which it is the artist's good fortune to be able to see more clearly than others. Responding sensitively to both old and new, valuing the old as a pliant springboard to discovery rather than as an inflexible block to progress, meanwhile searching for new paths and visions—and the most suitable and entrancing forms they can take—this is the exciting job of the artist.

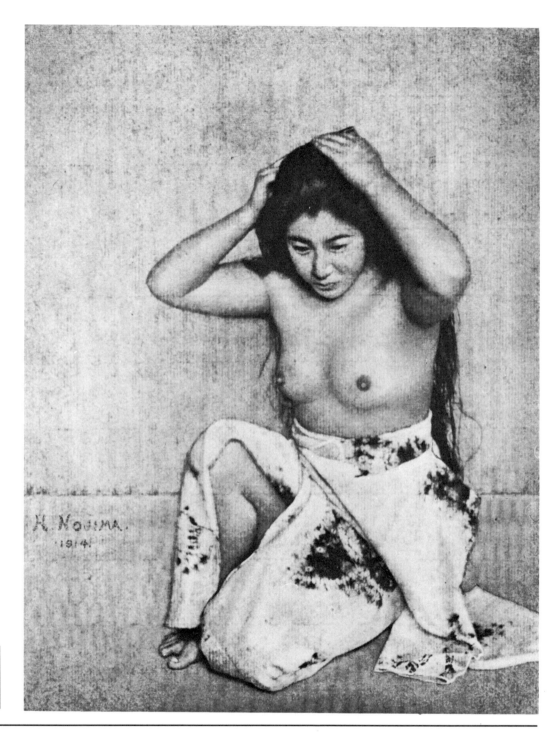

1

Aesthetics and Criticism of the Alternative Image

Photography began both as a scientific experiment in reproduction and as a means of depiction. Since antiquity, the camera obscura had been a tool of the artist. The name came from the Latin *camera* meaning "room" and *obscura* meaning "dark." Renaissance painters depended on this "dark room" to render accurate perspective and detail. In essence, the camera obscura was a pinhole camera that began as a large, darkened room. A tiny pinhole admitted light, which caused the scene or person outside the room to be reflected on the opposite wall of the room, upside down. By the 1700s the camera obscura was a small portable box with a lens to receive light and a ground glass to receive the image. Yet to be discovered was the means of preserving the image.

Henrich Schulze, a German physicist, discovered the light-sensitive properties of silver salts in 1727. In 1802, Thomas Wedgwood, son of the famous British potter, experimented by coating both paper and leather surfaces with silver nitrate to receive an image. He was successful in getting an image, but he had no way to desensitize the silver salts, and all his images gradually turned black.

It remained for Joseph Nicéphore Niépce to develop in 1826 a means of making the camera obscura images permanent. Unfortunately, this method was neither perfected nor publicized. Shortly after this development, when he was 64 years old and in failing health, Niépce formed a partnership with a younger and equally inventive Frenchman, Louis Daguerre. Daguerre, renowned for his theater dioramas, was also doing serious research on making the camera obscura images permanent.

Photography began with the research of Niépce and Daguerre which led, in 1839, to the demonstration of the *daguerreotype*. This sheet of silver-plated copper captured and retained the image. Although the daguerreotype posed difficulties—the long exposure time and the fragility of its surface—it signaled the beginning of a revolution in visual communication. For the artist of the nineteenth century, photography offered another tool and even another medium. For the historian, it offered the most realistic means yet available for documentation.

THE PLACE OF SURFACE IN THE HISTORY OF PHOTOGRAPHY

Papermaking, printmaking, and photography all trace their origins to the need for widespread visual communication. The response of each medium to the scientific inventions and intellectual concerns of its time has determined its historical significance. We speak elsewhere of the history of papermaking. Recognizing its importance in the development of both printmaking and photography leads us to look historically at another area—the surface. Both printmaking and photography were—and are—dependent on a paper surface as the vehicle for their communication. Thus the adaptability of paper to process is an essential requirement for their success.

The development of photography from the mid-1800s to the present generally presumes a paper substrate for the photographic print. In the same year that the daguerreotype came out, William Henry Fox Talbot in England developed a process of printing on a paper surface. Talbot called his method the *calotype* (later changing the name to *talbotype*), and he made both negative and positive images on paper. (This was the first negative-positive process.) The paper as negative could not give the sharp, clear detail of the daguerreotype, and the process never gained commercial success. The development in 1851 of the glass plate negative by Frederick Scott

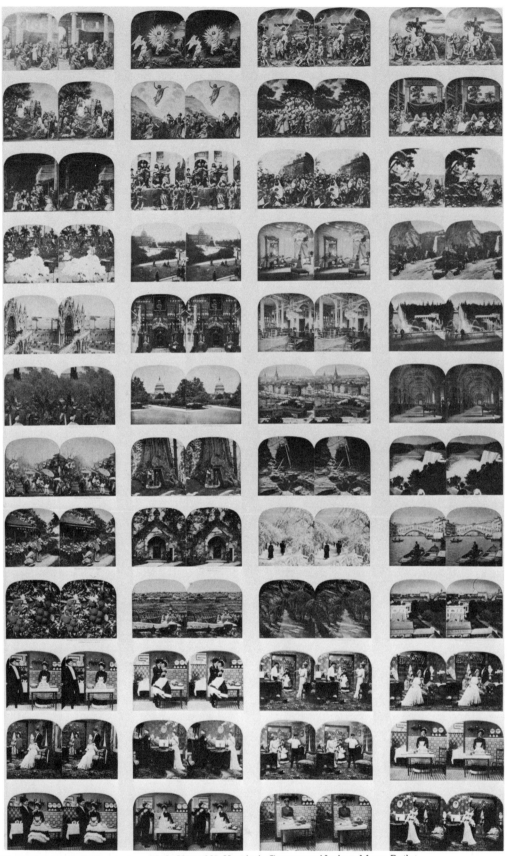

Uncut stereograph sheet, circa 1910, 30″ × 22″, Untitled. Courtesy of Joshua Mann Pailet, A Gallery for Fine Photography, New Orleans, Louisiana.

Archer returned the paper to its more comfortable home as the bearer of the final image. In the wet plate process, these glass plates, coated with collodion, were immersed in a silver nitrate solution and exposed while still wet. This process obliged photographers to travel with veritable "darkrooms on wheels" in order to capture the image. The collodion plate particularly influenced the *ambrotype*, the *tintype*, and the *carte-de-visite*. The carte-de-visites of the mid-1800s reflected an important evolution in the use of paper for the photographic print, for this process yielded a sharp negative from which an infinite number of duplicates could be made. With the development of roll film and the Kodak camera by George Eastman in the 1880s, photography became a tool for the general public, and the inundation of photographic images began. Paper as surface had become more a commercial than an artistic concern.

A number of alternative processes and systems use handmade and artists' papers as their base. We explore these other surfaces in this book. We also go into considerable detail on how to alter the surface of these papers and the surface of commercial fiber and resin-coated papers.

What is the reason for this interest in surface? This concern ties the photographer as artist to one of the central historic concerns of the visual arts. Art has been applied to thousands of surfaces throughout history, but the surface has always been a critical consideration—one that often altered or even predetermined the style or technique. The Greek artisan who applied curvaceous figures to a vase certainly considered the smooth and delicate surface. Michelangelo created his expressive ceiling figures in a style that accommodated the bold immediacy of wet fresco. In the long tradition of egg tempera from the pre-Renaissance works of Giotto through Vermeer and the Flemish masters, luminosity was accomplished through studied regard for surface. When Rembrandt painted light playing on the figure as more important than the figure itself, and when the Impressionists sys-

tematically broke that light across the canvas, surface was conveying a large part of the aesthetic. Cubists collaged in layers, altering their canvases, and artists like Jackson Pollock and Hans Hoffman moved paint in ways that made their own surfaces. In current times Minimalism has much to say about materials and surface, and artists such as Robert Rauschenberg make the statement that artistic surface may be any object found or created. These considerations illustrate the artist's regard for surface as an aesthetic continuum, which is our heritage as artists.

Conventional photography is not really a part of this tradition. The "straight" photograph may deal with these considerations as pictorial image, but it cannot respond to them directly. The glossy surface of commercial photographic paper speaks only a narrow language. The concept that surface and its manipulation can enter the field of photography on a regular and controlled basis brings new considerations to the field. It recalls an earlier period when photographers fought for the artistic value of their images.

The Photo-Secessionist Movement developed between 1895 and 1910 under the leadership of the flamboyant photographer and promoter, Alfred Stieglitz. The artists of this movement (they were fighting to be called such) wanted to manipulate their images in ways that made them unique to art and to themselves. They felt that the artist and art materials must be present in the print and that the print should be done directly, using photographic rather than etching processes.

Gertrude Käsebier's image of the young girl reflects her position in this movement. We see the photographic image, but we are also strongly aware of the photographer. The loose brush strokes are the entry for the viewer into the world of this artist. For the contemporary critic this is an easy step. But for the camera clubs of the pictorialists, Photo-Secession was an impassible trail. Rudolph Arnheim speaks of normal images and familiar forms: "To what extremes a particular observer will follow . . . deviation depends on the range of his

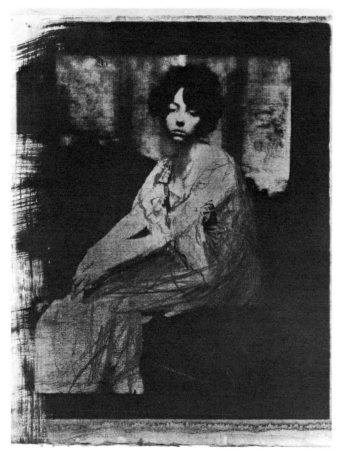

Gertrude Käsebier; "Untitled," gum biochromate and platinum, with hand-applied charcoal on paper, n.d. 10¼" × 8½". Collection of Sam Wagstaff, New York. Courtesy of the John Michael Kohler Arts Center, Sheboygan, Wisconsin. Photo credit: P. Richard Eells.

visual experience, the attention he pays to it, and his flexibility in the handling of standards."[2]

When today we view the work of Kenneth Shorr, we may come closer to the feelings of the contemporaries of Käsebier. We must make an emotional journey into the painted surface to find photographic reality. Once there, we are confronted with strong social and political commentary. The strength of this commentary gives a dimension sometimes lacking in current photographic manipulation, yet, interestingly, neither the drawing nor the photograph stands alone. They depend upon each other to heighten reality, and they gain substance through their interplay.

William Crawford suggests in *Keepers of Light:* "By finding the even balance Stieglitz makes us see the relationship that exists in photography between the image and the sur-

face that carries it—a relationship in which each contends with yet depends on the other. His images are tactile objects, full of their own physical substance."[3] Stieglitz himself said, "When that sense of touch is lost the heartbeat of the photograph is extinct—dead."[4]

By the early 1920s, photographers such as Paul Strand were moving away from the Photo-Secessionists. With the work of Edward Weston in the 1930s, manipulation had been abandoned. His work is commonly understood as the beginning of the desire to sharpen the image and free it from the painterly approach. The concern with sharp detail and a "real" image is reflected in the photojournalism of the late 1930s, as photography documented our social plight. Photographers such as Kenneth Shorr show us a contemporary concern with social–political statements that parallels the philosophy of the photojournal-

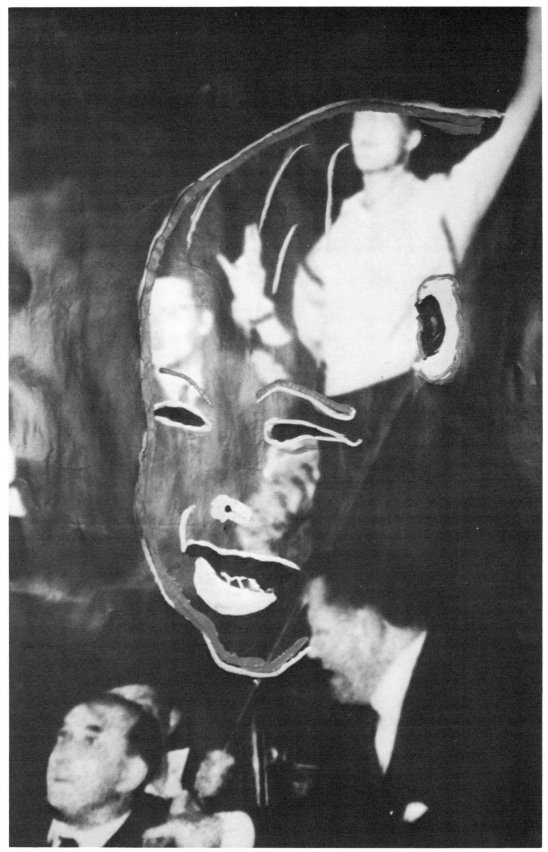

Kenneth Shorr: "More Human than Kind, More Kind than Human," acrylic on photograph, 1982. 5′ × 120″. Left panel detail. Courtesy of Nancy Lurie Gallery, Chicago, Illinois.

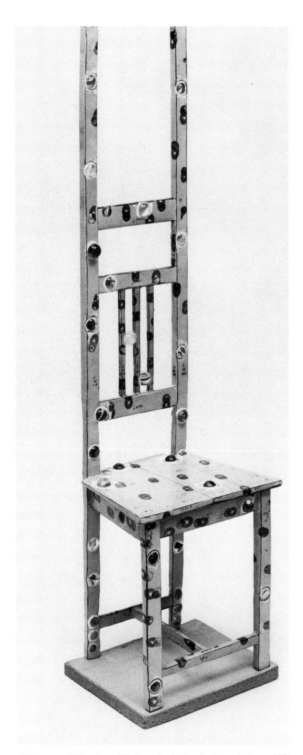

Margaret Wharton: "Saturn," photo chair sculpture, 1981.
28" × 7½" × 6". Collection of the artist, Chicago.
Photo credit: William Bengtson. Courtesy of
Phyllis Kind Gallery, Chicago, New York.

ists. Robert Heinecken comments, "There is a very strong sense in a lot of minds now about the relationship of photography to other fields and ideologies such as sociology, politics, Marxism, phenomonology, and social issues. I sense a cyclic effect which seems to develop in relation to outside influences."[5]

Although we see historic parallels for fractions of contemporary movements, each time a style, process, or technique is rediscovered, it is interactive with the philosophy and sociology of the times in which it is generated. Today's work may bear reference to its history, but it is not—nor need it be—the same. The ability to measure and reflect the moment is a criterion for evaluating the success of an artist's work. The artwork stands as the singular perception of a particular artist in a particular time who observes, records, and interprets that time. The honesty and integrity of the interpretation eventually measure the greatness of the work. As Hume states in his *Standard of Taste*, the artist's work receives ". . . the durable admiration which attends those works that have survived all the caprices of mode and fashion, all the mistakes of ignorance and envy."[6]

EVALUATION OF THE ALTERNATIVE IMAGE

Without waiting for history to make a perspective decision, how do we judge contemporary manipulated imagery? Obviously, the critic is one of those responsible for public understanding. We can hope that the critic brings to the assessment of alternative imagery a firm knowledge of photography and its history, with an additional awareness of a broad range of artistic disciplines and their history. And because photography, when heightened by other media and technology, is strongly related to literary and philosophical dialogue, we find ourselves searching for the Renaissance citizen to review the work. It is only with this diverse background that complete judgment may be given.

Surface manipulations can heighten access to imagery by attracting and diverting

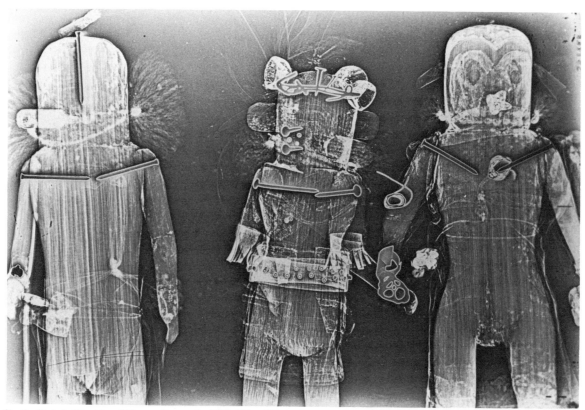

Sheila Pinkel: "Kachina," Xeroradiograph, 1981. 10″ × 13″.

the reviewer's attention and increasing the awareness of the artist's presence. Van Deren Coke states:

> Psychologically the marks and smudges—however slight they may be above the surface—take on a commanding authority that stems from our identification of them with the personality of the artist. We sense . . . a personal signature. It is almost as if the photographer with a camera wills his pictures into being in an instant, while the painted passages speak of an additive process in which the hand minds the mind. For many people, the deepest reality resides in the paint as a material, even though it may not represent a chair or cloud but is merely a coating. This is the case because we tend to trust that which has an actual existence even more than that which provides a detailed picture.[7]

In contemporary aesthetics we need to evaluate meaning in a larger scale than ob-

jectness. And to do so the artist must confront the heightened expectations of the viewer. He or she must have something to express. Media and manipulation attract but do not fulfill. The artist's unique vision enters as subject. For example, the machine print is only a novelty until it says more of the artist's perception than of the ability of the technology. This is not to say that the power of manipulation cannot have its own life. But, again, the strength of the artist breathes that life. We can look at the blending of idea, object, and image in the machine prints of Linda Gammel as an example.

Ruskin speaks of the power of art encompassing six factors:

> . . . The first merit of manipulation . . . is that delicate and ceaseless expression of refined truth which is carried out to the last touch, and shadow of a touch, and which makes every hair's breadth of importance, and every grada-

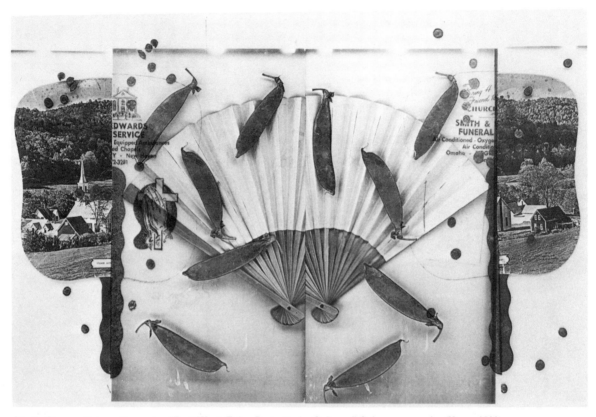

Linda Gammell: from the series "East/West: False Portrait of a Culture," Color xerography (Xerox 6500) transfer on rice paper, 1980–1981. 15⅛" × 24¼". Courtesy of the John Michael Kohler Arts Center, Sheboygan, Wisconsin. Photo credit: P. Richard Eels.

tion full of meaning. It is not, properly speaking, execution; but it is the only source of difference between the execution of a commonplace and that of a perfect artist . . .

The second quality of execution is simplicity. The more unpretending . . . the means, the more impressive their effect. . . . [A]bove all, any attempt to render hues attractive at the expense of their meaning, is vice.

The third is mystery. Nature is always mysterious and secret in her use of means. . . .

The fourth is inadequacy. The less sufficient the means appear to the end, the greater . . . will be the sensation of power.

The fifth is decision; the appearance, that is, that whatever is done has been done fearlessly and at once; because this gives us the impression that both the fact to be represented, and the means necessary to its representation, were perfectly known.

The sixth is velocity . . . the quickest will invariably be the best. . . .

. . . but I might have added a seventh—strangeness.[8]

It is interesting to note how Ruth Thorne-Thomsen's image, done with a pinhole camera, fulfills this premise. The power, mystery, immediacy, and strangeness linger like the image.

INTERVIEW WITH ROBERT HEINECKEN

Robert Heinecken has been a pioneer among artists working in alternative imagery. His name was repeatedly mentioned as artists discussed teachers, inspiration, support, and leadership. Our interview with him gave us further insight into alternative photographic imagery, its genesis, aesthetics, and place in

Cookdopis

Gregory Rukavina: "Kalewipoeg (theme of the three (?) caskets)", palladium print, © 1982. 10″ × 8″. (from "False Work: ADAMINUS/DESCO/GEOR/IO. ME/FECI/T." © Gregory Rukavina, 1982.) Used by permission.

photography today. What follows is an excerpt from that interview.

What was your own background?

The medium I used most when I was in graduate school was printmaking, but I did a lot of other things. I was very interested in art history and took a number of courses. Also, I studied design. It was a diverse education. I didn't really specialize, which I'm very thankful for. Of course, it's different with students now. More specialized. Also, I did it in three or four different blocks of time. My first brush with this whole thing was not really to use the photograph or camera as a singular thing, but to integrate photographic images into etchings. That's how I got started.

Do you think of yourself now as a photographer?

Yes, I suppose, but it doesn't describe what I do. I prefer my term, "paraphotographer."

You teach on the West Coast, in Chicago, and in other areas, so you see a broad range of students. Are you finding that the students have a perspective of what you're doing, and of what manipulation is about, and a sense of history?

It's really not geographical as much as it's institutional. Different institutions have different emphases. It's true that there's more indication of manipulation as you go southwest. But that will probably be true in most fields. When you get to California, everything is less stable, including the geology.

Do you feel that some alternative processes are perhaps generated out of a need to move photography into a larger realm?

Yes, and, more distinctly, toward something more expressive and away from optical reality. Anything that's hand-generated in some way retains that fact in its surface, and does certainly have more classic aesthetic possibility because of these qualities. It can be more expressive because there are gestures and choices being made that are not made in conventional photographs.

Do you think that emphasizes a different type of reality?

Yes, I think so, but it's not a reality that we think of as any different from the so-called reality of a painting. It's not optically logical like we've come to expect photographs to be.

Ruth Thorne-Thomsen: pinhole photograph from the "Expedition Series," 1979. 4½″ × 5½″.

So we accept the premise that there is a kind of reality that's distinguishable from the outward appearance of something. It becomes, of course, an inner or intrinsic reality.

What do you think about the language of criticism for alternative imagery?

That's a very good question because even though there now are some critics and theorists, they are mostly interested in conventional photographs. Most of these people do not gravitate towards specific explanations of these alternative kinds of photographs. If critics are interested in photography, they probably develop that interest around the medium's logical properties rather than its illogical ones. There are, of course, exceptions to this, such as Van Deren Coke, Aaron Scharf, and a few others.

A lot of the manipulated photographs that we see are not as interesting when you compare them to the other plastic arts, so I think they need, to some extent, the aegis of photography. That is, they become interesting primarily in their difference from conventional photographs, rather than in comparison to other media.

What quality do you think moves the work beyond manipulation?

A number of things—one is experience. If there is a lack of experience in working with certain materials of art or the ideas of art, that deficiency always shows up. Secondly, it's not just narrative content that is needed, but some sort of emotional content. This may not be a very emotional age. Generally, images, no matter how far removed from their original photographic state, will always have that residual look of a photograph which stands for something observed rather than something felt. Observation as opposed to response or reaction. Also, at least in teaching, I try to distinguish between analytic versus synthetic work. Photographing "in nature" is absolutely analytic from my point of view. Selection and time and place and viewpoint and all those things that are analytic, when compared to gathering various visual material at random from diverse illogical, irrational places, and

then sitting down and synthesizing, are quite different activities. One can even be involved in something highly technical (like some of these processes) and still take a synthetic point of view about how it's assembled.

From a personal point of view, what enhances the chance of putting content into this work? Is it art history, photographic history, life experience, tools, philosophy, literature? Are there any specific things? Neither of us has a degree in photography, and we are curious.

Neither do I! But I know photographers who have a background limited to photographic history. Usually, if they've come straight through photography, they have very little experience with other media and how it works at all. Some of them I would almost call illiterate in that sense.

I'm not saying that one needs to be a university or college graduate to be an artist—there's not any evidence that that's the case. Education cannot function as an isolated phenomenon—even the reading of this book, unless one can place it in relation to other motives and intentions, is going to be simply self-serving without a real base of understanding.

Does this mean that you find a connection between studies in humanities and photography?

I find a very interesting relationship between literature and conventional photography, because of its sense of description. In my experience, the students who know poetry or at least have a sense of how to construct creative writing, understand photographs right away. People who may not have any sense of that but have had training in other visual and plastic arts, immediately take to alternative processes. If your sense of art is really from writing, you naturally begin to string the photographs together in some narrative way, some relational way, so that you can simulate the act of narrative or poetic sequences. It's much more interesting to think of conventional photographs as units within some structural framework. A good exhibition

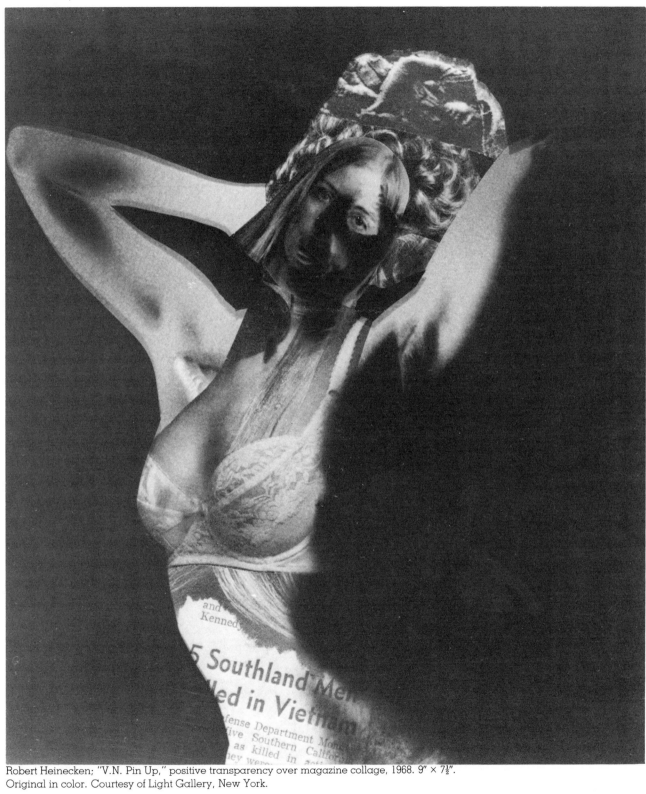

Robert Heinecken; "V.N. Pin Up," positive transparency over magazine collage, 1968. 9" × 7½".
Original in color. Courtesy of Light Gallery, New York.

or book of conventional photographs is really a series of sensitive relationships between the pictures. If it isn't, you don't have much to work with.

If you're going to train someone to work with alternative processes, are you going to have to bring them in through some media that's plastic or manipulative?

Yes, I think so. There's another interesting thing, not so much in the younger people but probably 20 percent of the photographers whose names you would know have some connection to music in their background. Their craft seems to translate well from that media. I'm comparing a performer of music to a composer—a composer is synthesizing, a performer is analyzing.

So you would put the performer and the straight photographer together and the composer with the experimental?

Yes, without making a quality judgment, and only for purposes of this conversation.

Is there something that you use beyond intuition to tell if you feel a manipulated image has meaning?

I suppose one would have to include intuition in any of this, either in the maker or in the observer. If you look at a photograph that you assume to be straightforward, something that was actually observed and selected, I would want to be struck by the absolute uniqueness of that place and that time and that light. Then if you move into theatric or directed photographs, I sense that an individual has chosen certain subjects and symbols and arranged this and moved that, and finally photographed it. Then I think, well, how imaginative is that? What were the other possibilities that could have been done with these objects and symbols as opposed to what was done? Then, when you get to what I'm calling synthetic photographs, I simply say

to myself, "how would I organize this material and configuration assuming that I know more about it?" That's intuition, I guess, but I'm really suggesting that you try in each different instance to put yourself in the shoes of that artist and based on your own experience not only of making things but of seeing art, ask yourself what decisions produced this work? And how striking is it? And try to use that as a guideline for quality. Analytic from a synthetic point of view, perhaps.

Do you have any particular thing that you do or way that you encourage people to move toward their maximum potential for making their individual statements?

I think I have a very good imagination in terms of looking at something that someone has made and immediately being able to sense a lot of other alternatives to it, not necessarily better, but different. I believe that, in order to achieve anything in this field, it is not necessarily about making it the finest but making it somehow, through a lot of personal trial and error, something that's unique and something that's in a sense owned by that person's intelligence or emotion—that no one else could possibly have come to that conclusion unless they were that individual.[9]

Robert Heinecken speaks about what he feels leads to strong imagery. Each of us must determine our concerns and needs for expression. These may change and evolve, but the working skeleton for this perception is formed by our knowledge of the craft and the tools. A thorough understanding of processes and alternatives provides a strong framework and facilitates expression of this perception. The other side of making artwork come easily is to remember that growth comes also from the frustrating struggle with materials and the long evolution of process.

The beautiful accident will also happen.

2

The Qualities of Light and Film

Opposite page: Martha Madigan: "3 June 1978, 2:00–2:50 P.M., Full Sun, Clear Cool," from "Forsythia," a year-long series of 84 images, cyanotype on paper (direct photogram sunprint), © 1978. 28″ × 40″. Courtesy of the John Michael Kohler Arts Center, Sheboygan, Wisconsin. Photo credit: P. Richard Eells.

And when he had broken past the net of separate things, within which feeling and thought are entrapped, the Buddha was so struck by the mind-shattering sheer light that he remained seven days seated exactly as he was, in absolute arrest . . . considering, he thought: "That cannot be taught." For indeed illumination cannot be communicated. Joseph Campbell[1]

LIGHT

Properties

You do not have to understand the physical properties of light to work with it successfully, but you will enjoy photography much more if you do. The word "photography" literally means "writing with light," from the Greek words *graphos* (write) and *photon* (light). Photographers have a special responsibility to understand this part of their medium. A basic comprehension of light waves and energies enriches your experiences not only in photography but in your total environment. It enables you to know exactly what you are doing when you choose to use one light source instead of another, such as direct sunlight instead of a quartz lamp. And it exposes you to another world of infinite complexity and possibility because you can understand what you are seeing, why you see it, and what you cannot see but still know is there. In an age where technology is developing at an almost incomprehensible pace, where computers and laser beams and holography are becoming an important source of art imagery, a working knowledge of the physics of light can make the world a more comprehensible and comfortable place.

The books available on the subject of light are innumerable, and the subject itself is far too complex to be covered in depth here. However, our research in this area was fascinating to both of us, and we encourage readers who have not had the time or impetus to study light to do so. (The related philosophical ideas are as varied and interesting as the underlying physics.) We have therefore included in the bibliography several books on light that we particularly enjoyed. We solicited this lighthearted explanation of the properties of light written for this chapter by Lewis Alquist and Kathleen Thompson.[2]

Sources

"If you're reading this, you're probably someone who is a photographer. You're used to working with light and manipulating it. Light has a real existence for you and, if you're fanciful, even a personality. But try to bracket what you know about light. Sit and look around you. Imagine that you are trying to understand the basic elements of life—wind, earth, water. What about light? Is it a thing or is it a force, like motion? Is it a substance, or is it the way other substances are?

If you can imagine that frame of mind, you can understand how important the prism was to the investigation of what light is. A prism materializes light. Let a beam of sunlight shine in one side of the prism and out the other side come bands of red, orange, yellow, green, blue, and violet.

Isaac Newton was familiar with this in the late fifteenth century. He approached light as the extraordinary observer and measurer he was. He was able to explain light in all its observable qualities by considering it a stream of particles that would produce different effects when they hit. But the genius that worked so well for explaining motion and gravity never hit right on the money with light. The success of his other theories carried the light particles idea for over two hundred years and nobody noticed.

In 1803 Thomas Young proved by experi-

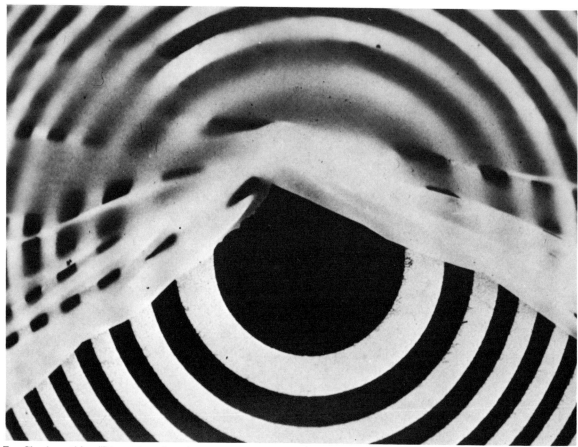

Eva Shaderowfsky: "Dimensions," combination projection print and photogram, 1981. 11″ × 14″.

ment that light did not behave like a particle but seemed much more like a wave. There was a problem here, however. Sound waves, motion, and shock do not travel through an empty space such as that between the sun and the earth. So how could light waves do it? Physicists answered this question by concocting a substance called ether. This hard-to-find material filled the empty space between the planets with a thin soup through which light waves could travel. And it continued to fill it for most of the nineteenth century.

This ethereal soup turned out to be ersatz stew in 1887 when Albert A. Michelson and Edward Morley proved that the reason ether remained so long undiscovered was because it really didn't exist.

At this point science began a race to face up to the paradoxical nature of light. The stuff that light is made of can go through empty space like a particle but travels like a wave. Keep that image in your mind. And let's go to where this particle/wave—or photon, as it is called—comes from. To do that we have to go into the subatomic world. One of the difficulties of going there is that we must leave the comfortable Newtonian world of observable certainty and put ourselves into the quantum world of invisible probabilities. It seems we must take a lot on faith from those persons who look into the atom. We have to settle for explanations of how things work that can only be appreciated with the addition of higher mathematics and complex experiments.

In 1913 Neils Bohr conceived a model of an atom that has proven to be the most workable for an explanation of how photons are produced. The Bohr atom has a nucleus with electrons spinning around it in defined orbits or shells. If you introduce energy into

the atom, these electrons can be kicked out of their orbits into higher orbits. The strength of the energy that was introduced determines how far away from its stable orbit the electron moves. The excited electron will quickly (in about one hundred millionth of a second) settle back down to its stable orbit. When it does, it releases a photon. How far the electron is kicked out and how far it drops back determines the frequency of the photon.

Let's deal with frequency. Waves have bumps in them. The longer the wave, the less *frequently* the bump comes along. Long waves, low frequency. Short waves, high frequency. The long waves produced by electromagnetic reactions include radio waves and infrared. Shorter waves include visible light, ultraviolet, X-rays, and cosmic rays. These are part of what is called the electromagnetic spectrum. A picture of it is introduced at this point in every explanation of light, so we won't put it in. Imagine it.

Visible light makes up only a small segment of the total spectrum. If we look at the visible spectrum—red, orange, yellow, green, blue, and violet—we find that the warm colors are actually of a lower frequency. The cool blues and violets are of a higher frequency and have greater energy. That may not make emotional sense. But science often doesn't.

Of course, these photons do more than go through prisms and break up into pretty colors. In a sense, they repeat the process that created them. They enter other atoms and cause more subatomic activity. That is, they change things. They don't have a lot of clout, so ordinary light doesn't cause visible changes in many things. But certain materials are particularly vulnerable to photons. They're called photosensitive for obvious reasons.

One of the most personal ways of experiencing how light can effect a sensitive surface comes to us after a day of fun in the sun. You strip down for a good shower and discover you have been made into a walking photogram. You do not need to understand physical properties of electromagnetic radiation to get a sunburn. Nor do you need to know what light is made up of in order to ruin your

photoemulsion by turning on the wrong safelight. In both cases, however, it becomes painfully clear that light can change things.

Sunlight is white light. White light is a mixture of all frequencies of color. You can blend the bands of colored light that are produced when white light comes out of a prism by running them through another prism and you'll have white light again. White light is not the absence of color. It is the presence of all colors.

Some photoemulsions are sensitive to all visible light frequencies. They are called panchromatic and must be handled in darkness without a safelight to avoid unwanted exposure. Most films that go into cameras—black-and-white and color—are of this type. Other emulsions are sensitive only to certain bands of color. These emulsions can be handled without exposure in other colors of light. Black-and-white print papers and

Two photo-lamps set at equally distant points above the negative and emulsion-coated paper during an exposure for the cyanotype process. Note the timer beside the image and the $\frac{1}{4}$" sheet of glass holding the negative firmly against the paper surface.

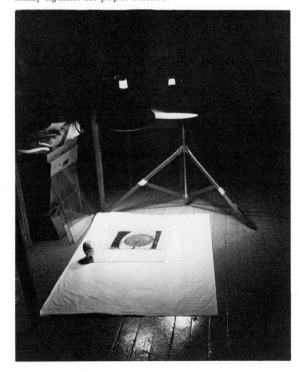

orthochromatic graphic arts films have photosensitive emulsions that expose best at higher frequencies of light, blue to ultraviolet. When these are used, the safelight is in the red to yellow-orange range. Nonsilver emulsions require heavy doses of ultraviolet light to make them work. They can be exposed with photofloods and quartz lamps, but, because these lights produce more yellow-orange than ultraviolet light, they are inefficient. For most photoemulsions, sunlight and ultraviolet lamps provide the shortest exposure times."

You may now put to practical photographic use some of the information and ideas from Alquist and Thompson. Certain basic materials need to be available and understood as you prepare to work with alternative processes. The first of these is the light box.

HOW TO MAKE A LIGHT BOX

To expose the emulsion-coated papers to ultraviolet light, you need a light box.

Light boxes are available in various sizes commercially, but it is not difficult to make your own. Place two or three unfiltered ultraviolet lamps, each 18"–24" long, in the bottom of a wooden frame or box. (Please note that these bulbs are very powerful and you should never look at them directly.) The sides of the frame should be at least 12" high. Cut a piece of glass large enough to cover the sides of the frame, and put it on top of the frame. When the emulsion-coated papers are ready to be exposed, place the negatives on the glass (emulsion side up) and the coated paper on top of the negative (emulsion side down). Cover them with a heavy sheet of glass to keep them absolutely flat during the exposure period. If the papers are covered individually instead of with one large sheet of glass, it is easier to check each one separately for the desired exposure. Needless to say, the glass on which the negatives are placed must be kept absolutely clean.

FILM CHARACTERISTICS

Film characteristics are of primary importance in traditional photography, and you will benefit by bringing those same considerations to

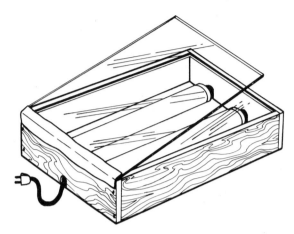

Light box drawing. Illustration by Jeanne Reilly.

the film you select for alternative imagery. Size of grain, speed of film, tonality, and contrast each has an influence.

It is important to understand the technical qualities of the films, emulsions, and papers so that you can work with them toward a final image that communicates its full meaning as completely as possible. The wholeness of this communication relies on the aesthetic qualities of its parts. Sometimes alternative images seem only attempts at art because they work as a part but not as a whole. A basic knowledge of the materials germane to the process enhances the possibility of creating successful images.

Light Sensitivity

Photographic film is composed of silver halide crystals in a gelatin base on a celluloid support. Exposure to light produces a particle of metallic silver in the centers of the exposed silver halide crystals. Unexposed crystals are removed during the developing process. The photographic negative remaining is thus composed of varying densities of metallic silver. Though the sensitivity of the silver compound to light is mainly responsible for the negative, the gelatin base (made from the hides and bones of cows) can also influence the film's light sensitivity. Ralph Hattersly reports that gelatin made from cows that fed on wild mustard grass is noticeably more light-sensitive than that made from cows that did not feed on mustard grass.

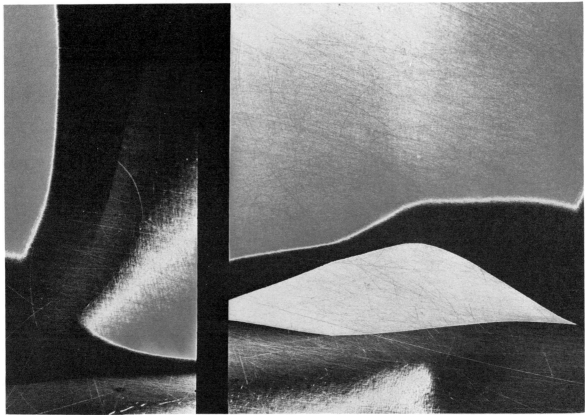

John Grimes: "Surface Treatment," solarized print from abraded multiple negatives, 1976. 9″ × 13¼″.

However, the primary determinant of sensitivity to light in any film is the size of the silver halide crystals. Large crystals have a greater light sensitivity (or *speed*) than small crystals. Greater speed is a trade-off, however, because the larger crystals tend to overlap and push against one another, yielding a less sharply defined image. The *graininess* of a film (that is, the size of its silver halide crystals) thus affects the image considerably. The graininess becomes a greater problem in projection printing than in contact printing. It demands particular attention when you are printing on a textured, handmade paper coated with a silver nitrate emulsion. The image loses sharpness because of the textured (or irregular) paper surface; a grainy negative projected onto such a paper could cause a distorted and blurry image.

Most of the alternative printing processes described in the following chapters use emulsions whose speed is so slow that normal projection (enlarger) printing is not practical. Thus, you need large format negatives (4×5, 8×10, or larger) to contact print when working with these emulsions and processes. Remember that the final image will be exactly the same size as your negative.

COPY NEGATIVES AND TYPES OF FILM

There are various ways to obtain large format negatives. The easiest, of course, is to use a large format camera. A good photography lab will make copy negatives for you, but it is expensive. In the long run, if your favorite images are on 35mm or 120–220mm film, making the copy negatives yourself is cheaper, easier, and more enjoyable. This way, you also have more control and can alter the original image during the copying process.

Several types of film are readily available and satisfactory for this process. The most common are the orthochromatic films, which are sensitive to all the light waves but red, and normally used in the graphic arts. Known as *ortho* or *litho films*, they can produce either high contrast or continuous tone negatives, depending on the developer used.

Kodak Kodalith #3 is probably the most popular graphic arts film for this process. It is available in a variety of sizes, and its versatility makes it useful for many purposes. The

Michael Keogh: "Abel," hand-colored photograph collaged onto a cyanotype print, 1981. 16½" × 13¼".

versatility is important, since the large format films rarely come in amounts smaller than 25 sheets to a box.

We have found the tonality of Kodak's Fine Grain Positive Film (Type 7302) very good. This film is less expensive than Kodalith, but it yields only continuous tone negatives and is not available in sizes larger than 11×14.

Chemco offers a film called Powerline Clear #626, similar to the Kodalith #3 but less expensive (see Sources of Supply). Another continuous tone film is Kodak Commercial Film #6127. By adjusting the developer, you can obtain a good "normal" negative even if the original is contrasty. Use HC-110 developer, Dilution A, if the original negative is normal; use HC-110, Dilution B, if the original negative is contrasty.

All of these films yield a large format *positive* from the original small format negative you are working with. To obtain a large

format *negative*, you must then contact print the positive you have made to another sheet of film. (This process is described later.) However, Kodak makes a film that eliminates the need for contact printing. It is called High Speed Duplicating Film (Type 2575), and it produces a negative from the smaller negative you are working with. Though this film is more expensive originally than most other types, it is the only one-step process that yields a high-quality, continuous tone, large-format negative from the original negative. The time and effort saved may be worth the additional expense.

Developing and Printing Graphic Arts Film

Directions for processing are included with each package of films, and we recommend that you follow them. Because graphic arts films are orthochromatic, they can be processed in a darkroom under a normal red safelight. The process is similar to enlarging

22

Marilyn Sward: "Envelopes Out to Dance," cyanotype positive and negative images on handmade paper, © 1982. 22″ × 10½″.

flat tonal range is preferable for this positive because the final negative gains contrast, as second generation negatives do. To save time, you may prefer to make a number of positives at one time, dry them, and return to make the contact negatives later.

If you have little or no experience with large format film, we recommend that you process only one sheet of film at a time. You have a large area of emulsion to care for; tiny scratches can be covered with Kodak opaque, but little can be done about large scratches. Process the film emulsion side up and treat it gently. Hang it to dry in a closed area; large films attract dust easily. After it is dry, protect it in glassine or mylar envelopes. Before making a negative from these positives, inspect them with a magnifying glass and do any spotting required.

Contact printing the large format positive to the full-size negative can be done in a contact printing frame. Being careful not to scratch the emulsions, put the films together, emulsion to emulsion with positive film on top. Make a test strip, then expose, process, and dry as described earlier. If you choose to use just a piece of heavy glass on top of the films

Joyce Neimanas: "Magic Fish," Polaroid SX-70 with silver ink drawing, © 1979. From the collection of Victor and Faye Morganstern.

onto photographic paper. Set up the chemicals in trays as follows: developer, stop bath, rapid fixer, wash, hypo clearing agent, wash, and Photo-Flo. Use either the developer recommended in the instructions or a Dektol dilution satisfactory to produce the desired results; to reduce contrast, increase the time to 5 minutes and dilute the Dektol developer to 1:10. Put the small negative in the enlarger, and place the large format film under it, emulsion side up (usually the emulsion side is slightly sticky). Make a test strip, as you would with photographic paper, expose it accordingly, process it, and from this test strip determine the proper exposure for the film. Often a

instead of a contact printer, it is a good idea to put a piece of dark paper under the films to avoid fogging by reflection. After the negatives are dry, spot them as required with the opaque or a similar material.

SPECIAL NEGATIVES
Paper Negatives

An easy and often lovely alternative to film negatives is the paper negative. You cannot get the same sharpness that you can get in film negatives, but you can exercise excellent control over tonality and image quality. Making alterations on the paper negative is easy, and, because the process is not difficult and is inexpensive, you are often less hesitant to experiment with it. Paper negatives are made by making a print on regular photographic paper. After processing and drying, it is contact printed onto another sheet of photographic paper. Because normal photographic paper is slow, it is preferable to use very thin paper, such as Kodak Document Weight and Kodak Translite Film Type 5561 (a

resin-coated paper that comes in large sizes). To make the paper negative more transparent (which gives shorter exposure times during the alternative processes), coat the back of the paper negative with a thin layer of oil.

Therma-Fax

Barbara Lazarus Metz uses an unexpected source for generating negatives: the Therma-Fax Copy Machine. Made by 3M Corporation, this machine is primarily used to make transparencies for overhead projection. It should be noted that these are not silver halide negatives. Special transparency films of varied sizes (available only from 3M) are used in the machine. There are three types of films, all 8½×11":

1. color film, which gives a *positive* image on the film, so any print made from it is a negative print.
2. negative film, which gives a clear image on a black background.
3. positive film, which gives a black image on a clear background.

Sheila Pinkel: "Family," Xeroradiography, 1981. 13" × 27". This shows an innovative use of a film source infrequently used by photographers.

Iris flower paper negative
by Judith Harold Steinhauser.

Béla Kolářová: Du Cycle "Traces et Vestiges,"
a black and white print made
from a wax negative, 1961.
This is part of a series developed by the artist
in which wax is softened, formed, and cut
away to create a unique negative.

The 3M Therma-Fax Copy
Machine used by Barbara
Lazarus Metz.

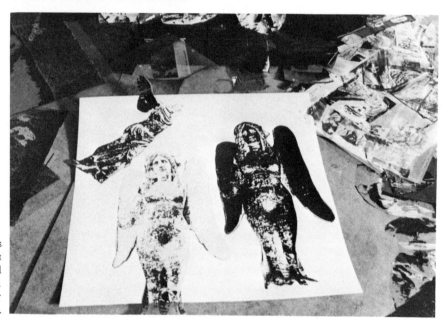

Negative and positive images
generated by Barbara
Lazarus Metz from the special
3M transparency films used
in the Therma-Fax Copy
Machine.

The black-and-white films are high contrast, and they can be used instead of Kodalith. Also, if you use the negative film and pull it apart after getting the image, you have both a positive *and* a negative to work from. It is a quicker and easier way to generate negatives for contact printing than doing the normal double set of positive and negative images in the darkroom.

The main drawback of this process is the limitation in size, since it is not a projection process. Thus, an 8×10 photograph gives an 8×10 negative, and a 4×5 photograph yields a 4×5 negative. You cannot work larger unless you do collage. Some photographers have made good use of the film images themselves as parts of larger art works. If your

images are usually 8×10 or smaller, this would seem a most worthwhile investment. Used machines are sometimes available in camera stores specializing in used equipment. You could also check with 3M.

Transfers

Another way to generate images for printing is through transfers. After all the time and effort involved in making the large format negatives, magazine transfers are a welcome relief; they are easy, quick, and fun. In this process, you need images on clay-coated casein paper stock, such as pages from *Newsweek*, *Time*, and the like. (Do not use magazine covers, since they are usually varnished.)

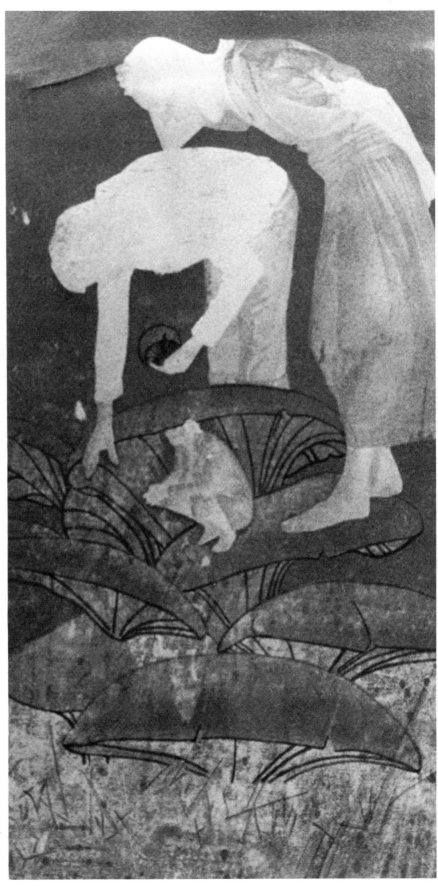

Paul Calhoun:
"Magic Kingdom,"
collage of magazine
transfers, cyanotype,
and litho pencil. 13″ × 6¾″.

Nancy Rexroth: "Untitled," Cut Paper Series, SX-70 Polaroid transfer, 1981.

Newsprint does not work because it is not clay-coated. You also need transparent Contact paper (clear plastic with an adhesive backing) or a similar product. You may choose to work in a traditional format with a single image, or you may collage images and/or alter the size and shape of the Contact paper.

Select an image from a magazine, remove the backing from the Contact paper, and adhere the front of the image to the sticky side of the Contact paper. Trim the excess Contact paper away from the image. To remove bubbles and get the image into the adhesive layer of the Contact paper, you must burnish it well. Do so by rubbing the plastic coating with a metal spoon or similar object, pushing the air bubbles to the side. Next, soak the Contact paper with the adhered image in very warm water for five minutes or so, until the paper backing dissolves enough to be pulled off. Remove it thoroughly and hang the image to dry. You may want to put a clear piece of Contact paper on the other side of the image, so that the image is effectively sandwiched

between the two. Apply it the same way, burnishing vigorously to remove air bubbles. You get a positive through this method, but you can also get a large format negative by contact printing this image onto one of the films mentioned earlier in this section. It can also be effective to use the positive to get the final image.

There is an alternative to the Contact paper method of making a transfer, and it yields a more flexible image. The process is to coat the magazine print (again on clay-coated casein paper) with several layers of acrylic gloss medium. Brush the medium on in one direction, and let it dry. Then brush a second coat on in another direction, and let it dry. Continue until at least several layers are built up. After all the layers are applied and dried, soak the entire page in very warm water for 5 minutes or more. The paper backing of the magazine image dissolves and can be peeled off. Hang the image to dry. (The acrylic looks white when it is wet, but it becomes transparent again as it dries.) This image is so flexible that it can be shaped, stretched, and

Nancy Rexroth: "Untitled," Winter Weed Series, SX-70 Polaroid transfer, 1979. This image, composed of three abutted transfers, represents another type of transfer process which requires a surgical delicacy. The image is cut out of the Polaroid SX-70 pack, the back is peeled off, the front is sprayed with water and laid on a sheet of Reeves BFK paper. The emulsion is then transferred to the paper. The outer mylar plastic is lifted off, leaving a malleable, matte surface image on the paper.

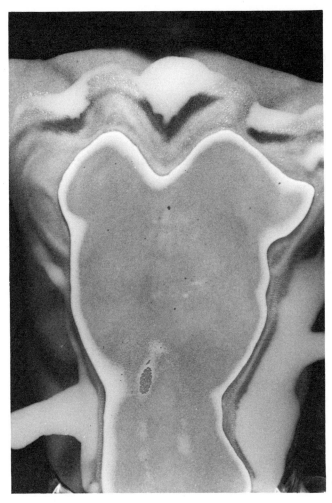

Linda Girvin: "Untitled," Ektacolor print, 1981. 16" × 20". The picture was taken using a large glass structure with the model on top of the glass and the photographer underneath looking up. Milk was placed on the surface of the glass.

Barbara Crane checks the degree of exposure of a platinum-palladium print in her contact printing frame.

Multiple Printing

Some of the processes described in subsequent chapters require multiple printing. You may also want to combine two or more processes (cyanotype and gum bichromate, for instance), using the same or different images. Whatever the use, successful multiple printing usually means that you must develop a system of negative registration.

Here is a registration method that is frequently used in projection printing. Project the negatives to be used onto thin paper (exactly the same size as the printing paper), and trace the outlines of one or two definite areas. You may prefer to use a separate sheet of tracing paper for each negative. When ready to print, adjust the enlarger and paper by putting the tracing paper in the easel and lining up your drawing with the projected image. You have to ascertain that the thin paper and the printing paper are in exact alignment each time you print.

In multiple printing with a contact printing frame, the negatives to be placed in registration must be the same size. The easiest method is to place the first negative against the sensitized paper and put one T-pin on either side of the top left and bottom right corners (four T-pins total). Tape the negative down with small pieces of masking tape, remove the T-pins, place the paper and negative into the contact printing frame, expose, develop, and dry. Coat the paper with a second emulsion and let it dry. Place another (or the same) negative onto that same paper you have just coated and dried, lining it up according to the holes made by the T-pins. Insert the T-pins, check for exact alignment, tape the negative down, remove the T-pins, and proceed as you did for the first negative. When using T-pins, we suggest that you use a piece of foam core under the sensitized paper.

As you proceed to organize your darkroom and investigate alternative processes, an understanding of the types of negatives, light sources, why film works, and some of the individual film's special characteristics will help you.

stuffed. Use a hair dryer to warm it prior to stretching and shaping, and work carefully so as not to crack the glossy coating.

CONTACT PRINTING FRAMES

You may buy contact printing frames in several sizes (a common brand is Premier), and sometimes you can obtain used ones at low prices. However, it is easy to make an adequate contact printer yourself simply by taping (both masking tape and duct tape work well) one side of a piece of heavy plate glass ⅛" or ¼" thick to a firm backing such as sturdy cardboard or foam core. Hinged only on one side, these homemade print frames can be made in any size, and they are convenient. If you are using the sun as your light source, you may want to make several printing frames so that you can expose several images at once.

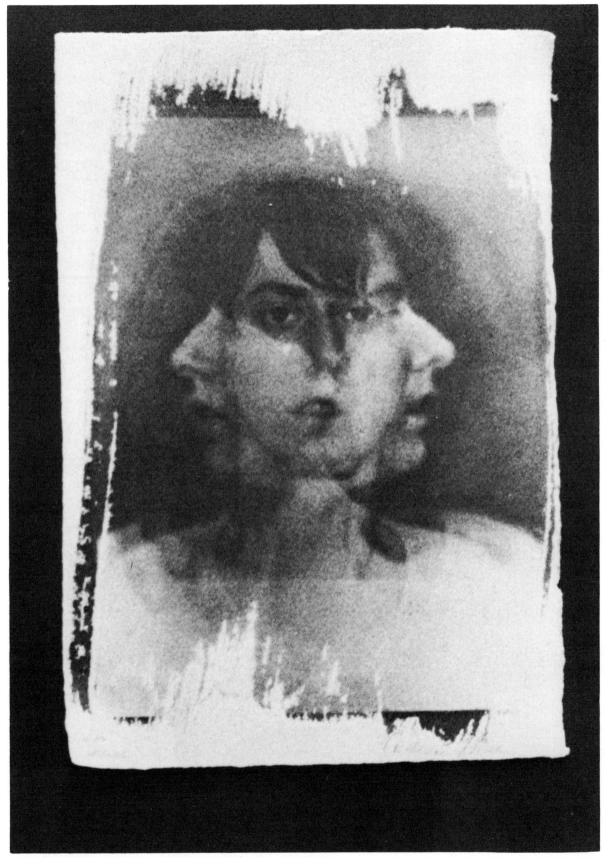

Catharine Reeve: "Susie," cyanotype on handmade paper, multiple
in-camera exposure, © 1982. 12″ × 9″.

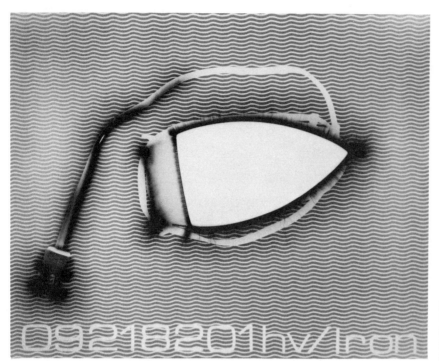

Mary Jo Toles: From the series, Domestic Reflections:
Clandestine Scientific Investigations of Household Item
(#09218201 hv/iron)," © 1982. 16″ × 20″ Ektaprint
illuminated by high-voltage and projected light
from an enlarger.

Helmmo Kindermann:
"Allows Time for the Easy Life,"
cyanotype with collage and
applied color on paper, 1977. 9⅜″ × 12″.
Courtesy of the John Michael Kohler
Arts Center, Sheboygan, Wisconsin.
Photo credit: P. Richard Eells.

3

Emulsion Processes, Darkroom Supplies, and Safety Procedures

Opposite page: Catharine Reeve: "Clouds," silver nitrate emulsion on handmade paper, © 1980. 12″ × 14″.

My own creative work comes to me like a gift, pushing itself into my consciousness. . . . To be a creative person is a significant privilege as well as a great responsibility.
Ruth Bernhard[1]

During the years since Niépce and Daguerre, groups of photographers have experimented with alternate printing surfaces. In the beginning, this experimentation occurred because the materials then in use were unsatisfactory. Later, research into alternative processes and surfaces was motivated by a desire for something beyond the traditional. Having the capability to coat a paper with emulsions (blueprinting, brownprinting, silver nitrate, and the like) increased the desire for a paper ground that was more related to the image and process than the commercially available photographic papers.

COMMERCIAL PAPERS

We describe in detail in Chapter 5 how to make handmade paper for use in all areas of photography. It is a simple and gentle process, and one we believe you will want to incorporate into your own work. However, there are papers available in art supply stores that also accept emulsions and travel safely through the chemical processes. Rives, Arches, Fabrianno, and other fine rag, etching, and watercolor papers are among these. These papers range in tone from warm pink and buff tones to cool blue and pure white. For a complete listing of available papers, send for the catalog by Andrews, Nelson & Whitehead (see Sources of Supply).

Hand Mills

Several handmade paper mills exist that will make paper to your specifications, as well as sell you papers from their commercial stock. Try to obtain sample papers for testing from these mills before ordering complete sheets.

(To test, soak the paper in water for 15 minutes. If the paper buckles excessively or becomes so soft that the fibers begin to separate, it is not satisfactory.) Many small mills have a single proprietor who will be pleased to discuss paper characteristics. Simply indicate that you wish to use the papers in photographic processing and that they must be able to withstand water washing. A list of these mills is included in Sources of Supply.

Oriental Papers

If you choose to experiment with Oriental papers, the range of texture, pattern, and color is infinite. Be aware that most of these papers cannot withstand water and chemical processing and need to be sized before coating with an emulsion. Following is a list of some that you may wish to try:

Natsume—Japanese paper in varieties of color, fibers, patterns, and density

Shuji and Sumi—soft absorbent papers traditionally used for Oriental brushwork

Amime, Uzu and Lace papers—semitransparent papers with geometric and floral patterns in transparent and open areas

Yamato Chri—brown leaf specks embedded in natural or white paper

Kawari Unryu—clouds of blue, brown, green, gold, or combinations of threads in semitransparent paper

Unryushi—papers with heavy fiber texture on ivory to dark brown grounds

Sekishu—Kozo fiber paper in white or natural

Imbedded papers—Japanese papers with objects such as entire leaves or butterflies encased in semitransparent paper

35

An old hand papermaking mill in New England. Courtesy of the Institute of Paper Chemistry, Dard Hunter Collection, Appleton, Wisconsin.

Kozo Kyokushi—Natural Kozo fiber paper of great strength for printing. Produced in Kochi.

An Oriental paper sample book is available from Andrews, Nelson & Whitehead, and Aiko's[2] (see Sources of Supply).

THE PI SYSTEM

The Pi System was formulated and developed by the authors to facilitate the use of hand-made paper as a support for emulsion-based photographic processes. The Pi System allows artists to create their own paper substructure for each photographic image. The shapes and surfaces of the individually created papers can be further manipulated to enhance the image. This may include changing the photograph from a traditional two-dimensional for-

Interior of Paper Press, a center for experimental hand papermaking, Chicago, Illinois. Sherry Healy, Linda Sorkin, and Marilyn Sward, proprietors.

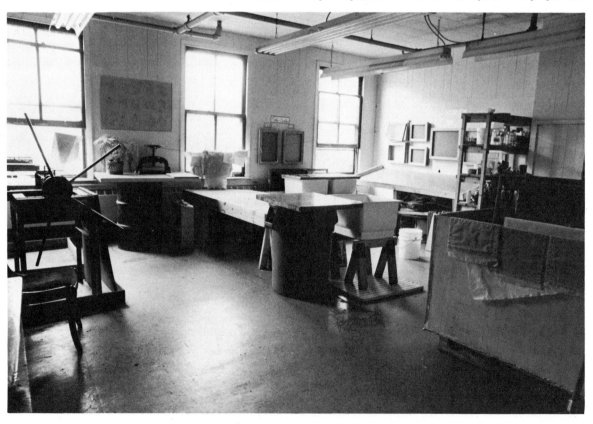

Interior of Aiko's, Chicago, Illinois, a large supplier of Oriental papers, brushes, inks, and bookbinding supplies.

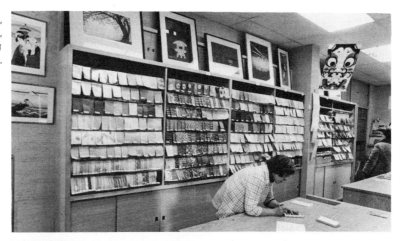

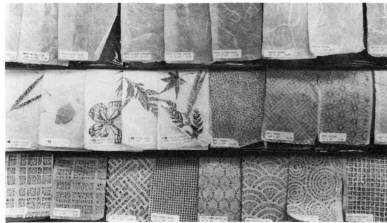

Detail showing some of the Oriental papers available from Aiko's.

mat to a three-dimensional sculptured form. (See Chapter 5, page 120.) The Pi System is defined as a method that utilizes a specially sized handmade paper for photographic printing techniques. The following information outlines the procedures developed for producing sized papers for use with photographic emulsion printing processes.

SIZINGS

As noted, many Oriental papers disintegrate during the prolonged immersion in chemicals and water, and so they need to be sized. *Sizing* is the material added to the handmade paper to fill the interstices between the fibers. Sizing adds strength to the paper and makes it water-resistant. The amount and type of sizing determine how strong, how limp or stiff, and how water-resistant a sheet of paper is. (The commercially-available Japanese papers require an external sizing, as described in a subsequent paragraph.) In Chapter 5 we describe how to make Japanese papers with internal sizing.

In the long history of hand papermaking, a variety of sizing components has been used: glue made from boiled scraps of animal hide, arrowroot, gelatin, alum-rosin, and starch. Today we have many commercial sizings whose individual formulas have been, and are, closely guarded secrets. For adapting handmade papers for photographic use, we have found that the synthetic sizing made by Hercules (Hercon 40) is the most effective and the easiest. (Measurements and ways to use this sizing are detailed later in this chapter.)

There are two methods of sizing paper:

internal and external. *Internal sizing* is added to the pulp before the sheet of paper is formed and dried. *External sizing* is added to the paper after it has been completely formed and dried; this is how you size the Japanese papers listed. Both are effective methods. The internal sizing, however, is more convenient since it does not require any extra steps, and it allows the surface character of the paper to remain visible. External sizings may cover and block some of the textural quality of the paper.

Internal Sizing and Additives

Sizings added to the pulp affect not only its strength and water-resistance but also its appearance and "feel." Certain sizings also have a higher reflective quality than others. Argo starch is such a sizing; when brushed onto a paper, it yields a particularly brilliant surface. All such side effects need to be taken into consideration as you look ahead to the photographic image you plan to print on the handmade paper.

There are also several chemicals that affect the paper's characteristics when added internally. Some common additions for handmade paper are calcium carbonate, manganese carbonate, and titanium dioxide. The first two are buffering agents; titanium dioxide

is a brightener. Manganese carbonate is more expensive than calcium carbonate, but it more effectively binds any trace of iron in the pulp. These chemicals are placed in the beater (3 grams per 100 grams dry fiber) during the end of the beating cycle. Of importance to photographers is the fact that titanium dioxide brightens the finished sheet. Titanium dioxide, also added in a 3% solution in the beater, is a highly effective brightener for both white and colored paper.

Internal sizings are a necessity for processing handmade papers in photo chemicals. The two most common internal sizings are industrial chemicals, Hercon 40 and A-quapel. They are available from Lee McDonald and Twinrocker (see Sources of Supply). Hercon 40 must be refrigerated to insure its effectiveness. It is added at the very end of the beating cycle at a proportion of ¼ cup per pound of dry fiber. Too much beating at this point will cause the sizing to foam excessively.

Aquapel comes in a waxy granular form and must first be mixed with hot water to dissolve into liquid. Mix 1 tablespoon dry Aquapel with 2 cups of hot water. Allow it to stand ½ hour, and then add it to the end of the beating cycle in the proportion of ¼ of the Aquapel water solution per pound of dry fiber. Both of these sizings coat the fiber and

Electron micrograph of methyl cellulose sizing, magnified 370×. The dark areas show the sizing filling the spaces between the fibers of the paper. Courtesy of Odell T. Minick, Department of Pathology, Northwestern Memorial Hospital, Chicago, Illinois.

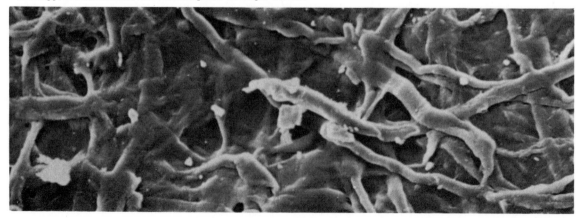

are not reversible (they will not wash out); therefore, it is necessary to experiment with the proportion you use to arrive at the desired character of the final sheet. Too much internal sizing masks the natural character of the fibers.

Aquapel may be used with the synthetic formation aid PNS (see Sources of Supply) in Oriental sheet making. Hercon 40 does not blend with PNS. Add ⅛ cup Aquapel solution (1 tablespoon Aquapel crystals to 2 cups hot water) to 8 gallons of Oriental fiber and water in the vat. Mix well and then add approximately 500 ml of PNS solution (see Chapter 5, page 110).

Pastes and starches such as methyl cellulose and gelatin may be used as either external or internal sizing. They are reversible. If they are used internally, the paper will slowly dissolve back to pulp when soaked in water. It should also be noted that some grades of methyl cellulose become yellow over a period of time, and that gelatin sizing gives a slight acidity to the finished sheet. Talas (see Sources of Supply) sells an archival grade of methyl cellulose. When this is mixed in the proportion of 2 tablespoons methyl cellulose to 1 quart of water and allowed to sit 15–20 minutes, it forms a clear paste for sizing or adhering papers together. This proportion may also be added to 1 pound of fiber in the beater to produce a light internal sizing. The proportion of sizing to water may be increased for added stiffness when pulp is used for casting.

If you prefer to make your paper in a blender, we list below the sizing proportions. Work with only 2 or 3 cups of the mixtures at a time in order not to strain your blender.

HERCON 40 SIZING

Blender:

2 tablespoons sizing

4 cups water

1 cup pre-soaked linter pieces

Blend pre-soaked linter pieces with 3 cups water and process into pulp in small amounts.

Samples of a variety of handmade papers that have been internally sized to permit the characteristics of the paper surface to remain visible and allow the papers to withstand photographic processing. Courtesy of Paper Press, Chicago, Illinois.

Mix sizing with 1 cup water, add this mixture to the blender, and process for 6 seconds.

METHYL CELLULOSE SIZING

Blender:

2 teaspoons methyl cellulose

4 cups water

1 cup pre-soaked linter pieces

Blend pre-soaked linter pieces with 4 cups water and process into pulp in small amounts. Mix sizing with 1 cup water, add mixture to the blender, and process for 6 seconds.

AQUAPEL SIZING

Blender:

1 tablespoon Aquapel

1 cup hot water

Mix the above and let stand for 10–15 minutes.

3 cups water

1 cup pre-soaked linter pieces

Blend the pre-soaked linter pieces with 3 cups water and process into pulp in small amounts. Add 2 tablespoons of the pre-mixed sizing to the blender and process for 6 seconds.

A sampling of sizing materials that can be used with handmade papers.

External Sizing

Any of the foregoing sizings can also be applied as an external sizing. You may apply the sizing with a brush (use a good quality 1" watercolor brush that won't leave bristles on the paper) or by the tray-soaking method. If you are using a brush, put the dried sheet of paper on newspaper, brush the sizing on, and let it dry. You should brush on two overlapping coats to make certain the paper is thoroughly covered. For better water resistance, after the paper is totally dry, coat the other side in like manner.

For the tray-soaking method, select a tray somewhat larger than the paper and fill it partially with the sizing ingredient you have selected. Place the paper in the tray for 2 minutes. Then lift it out and hold it diagonally over the tray so that the excess sizing can drain off. Using clothespins, hang the paper

An example of Hercon 40 sizing being applied externally to handmade paper, using a Japanese brush.

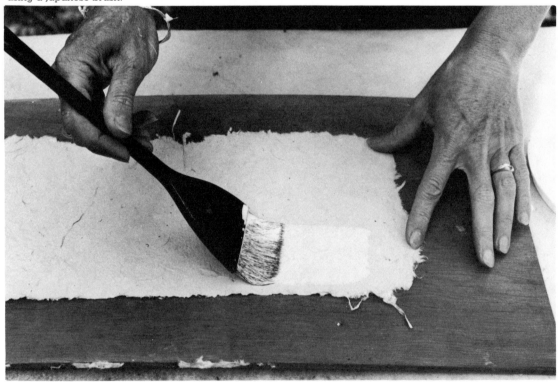

on a line to dry. Hang it loosely, as the paper may shrink as it dries.

GELATIN SIZING Unflavored gelatin (available from any supermarket) can be used as a sizing agent. Special steps must be taken if you choose to use gelatin sizing in the tray-soaking method. First, soak the required amount of gelatin in cold water until it swells. Heat it slowly until it is thoroughly dissolved (90°F—do not boil), then pour it into a glass or enamel pan. Keep the pan on a hot plate set at the lowest heat setting while soaking the paper for 2 minutes. Hang to dry as already described.

ARGO STARCH SIZING This sizing is of parlar interest because of its reflective quality. It lends a brilliancy to the surface of a print. We recommend it as one of the most effective external sizings.

> 1 tablespoon Argo Starch
> 2 cups distilled water

> *Mix small amounts of the two ingredients into a paste, until it is all mixed. Do this in a glass or plastic container, which is very important if you are using it in the platinum process. Boil it for 3 minutes (5 minutes is too long).*

We wish to reiterate that our most consistent results have come from using the Hercon 40 sizing mixed at the time the pulp is made.

Handmade Oriental papers are seductively beautiful to the photographer just awakening to the limitless possibilities of combining photographic images and handmade papers. Many have bits of grasses or flowers pressed onto the surface. Others are fragile, transparent, or lacy. Still others are beautifully colored and flecked. Fortunately for the photographer, these handmade papers, though not sized internally, can also be used for printing. We have used an acrylic *matte* medium (available at any art supply store) to make these papers water-resistant and able to withstand the photographic chemical processes. You can apply the acrylic matte medium straight from the bottle onto the paper,

A variety of artist's brushes.

using a 1″ soft watercolor brush of good quality. Place the paper on newspapers, coat one side, let it dry thoroughly, and then coat the other side. (Acrylic *gloss* medium does not work, because the emulsion does not adhere to the glossy surface.) As the paper dries, check to see that it is not sticking to the newspaper underneath. The acrylic matte medium makes the paper rather stiff, but, because it is transparent, it does not affect it in any other way. This works most satisfactorily with silver nitrate emulsions. It is not as effective with sensitizing materials that require contact with a fibrous paper surface.

You may, as mentioned, brush or roll on the sizing, or spray it on. It is possible to size only part of the surface and even to size it randomly. An awareness of the properties of the sizing and of its importance in enabling the coated papers to withstand photographic chemical processes helps you decide how you want to apply it.

Russell McKnight: "Kitchen Interior," a platinum-palladium print on handmade paper. 9″ × 12″. The brush strokes give a loose outline to this picture, which is printed on Hale paper made in England.

Methods of Applying Sizings and Emulsions

You will need to apply the emulsions listed in the following chapter by one of several methods. The most common way is to brush the emulsion on the paper. The brush stroke becomes an integral part of the final image, so it is important to learn the types of strokes that are most successful. Perhaps the best way is to print an identical image on a variety of papers, using as many brush strokes as you can devise (such as vertical, horizontal, uneven, or block). If you do not want the brush stroke to be noticeable at all, then coat the paper edge-to-edge and in both directions. If

you prefer to emphasize the edge of the image, coat the paper only partially so that the strokes are visible. Be careful to keep the bristles well coated with the emulsion, or you will get a blotchy and uneven image. For a uniform effect, use a foam or sponge brush (sold in the paint department of hardware stores). A Blanchard brush may be made by smoothly folding a soft cloth around a wide (2″ or 3″) bristle brush to encase it. Rubber bands are used to hold the cloth to the ferrule of the brush. It is also effective to sew a small case—similar to a pillow case—out of soft felt. These make absorbant covers that give a very even coating in emulsion application. For a loose effect, use Japanese or fan brushes. (For a

further description, refer to Chapter 6.) The uneven edges are effective in many images.

Other ways of applying the emulsion include finger-painting it onto the paper (wear rubber gloves), rolling it on with a roller, and rubbing it on with a sponge. You may also float the paper on top of the emulsion. Combinations of these methods can be interesting and effective.

Finally, although papers you buy are expensive, papers you make yourself are often one-of-a-kind and precious. Thus, we wish to emphasize the importance of test strips. It is not uncommon to find yourself out of test strips at the end of a printing session, when you have saved your favorite sheet of paper for just this last image. Errors in exposure made at this time cannot be corrected. Be sure to coat a large number of test strips when you are coating the printing papers. (Test strips left from an earlier printing session cannot be trusted, as the emulsions change with age.) If you do not have an extra scrap or sample of the particular paper to use as test strips,

Crane's stationery works well (try Crane's Kid Finish #8111). Be attentive to any variations in contrast between Crane's paper and your own, and you can adjust your exposure accordingly.

Test strips also let you see how the color and tone of the paper affect the final image, since the paper is visible through the emulsion. For this work, you must use test strips that are identical to the paper you are printing on.

THE DARKROOM

Special Equipment

In experimental processes, the darkroom is often used for coating papers with emulsions and drying them, as well as for printing and developing. A large dry area for coating and drying is desirable (a board over the darkroom sink works nicely). If space allows, a separate work table with a nonporous top is more convenient. Drying screens are recommended but not necessary. Such screens can

Louva Calhoun: "Reeds," silver nitrate emulsion on handmade paper, 1981. 5″ × 9¼″. The emulsion was brushed on the paper specifically to relate to the image.

Authors examine photographs using silver nitrate emulsions on handmade papers prior to placing them on fiber glass screens for drying. Note that screening material is used as an underlayer to facilitate moving delicate papers through the chemical processes. Photograph by Lois Cowen.

be made by tacking fiberglass screening to plywood frames. Old window screens can be used if the screening material is noncorrosive. The screens should be positioned so that the air circulates freely through the surfaces. The screens are useful both for drying emulsion-coated papers and the washed prints.

We recommend two 25-watt normal safelights in the darkroom, one over the coating area and one over the wet chemical area. The hand-applied emulsions are significantly less light-sensitive than traditional silver-coated papers, and they can thus endure a longer exposure to the safelights. Keep the safelights at the normally recommended distance of 4 feet from the printing papers.

Because it is convenient to coat several papers at a time, you need some type of light-proof box in which to keep them until you are ready to print. Photo stores sell such boxes in various sizes. These black plastic boxes are deep enough to hold 10 or 15 sheets. Empty photo paper boxes and any other box with a

tight-fitting cover can also be used. Spray paint the inside of the box with flat black paint and tape the box closed. It is helpful to note the date and type of emulsion you have used on the outside of the box for easy reference.

Hand-coated emulsions are more fragile than those on traditional photographic papers. To avoid abrasions, treat your papers gently as you process them. The chemicals and water should be kept at the temperature recommended for the emulsion you have used. Generally this temperature is between 65°F and 68°F. Many emulsions can wash off the paper if the rinse water is too warm or too forceful. Be certain to check instructions for the individual process. Hardware stores sell inexpensive attachments that screw onto the water faucet and permit you to attach two hoses to the same water source. Thus you can wash two prints simultaneously. Since the wash time can be long (20 minutes), this attachment can save much time. The prints should be washed emulsion side down at a temperature

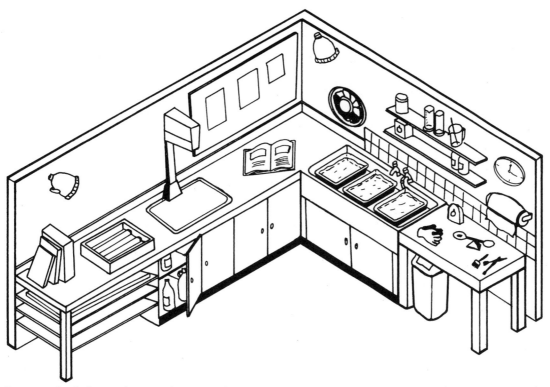

Drawing of a darkroom showing placement of equipment mentioned in this chapter.
Illustration by Jeanne Reilly.

of 60°–70°F. A thermometer put just inside the tray is helpful.

If you plan to continue printing while some papers are washing, you may find a second timer convenient. The printing can take as long as the wash, so we use the darkroom timer to time the chemical processes and a small kitchen timer to time contact printing exposures. Thus, if we are out of the darkroom while the exposure is being made (or are printing outside in the sunlight), we can take the smaller timer with us. You also need an accurate graduate that measures centimeters or milliliters. A funnel makes spills less likely when transferring liquids from one container to another. We also keep masking tape and rubber cement at hand, as well as a good supply of paper towels and clean rags.

Chemicals

Many of the chemicals required for experimental processes come in powdered or crystal form. These must be measured on a gram scale before being diluted with distilled water. There are several types of gram scales. We are particularly fond of the Pelouze scale (see Sources of Supply). You will probably enjoy a sense of alchemy as you measure and mix the blue and green crystals and white powders, all the while adjusting the tiny brass weights on the gram scale. Measure the dry ingredients onto a small piece of white paper (an individual-size coffee filter also works well), never onto the scale itself. Dispose of the paper once the chemicals are mixed and in solution.

Due to the interaction of some chemicals with metal, the mixing spoons, containers, storage jars, and the trays used in processing and washing should be plastic or glass. We also recommend a glass stirring rod and glass beakers for mixing the chemicals.

In summary, the equipment you need in the darkroom for the processes described in the subsequent chapter includes:

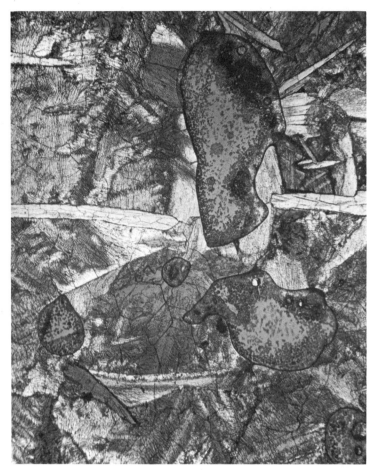

Norman Mizel: "Untitled," Cibachrome A II print, 1982. 19″ × 23″. Private collection. This work uses chemicals as a source for imagery. The process consists of melting and manipulating complex chemical compounds on a microscope slide. The crystallization resulting from this process is then photographed on 4 × 5 Ektachrome film through a polarizing microscope that has the light source interfered with in varying degrees by a combination of filters.

storage jars (glass or plastic)

glass stirring rod

glass beakers

glass or plastic darkroom thermometer

graduate (with milliliters and centimeters)

funnel (glass or plastic)

2 safelights

drying screens

light-tight box

2 timers

gram scale

mixing spoons (glass or plastic)

containers (glass or plastic)

darkroom trays (plastic)

SAFETY PROCEDURES IN PHOTOGRAPHY[3]
by Theodore Hogan, Ph.D.

[As we have indicated in discussing the darkroom set-up and materials, safety and handling are of primary importance. We include the following information with the hope that you will incorporate it into all your procedures.]

Ignorance of how to safely handle the chemicals used in various printing techniques can put you out of the picture. Artists may inadvertently consume chemicals while drinking, smoking, or eating in darkrooms. Because darkrooms are often poorly ventilated, photographers may breathe in excessive amounts of chemicals. If a kitchen is used as a darkroom, spills of chemicals could be left on counters and transferred to foods. Handling chemicals with bare hands is also a dangerous practice, since many chemicals easily pass through the skin and are absorbed into the bloodstream. This is especially true if there are cuts on the skin.

Almost all photographic chemicals can

Gram Scale. Courtesy of the Pelouze Scale Co., Evanston, Illinois.

irritate the eyes, nose, throat and skin. Exposure to some chemicals such as cyanides and solvents (turpentine, mineral spirits) may cause headaches, weakness, dizziness, and a sense of confusion. Prolonged contact with chromates may result in skin ulcers. Other chemicals can produce severe skin and lung burns, and, if they get into the eyes, blindness (hydrochloric acid, oxalic acid, potash, silver nitrate).

Adverse effects from repeated or prolonged exposure to chemicals might include ulceration and perforation of the nasal septum (chromates), kidney damage (chromates, uranium, and oxalic acid), lung allergies (platinum salts), and pigmentation of the skin, eyes, nasal septum and throat (silver nitrate). Skin rashes and allergies may result from long-term exposure to almost any photographic chemical. Formaldehyde, which is sometimes used as a paper hardener, is a suspected carcinogen.

Ingestion of even small quantities of some photographic chemicals can be fatal. As little as 5 grams of oxalic acid (approximately the same weight as five raisins) can kill an adult. One-half gram of potassium dichromate can kill a child. However, photographic chemicals can be properly handled to prevent adverse health effects.

Contact with chemicals can be avoided by constructing barriers between the body and the chemicals. For example, rubber gloves can act as a barrier to keep chemicals off the hands. Barriers can also be placed around the chemicals. Using the chemicals on only one table located away from other areas in the workroom isolates and minimizes exposure to chemicals. Properly designed ventilation assures that chemicals that escape into the workroom air are removed before they get into the breathing zone of the artist. A combination of barriers around the body, isolation of the chemical area, and ventilation will allow one to work safely in the darkroom.

When you buy a hazardous material, you are also "buying" the responsibility to handle the material in a safe fashion. If you are not equipped to handle the particular chemical safely, it should not be purchased until safeguards are in place. For example, one of the authors of this book became ill during the period she was experimenting with the cyanotype process. Repeated consultations

Ventilating fan installed in darkroom. Made by Dayton. ¼ horsepower, 115 volts, 3160 rpm.

with a physician did not reveal that she was the victim of low-grade cyanide poisoning. Instead, the symptoms were relieved by the installation of an inexpensive ventilation fan and by wearing gloves during all mixing and washing processes. The cost of acquiring safeguards is much lower than the cost of medical treatment and care.

You should be especially careful about experimenting with chemicals. One photographer reported experiencing a three-day druglike "trip" after breathing vapors released when some color dyes were heated. Such accidents are bound to happen if you are obsessed with learning the limits of materials. Just remember that you may exhaust your limits long before the materials reveal theirs.

Barriers Around Chemicals

The most effective control for exposure to a hazardous chemical is to use a less hazardous material. Exposure to the paper hardener

formaldehyde (which may cause cancer) can be avoided by using inert polymers (such as Aquapel). However, you cannot avoid the use of some dangerous chemicals. If you are going to do cyanotype printing, you need to use cyanides. But you can reduce the degree of exposure to the same chemicals by using many different processes instead of relying on just one. Sonia Sheridan suggests that this approach of switching materials and processes helps to keep you both intellectually and physically healthy.

There are ways to handle almost any material safely. The first step is to find as much information as possible about the potential hazards for each chemical. Manufacturers of chemicals are required to provide to customers Material Safety Data Sheets (MSDS), which describe the hazards and precautions to take when using a chemical. These can be obtained by making a written request to the manufacturer (not the supplier) of a chemical and asking for MSDSs for the particular chem-

icals in which you are interested. It would be a good idea to save these MSDSs in a file so that they can be easily found in case of an emergency or illness.

There is a temptation when buying anything to buy in bulk and save money. Large quantities of chemicals may save money, but their presence may lead to serious problems in handling and cleanup. Buy the least amount of trouble that you can. Mix small amounts of chemicals more frequently and avoid storage problems.

Once chemicals have been purchased, they should be properly labeled so that you or anyone else who may come in contact with the material can be aware of the hazards. The label should include: the name of the chemical, a warning such as DANGER or CAUTION, a brief indication of hazards, and safe handling practices. A label for potassium ferricyanide might read:

Potassium Ferricyanide

DANGER. Cyanides can be absorbed through the skin and lungs. Do not swallow.
Sufficient cyanide can be absorbed through the skin, especially if there are cuts, to cause fatal poisoning.
Avoid prolonged breathing of vapor and skin contact.

The labels should also have the name of the user and the date of purchase so that it is easy to know who has responsibility for the chemical. Since all this information may sometimes be hard to fit on the label of a little bottle, the hazard warnings and precautions could be posted in a conspicuous place in the workroom.

Chemicals should be stored in a place where only those who know how to handle them have access to them. If children are in the home or studio, chemicals should be stored in locked cabinets or in containers with child-proof caps. Incompatible chemicals should be stored separately. For example, cyanides should not be stored with hydrochloric acid or other acids, since contact between the two chemicals results in the

Safe chemical storage includes placing bottles in cabinets and proper labelling.

formation of hydrogen cyanide, which can be fatally toxic if inhaled. Some materials, such as chromates (for example, the bichromate used in gum printing), are extremely reactive, and special precautions should be taken with their storage. When chromates come into contact with metals, wood, or plastics, spontaneous combustion may take place. Solvents, such as turpentine and mineral spirits, are flammable and should be stored away from fire, heat, or sources of ignition (including electrical appliances). Solvents can cause a great deal of damage if improperly handled. An accident at a university laboratory caused by the explosion of just 1 gallon of a solvent resulted in over a quarter of a million dollars worth of damage to the lab, as well as serious injuries to two workers.

It would be best if the use of chemicals could be isolated to one workroom or even to one table in the workroom. Using the chemicals in one spot places a barrier between the

chemicals and all your other activities. If you must work with chemicals in a place where other work and living activities also take place, barriers can be constructed that allow you to isolate the chemical-handling activities. Select a surface that does not absorb chemical spills. Plastic laminate and glass surfaces are best. Wood is unacceptable because it is porous. Place newspaper on the work surface to absorb spills. Spills should be cleaned up immediately. Place the paper in a safe container and put new paper down. After work is completed, the newspaper should be placed in a plastic bag and taken outside to the trash. (Always use a covered waste receptacle in the studio.) The work surface should be thoroughly washed with soap and hot water to remove all traces of the chemicals. Do not wash the work surface with a kitchen sponge or any other material that will be used anywhere other than in the immediate area. Better yet, use paper towels so that you can avoid carrying chemicals over to other activities. Wear gloves when cleaning up. It is also important to use separate measuring, stirring, and storage containers for chemicals and for the kitchen. Label all chemical-handling equipment to avoid using it for anything else. If you spill chemicals on the floor of your workroom, you should be careful to avoid tracking chemicals to the rest of your space. Periodically clean your darkroom so that the chemicals do not build up. This cleaning should include a thorough washing of all counter surfaces and the floor.

Special care should be taken in the disposal of photographic chemicals. Washing large quantities of chemicals down the drain is not a good idea. Some of the chemicals could damage your plumbing, and reactions can take place between different chemicals, producing dangerous compounds. Ecologically, it is inconsiderate. Extremely hazardous liquid chemicals (such as unused cyanotype mixtures) should be absorbed onto kitty litter, put in a plastic bag, and placed in the trash outside the building. Dry chemicals and chemically soiled materials should be sealed in a plastic bag and placed in an outdoor container. Do not mix liquid and solid wastes: Dangerous reactions can occur. Keep chemically contaminated trash separated from household trash. Chemical trash should always be taken outside after each session in your studio since it may pose a fire and health hazard.

With our ever increasing awareness of the importance of careful and considerate disposal of toxic chemicals, you may want to organize a system with other photographers to gather toxic waste chemicals in a central location and take them to an approved sanitary landfill designated for hazardous waste products. Consult the environmental section of your area's Board of Health for such locations, as well as for advice on which chemicals must be transported in glass and which in plastic. Never mix toxic chemicals together without first checking to see if this can be harmful. An agent from the Environmental Protection Agency can answer many of your questions about toxicity.

Ingestion of chemicals in the darkroom is easily avoided. Don't eat, drink, or smoke in the darkroom. Keep fingers away from your face. Every time you leave the darkroom, wash your hands, even if you wore gloves. By washing your hands whenever you leave the chemical-handling area, you place a barrier between those chemicals and the rest of your life. Washing takes only a couple of minutes, but it could save you a lifetime of suffering. This precaution may seem excessive, but we cannot underestimate the very toxic properties of these chemicals.

Protective barriers can be placed around the body to keep chemicals from entering the body via the skin, lungs, eyes, and stomach. A separate set of clothes should be worn for working with chemicals. By changing clothing, you keep the chemical-handling activities separate from the rest of your activities. A lab coat, apron, or disposable plastic covering can be worn. Clothes worn in the studio or darkroom should be washed separately from your regular laundry.

Your hands require special protection since they are the part of your body that has

the most contact with chemicals. Gloves can provide protection from chemicals, but only if they are of the proper type, because some chemicals can pass right through household rubber gloves. The proper gloves for most photographic chemicals described in this book are made of neoprene (available at any hardware store). Wash the gloves with water between work sessions and replace them at the first sign of damage.

If you are using chemicals in a way that can cause splashing, you should protect your eyes with goggles. Special care should be taken if you wear contact lenses, since airborne chemicals can get trapped behind the lenses and irritate your eyes.

Devices called respirators can be worn on the face to filter out the dusts and gasses that you might breathe. For a respirator to be effective, it must have the correct type of filter for the chemical you want removed. Unfortunately, for the removal of hydrogen cyanide (which may be formed in cyanotype printing), the type of respirator and filter needed is very expensive. Ventilation would be cheaper and more effective.

Ventilation

Ventilation is essential in the darkroom. To set up an effective ventilation system, you need to understand some basic rules. The most effective type of ventilation is a system that captures the vapors right at the point at which they are released into the room. By capturing the vapors before they get into your breathing zone, you avoid contact with the chemicals.

Such ventilation is simple to set up. First, identify the major sources of vapors. In the darkroom, these are the developer, fixer, and the areas where the chemicals are mixed and the papers are coated. If possible, these activities should be done in the same place so that there need be only one exhaust. The exhaust pipe should be as close as possible to the source of the vapors. Like a vacuum cleaner that cannot clean the rug if it is lifted very far off the carpet, an exhaust system does not capture the vapors unless it is very close to the source. The exhaust should be located in

such a way that the vapors from the source do not pass by your face on the way to the exhaust. This can be accomplished by placing the pipe on the side or in the back of the source.

The Willson respirator, available at large hardware stores, effectively safeguards the artist from most chemicals. Different types of filters are available.

When setting up your system, remember that the volume of air is not the most important factor. What is important is that the fan creates enough air movement to capture the vapors at the point of generation. This can be easily tested by using a cigarette. Place a lighted cigarette at the point where vapors are generated and watch to see if the smoke is all drawn up into the exhaust. Be certain that the smoke is not being drawn past the place where your face is normally when you are working. Properly installed, the ventilation system captures the vapors before you can breathe them. If all the vapors are not being drawn toward the hood, move the exhaust pipe closer. Decreasing the distance between the source and exhaust can have a dramatic effect on the capture of vapors and is less expensive than putting in a bigger system.

For a ventilation system to work properly, new air must be able to come into the room. Darkrooms are usually well sealed to keep out light. Unfortunately, if fresh air has trouble getting into the darkroom, the ventilation system cannot work effectively. You need to keep cracks under doors or install light-blocking vents to let in air. Be careful to avoid drawing in outside air that you have been exhausting from the darkroom. Recirculation of exhausted air can be avoided by keeping a distance between the fresh air intake and the exhaust.

Emergencies

Sometimes the barriers break down and chemicals enter the body. Should this occur, immediately call the nearest Poison Control Center and give them the name of the chemical involved. Proper labeling can save a life. If you spill chemicals on your clothes or skin, remove the clothing immediately and wash the skin with soap and water. Spills of chemicals on clothes may soon dry up, but the chemicals remain on the clothes. Don't take chances: Wash your clothing before wearing it again. If you get chemicals in your eyes, *immediately* rinse them under running water for 15 minutes; then see a doctor. If you breathe in large quantities of chemicals, get to fresh air. When in doubt, seek medical attention.

Your doctor should be made aware that you are working with chemicals in sufficient quantities to possibly produce ill effects. If health problems do occur, give consideration to the possible role that chemicals may have played. Your file of chemicals will prove useful in discussing this with your doctor.

Just a few, simple, inexpensive precautions can keep you well. Clumsiness, laziness, or shortcuts can turn the creative joy of photography into a nightmare of illness. Be alert, be informed, and see what develops.

I think he died afterward. . . . Yes, I remember now, he did die. Mortification set it, and they had to amputate him. But it didn't save him. . . . He turned blue all over, and died in the hope of a glorious resurrection. Mark Twain, *Huckleberry Finn* (Chapter XXXII)

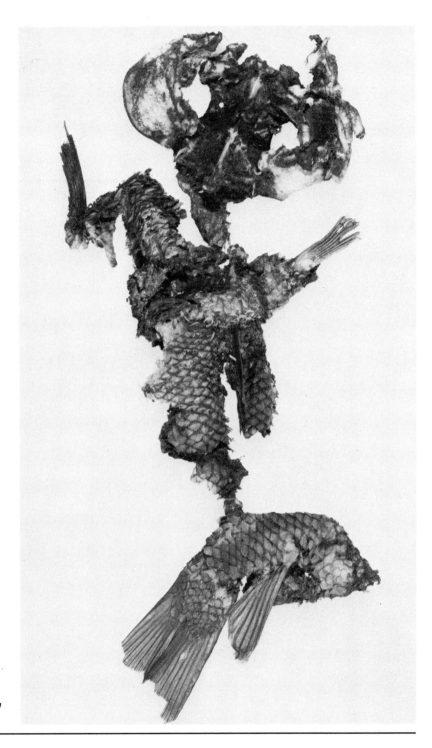

4

Alternative Processes

My own experience has long convinced me that any historical fact, recent or distant, may well be utilized as a stimulus to set the creative faculty in motion, but never as an aid for clearing up difficulties. Igor Stravinsky[1]

Today we use the terms "alternative" or "nontraditional" for processes that, while not currently "traditional," have an historic background. Photography grew from these formulas and practices, and we are returning to them with a new appreciation. It was through investigation of these procedures that the Pi System described in Chapter 3 was developed. As you try these processes, you relive some of the joys and the frustrations of the early practitioners of this blending of light, alchemy, and paper. Patience and a willingness to experiment are essential. Photographers of the 1800s studied the relationships of organic materials, metals, and light, examining their infinite possible combinations. The same chemicals and rules are here for the playing and orchestration in these processes. Careful analysis and experimentation may lead to new directions.[2] It is the pattern of photographic history.

CYANOTYPE/BLUEPRINTING

Interestingly, the first extensive use of Sir John Herschel's 1842 discovery of the cyanotype was in a book of botanical photograms—that is, contact prints of specimens of British algae—by Anna Atkins. Here was a blending of plant image, paper, fiber, growth process, iron salt, and light for meaning. Around the turn of the century, prepared blueprint paper was available and used extensively by amateur and professional photographers for proofs. It was also prevalent in postcards and stereographs of the period. Beyond this, the process never enjoyed any real popularity. It was used primarily as a copying process (Herschel himself used it this way, as engineers and architects do now).

Cyanotype is a simple procedure and a good process to begin experimenting with nonsilver processes, since the techniques relate to all the emulsion-based printing methods. The materials are relatively inexpensive, and they may be used on a variety of surfaces. If the strong Prussian blue color is undesirable, it may be changed with added processing. This process is quite permanent. The fading is only very slight, and, to enhance archival properties, it is possible to use papers with fibers that are toward the acid side, as they become more alkaline in time. Cyanotype prints are highly sensitive to moisture and should therefore be stored in a very dry environment.

Chemistry

The chemistry of the process involves the reduction of a ferric salt to a ferrous salt. This ferrous salt in the presence of ferricyanide and water becomes ferro-ferricyanide or Berlin blue. It forms as a result of the reaction between the ferrous salt and the ferricyanide. Washing removes the unreduced salts. Also note that these iron salts are most sensitive to and react to the red end of the light spectrum. Potassium citrate and iron form a complex molecule that absorbs the red spectrum. Therefore, using natural sunlight for exposure is desirable.

Warning: Before beginning any of these processes, please refer to the section on chemical hazards. Almost all photographic chemicals are poisonous. But some, such as oxalic acid, can be taken into the bloodstream on contact with the skin surface, and others, such as cyanide, may deposit toxic crystals on or under work surfaces where they are used. So follow the suggestions in Chapter 3 faithfully.

55

Formulas

There are three primary formulas for blue-printing. We recommend the first but include the second in case you wish to mix single solutions for use on fabrics. The second formula is a single solution to be used in one session. The third formula contains oxalic acid, which increases the storage life of the solution (up to six months), lowers the pH, and makes a slightly more soluble compound.

Formula 1

Solution A

| Ferric ammonium citrate (green scales or powder) | 50 g |
| Distilled water | 250 ml |

Solution B

| Potassium ferricyanide | 35 g |
| Distilled water | 250 ml |

Mix these solutions separately and store them in tightly sealed brown bottles. They have a shelf life of four to six weeks. When ready to use, mix together equal portions of A and B. Discard the combined solution after 24 hours.

Formula 2

Oxalic acid	1.25 g
Ferric ammonium citrate	33.7 g
Potassium ferricyanide	11.2 g
Ammonium dichromate	.25 g
Distilled water	250 ml

If you do not want to make stock solutions, this formula makes an amount large enough for a single coating session. Mix the ingredients together. Discard the solution after 24 hours.

Formula 3

Solution A

Oxalic acid	1.25 g
Ferric ammonium citrate	67.5 g
Distilled water	280 ml

Solution B

Oxalic acid	1.25 g
Potassium ferricyanide	22.5 g
Ammonium dichromate	.5 g
Distilled water	250 ml

Mix these solutions separately and store them in tightly stoppered brown bottles. They have a

Martha Madigan: "East Falls Bridge," cyanotype photogram, 1982. 52″ × 120″. The artist coats large sheets of paper with a cyanotype emulsion and places them beneath trees or in various structures. The paper is exposed, using natural light, for varying lengths of time (up to eight hours or more).

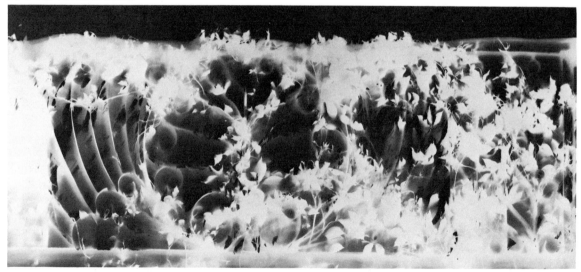

Roger Arrandale Williams: "Untitled," cyanotype, © 1980. 12″ × 20″. "The mask as a means of both concealment and focusing attention on the face has a long and varied history in the culture of humankind. The face, though hidden by the mask, remains psychologically paramount. Whether the image is perceived as fact or fabrication, it is the ambiguity and incongruity offered by the juxtaposed elements which is the prime appeal for me."

shelf life of four to six months. When ready to use, mix together equal portions of A and B. Discard the combined solution after 24 hours.

The ferric ammonium citrate is the light-sensitive chemical, and the potassium ferricyanide is the coloring agent. Too heavy a proportion of potassium ferricyanide tends to slow the emulsion by blocking light needed by the ferric ammonium citrate.

You need approximately 8 milliliters of solution to coat an 8″ × 10″ sheet of paper. The paper is most sensitive within the first two hours after coating. However, stored in a light-safe box away from excessive moisture, it may be kept for up to two weeks.

These solutions, once mixed together, are light-sensitive, so do all coating under a safelight. You may also use a yellow bug light as a safelight with the cyanotype process.

Measuring

To begin, the chemicals must be carefully measured, using a gram scale that is accurate and sensitive. The scale is balanced at zero, and then a paper to hold the chemicals is added to one side. We have found using coffee filters good for this purpose; they are the proper size and shape, and it is easy to remember to discard them after each use. The proper weights are added to the other side, and the chemicals are carefully added until balance is achieved. You then add 250 cubic centimeters of distilled water to a mixing container. It is important to use distilled water rather than tap water because tap water contains metallic substances that react with these chemicals. Slowly add the chemical to the water and mix for 2–3 minutes until completely dissolved, and then pour it into a

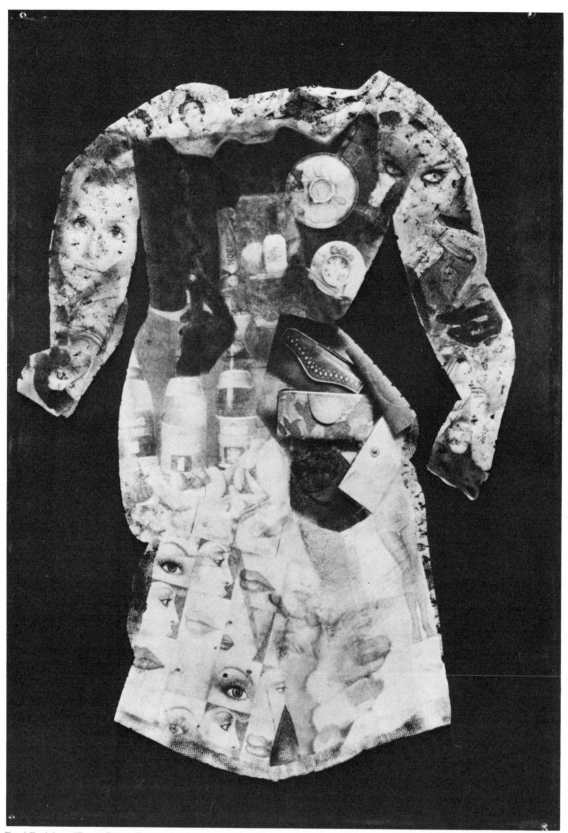

Fred Endsley: "Party Dress," cyanotype, gum print with pastel and acrylic, © 1975. 40" × 30".

brown bottle labeled SOLUTION A and the date. Everything is cleaned, and a new paper is placed on the scale. The chemicals for solution B are measured and mixed using the same procedure as above, and poured into a new bottle labeled SOLUTION B.

Note: use disposable plastic spoons or glass stirring rods for mixing. Metal must not be used, and wood absorbs and then pollutes subsequent chemicals.

If using A and B solutions, measure and mix equal portions of A and B. Then pour them into a shallow wide-mouth container (nonmetal cottage cheese containers work well). This allows easy dipping of the coating brush (see the section on brushes in Chapter 3).

Coating Papers

The paper you have selected should be taped to a nonporous surface and the emulsion brushed evenly across the paper. Care should be taken to allow this emulsion to saturate the surface; heavily surface-sized papers are not desirable for this process. The emulsion must be kept wet during the coating process. Dry areas should not be worked over or recoated, or those areas will lose sensitivity. You may wish to wipe over the damp paper with a soft pad to assure an even coating. Manipulations of brush work, application with a variety of tools, and application in only certain areas are just a few of the experimental possibilities. The paper should be dried *in the dark*; a hair dryer or heat fan may be used to speed the process. (It will be yellow-green when dry.) If the paper is warm when printed, it will shorten the exposure time slightly.

Exposure

Cyanotypes are exposed by contact printing. Place the negative and sensitized paper in a contact frame or under heavy glass. Objects, mylar drawings, paper negatives, cliché verre negatives, and anything else that can make surface contact may be printed.

Sunlight is the best exposure source, and it takes half the time (5–10 minutes) as artificial light. The next best alternative is an ultraviolet lamp (see Chapter 2). The exposure time for artificial light (unfiltered ultraviolet lamps) is approximately 15 minutes. You may check this easily because, as it is exposed, the paper turns from yellow-green to blue-gray, and the image appears. The exposure time can be predetermined by making test strips.

Development

After exposure, the print is developed by placing it face down in running water (68°F) for 10–15 minutes under safelight conditions. Wash until the yellow-green stain is removed. Gloves should be worn, since chemicals are present. Place the print on a plastic screen or hang it with plastic clothespins to dry. Again, a hair dryer may be used to hasten the process.

Problems and Solutions

ALKALINE WATER SOURCE The image is soluble in alkaline conditions, so if your water tests at over 8 pH, you need to lengthen your exposure times.

YELLOW-GREEN STAIN DOES NOT CLEAR Prepare a 1:7 Dektol solution. Dip the print in this and *quickly* remove it. Wash for 10 minutes. If this does not remove the stain, it may indicate that the print was overexposed.

Controls

INTENSIFYING COLORS Use 4 drops of hydrochloric acid in 1 quart water, 1 ounce household bleach in 1 quart water, or a 10-percent solution of ammonium dichromate. Dip the print in any of these solutions, and then wash again for 15 minutes.

Coating the surface with acrylic matte medium diluted with one-third water will also intensify colors. When using multiple techniques, blueprint last.

COLOR SHIFTS AND TONING The chemicals that affect the color of the cyanotype vary from common sodium carbonate (washing soda) and ammonia and tannic acid (wine-making

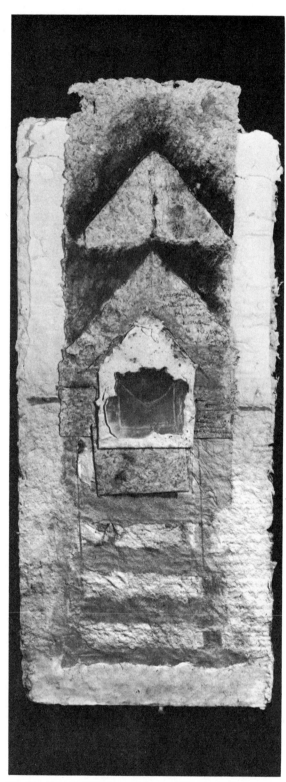

Marilyn Sward: "Magic and Alone," Van Dyke Brown, pastel, oil, collage, © 1982. 18″ × 40″.

supply) to pyrogallic and gallic acid. Direct-toning in ammonia or ferrous sulfate should be avoided, because the colors are fugitive. The processes for toning blueprinted images follow. These images should have no surface coating.

Warning: Some of these chemicals are hazardous. Wear gloves and follow the dark-room safety procedures listed in Chapter 3. In all cases, *distilled* water should be used.

Black

Ammonia	250 ml
Water	1,000 ml

Mix the ammonia and water. Immerse the print until the blue image fades. Wash for 5 minutes.

Tannic acid	30 g
Water	1,000 ml

Mix the tannic acid and water. Then place the bleached print in the solution until the image turns black. Wash for 10 minutes in running water.

Ultramarine Blue

Make a 5-percent lead acetate solution. Heat it to 85°F and immerse the print until the desired color is reached. Wash for 10 minutes in running water.

Red-Brown

Tannic acid	6 g
Water	180 ml

Mix the tannic acid and water. Leave the print in this solution for 5 minutes, and then wash for 10 minutes. This process yields a brown tone with yellow highlights.

Lilac to Purple-Brown

Tannic acid	70 g
Water	1,000 ml
Pyrogallic acid	2 drops

Mix the tannic acid and water. Heat to 120°F. Add the pyrogallic acid. Tone the image to the lilac color. (Work quickly or splotching

can occur.) *Wash for 15 minutes. If a deeper color is desired, place the print in a solution of 15 grams caustic potash in 1,000 ml water. Wash for 15 minutes.*

Violet-Black

Washing soda	50 g
Water	1,000 ml

Mix the ingredients. Leave the print in this solution until it becomes yellow. Wash for 2 minutes.

Gallic acid	8 g
Pyrogallic acid	.5 g
Water	1,000 ml

Mix the acids with the water. Immerse the yellow print in this solution until you have the desired color. Wash for 10 minutes.

Gallic acid produces violet tones. An increase in pyrogallic acid yields a blacker image.

All these coloring processes bleach or reoxydize the ferric compound and then allow it to reform with other organic compounds to produce a new color.

The color changes may also be brushed on selected areas of the print, allowing you to avoid immersing the entire print. The washing and other procedures are followed as already outlined. More than one color change can be done on a single print. However, these color changes are dependent upon an initially strong cyanotype print.

KALLITYPE AND VAN DYKE OR BROWN PRINT

Chemistry

W. W. J. Nichol, an English chemist, developed the kallitype process in 1889. Its reputation for impermanence (not wholly deserved) restricted its popularity, as did the difficulty of the process itself. It yields, however, a very beautiful and fairly long-lived image.

The use of kallitype and Van Dyke moves from a simple silver nitrate process toward the more complex platinum pro-

cess. Except for the metals (silver in kallitype), there is little difference between kallitype and platinum printing. It again, as in blueprinting, entails the use of ferric salts. Silver nitrate and ferric salt in the presence of light are reduced to a ferrous state and by development become metallic silver. This metallic silver has inherent instability. However, care in processing removes the ferric salts and nonimage silver that create most of the deterioration problems. Kallitype is a less expensive way to arrive at the look of a platinum print. Prints made with this process have the same long straight-line characteristic curve and therefore a very favorable continuous tone response. Many formulas and processes are available under this heading. The easiest is Van Dyke brown.

Van Dyke Formula

Solution A

Ferric ammonium citrate	90 g
Distilled water	250 ml

Solution B

Tartaric acid	15 g
Distilled water	250 ml

Solution C

Silver nitrate	30 g
Distilled water	1 l

Mix each solution separately. Combine solutions A and B and slowly add solution C, stirring constantly.

Note: Each time you use this emulsion, shake it to distribute the silver evenly. This solution should be stored in a light-safe container. It has a shelf life of several months. It should be prepared two or three days ahead of planned use and allowed to "age." Remember that the silver is light-sensitive, so the preparation of chemicals, storage, and coating of papers must all be done under safelight conditions.

Warning: Silver nitrate is highly poisonous. It also stains skin and clothing. Take precautions.

Coating Papers

Acid-free pure rag papers are best to use when working with silver, as they prevent mottling and fading. The surfaces may be coated by floating or brushing on the emulsion. As with cyanotype, it is important to saturate the paper fibers; however, with the high cost of the silver nitrate, it is prudent to use sized papers. (See Chapter 3 on sizing.) No metal should come into contact with this emulsion. If you are using brushes, make certain that they have wood ferrules (see Chapter 3 on brushes). Again, our favorite Japanese brushes are a good choice. Heat is beneficial to this process, so you may wish to use low heat to dry the papers. They should then be printed because this coated emulsion does not keep well over a day.

Exposure and Development

The Van Dyke print is contact printed, using sunlight if possible (see Chapter 2 on light sources). The exposure time will vary. It is approximately twice as fast as blueprinting, and you will notice a characteristic shift in color toward deep red-brown as the exposure is completed.

Develop the print face down in running water. You may add 2 teaspoons Borax, and the light may be turned on after about 5 minutes.

Continued washing for 10 minutes produces a reddish-brown toned print. To arrive at the true "Van Dyke brown" tone, the image must be fixed.

Fix in a 5-percent solution of 25 grams sodium thiosulfate to 500 milliliters water. Replace this dilute solution often.

The print should be placed in a hypo clearing agent for 2–3 minutes, then washed for 10 minutes.

Kallitype Formula

The kallitype is the same basic process as Van Dyke brown. It uses different iron salts and is more difficult. However, kallitype gives better control and variations in the color of the image.

Ferric oxalate	75 g
Oxalic acid	5 g
Distilled water	500 ml
Silver nitrate	30 g

Dissolve the ferric oxalate and oxalic acid in the water at 100°F. Add the silver nitrate, stirring constantly. Store this solution in a brown bottle. It must age at least three days before using. If necessary, filter the solution two or three times through muslin before using. Coat papers and print as recommended with Van Dyke, again heating the emulsion to dry the paper. Immediate printing is advisable.

Warning: Oxalic acid and silver nitrate are extremely poisonous. They also stain badly. Take proper safety precautions.

Kathryn Paul: "Bedroom," Van Dyke Brown and colored inks, © 1979. 4" × 24".

Processing for Color Shifts

For a *black-toned* image, use the following formula (use distilled water in all cases):

Borax	90 g
Water (100°F)	1,000 ml
Rochelle Salts (sodium po-tassium tartrate)	60 g

Dissolve the Borax in the water. Add the Rochelle Salts. Develop the print in this mixture for 10 minutes to produce a black tone. To increase contrast, add 5–20 drops of potassium dichromate.

For a *purple-brown* image:

Mix:

Borax	45 g
Water (100°F)	1,000 ml

Dissolve thoroughly.

Add:

Rochelle Salts	90 g

Develop the print in this mixture for 10 minutes.

For a *sepia-toned* image:

Mix:

Rochelle Salts	45 g
Water	1,000 ml

Develop the print in this mixture for 10 minutes.

After any color process, rinse the print in running water. Then clean and fix as follows:

Clearing bath:

Potassium oxalate	20 g
Water (68°F)	1,000 ml

Mix. Clear the print for 5 minutes.

Fixing bath:

Sodium thiosulfate	45 g
Household ammonia	12 ml
Water (68°F)	1,000 ml

Mix these ingredients and fix the print for 5 minutes. After fixing, immerse the print in hypo clearing agent for 3 minutes. Wash in running water for 10 minutes.

Blueprinting and kallitype formulas contain opposing substances that attack each other when combined on the same surface. This often produces strange and magical effects. Their archival properties are doubtful, however.

SALT PAPER PRINTING

One of the enjoyable aspects of doing salt papering is that it returns us to the very beginnings of photography. In 1834, William Henry Fox Talbot discovered the effect of salt on silver. By persevering in his research, Talbot learned that an excess of silver nitrate increased the sensitivity of silver chloride, and

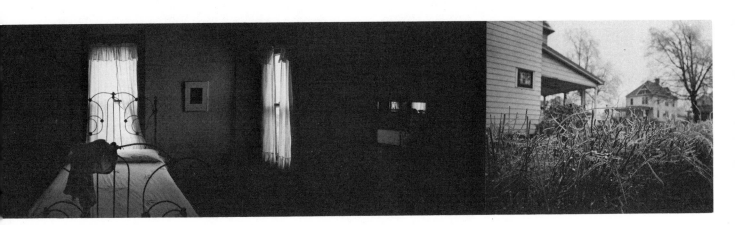

Charles Reynolds: "Cucumber Falls," kallitype on Arches paper, © 1980. $9\frac{9}{16}'' \times 7\frac{1}{2}''$.
Courtesy of Jacques Baruch Gallery, Chicago.

that an excess of salt greatly reduced the sensitivity of the silver. This salt papering process (called *calotype* and later *talbotype* by Talbot) produced the first negative-to-positive image in photography.

Chemistry

$$NaCl + AgNO_3 = NaNO_3 + AgCl$$

This is a simple process using common household salt and silver nitrate. The sodium chloride ($NaCl$) and silver nitrate ($AgNO_3$) combine to form sodium nitrate ($NaNO_3$) and silver chloride ($AgCl$). Silver chloride is not unlike commercial printing-out paper. In its most direct application, you need only table salt (noniodized is best), silver nitrate, and distilled water. Note, however, that organic materials help to complete the reduction of the silver nitrate into silver chloride. As a result, many formulas contain organic substances such as oxalic acid, citric acid, and tartaric acid. The other primary concern is keeping the silver formula on the surface layer of the paper rather than allowing it to "sink" into the fibers. This gives a final image that is higher in contrast. To keep the salt emulsion and silver nitrate coating on top of the paper, the paper may be surface-sized with gelatin, Argo starch, or albumen (see Chapter 3 on procedures for sizing). It should be noted that gelatin sizing produces a cooler image and that starch gives warmer tones. Solutions B and C contain organic acids in the salt coating. You may find your results are better if you size the paper with starch or gelatin before coating with any of the salt formulas.

Handmade papers may be used for the salt-paper process; however, coarsely textured, porous surfaces give low contrast, flat prints. Therefore, you may wish to press papers an extra time using an iron, placing them in a drymount press (see Chapter 3) or calendering them in an etching press before using this process.

Select one of the following salt paper formulas for the initial paper coating:

Solution A

Noniodized kitchen or sea salt	2 tsp
Distilled water	1,000 ml

Dissolve the salt in the water. Brush onto sized paper.

Solution B

Gelatin	2 g
Distilled water	280 ml
Sodium citrate	6 g
Ammonium chloride	6 g

Dissolve the gelatin in 100 milliliters distilled water for 10 minutes. Add the rest of the water and the chemicals. Mix and brush onto sized papers.

Solution C

Starch (Argo is excellent)	5 g
Water	280 ml
Sodium citrate	6 g
Ammonium chloride	6 g

Dissolve the starch in 80 milliliters water. Add the remaining water and bring to a boil. Boil for 3 minutes. Remove from heat, and stir in the sodium citrate and ammonium chloride. Allow to cool and thicken slightly before coating.

Coating Papers

The paper should be immersed in one of the foregoing salt solutions until it becomes thoroughly saturated (approximately 5 minutes). The paper is then drained and hung to dry. It should be rotated as it dries to insure even saturation. The paper at this point is not light-sensitive and may be stored indefinitely.

The sensitizing formula is: 25 grams silver nitrate and 250 milliliters distilled water (or lesser proportions in the same ratio to guarantee even coating). The paper should be floated on this solution—submerging the paper only sensitizes both sides and wastes expensive silver nitrate. After floating it for 2–3 minutes, carefully lift it off the surface and hang it from the corners of its longest side to dry. The solution may also be brushed on,

William Henry Fox Talbot: "The Chess Players," salted paper print from calotype negative, © 1845. 14.5 × 19.3 cm. Courtesy of The Art Institute of Chicago.

applying even strokes in first one and then the opposite direction. It may be necessary to repeat this procedure to obtain an even coating. This process allows you to coat limited areas. It has the advantage of using less solution, and it does not sensitize the back, thereby preventing uneven density in the final print. A slightly higher precentage of silver nitrate may be used in the brushed-on process: 4 grams silver nitrate to 30 milliliters distilled water. All coating with silver nitrate must be done under a safelight.

Warning: Silver nitrate is extremely poisonous and stains skin and clothing. Please refer to Chapter 3 before using this chemical.

Sensitized paper keeps for 2 or 3 days if properly stored. Since moisture must be avoided, keep papers in a dry, dark place.

Exposure

Exposure is made by contact printing, and the best light source is the sun, with its advantageous ultraviolet light spectrum. Contrast is lowered by using other light sources. When using the sun, contrast is further increased by turning the contact frame to face the shadows. In other words, reflected sunlight is preferred to direct sunlight.

The exposure time should be approximately 10 minutes. This may vary up to 30 minutes, depending on sun conditions. Watch

to see that the print is somewhat overexposed, because there is a significant loss of the light tones when the print is fixed.

Development

Wash the print face down in several changes of tap water. Continue to wash until all the milkiness has cleared from the water. This milky residue is unexposed silver. (Large laboratories recover it for resale.) If you wish to expose again, dry the paper completely in the dark and recoat it with silver nitrate. There is no need to repeat the salt process. The images will keep without further processing if stored away from light. However, for better permanence they should be fixed in sodium thiosulfate (hypo), mixed 50 grams hypo to 500 milliliters water at 90°F. The print should be agitated in this solution for 10 minutes. Then

place the print into a hypo clearing solution for 5 minutes. Then wash it in water for 10–15 minutes. Hang or lay on screens to dry. The finished image is a light tan color and considerably bleached in comparison to the initial exposure. It is possible to achieve a gray-blue color with the use of gold chloride in a toning bath. We refer you to *Keepers of Light* or *The Albumen and Salted Paper Book* (see Bibliography) for the formulas and procedures. This is a fairly costly process, but the image in its tan color is quite pleasing and usable for many further experiments.

GUM BICHROMATE PRINTING

The origin of gum bichromate prints is similar to the salted paper process in that both evolved from the need of early photographers to make prints that would not fade. A variety

Judith Harold Steinhauser: "Delicate Haze," gum bichromate and cyanotype, © 1974. 11″ × 14″. "This print is intentionally done slightly out of registration. If the successive color exposures are made precisely in registration, the edge quality of one color against another is lost. Somehow that takes away an energy or vitality (which I consider half the reason for doing the print anyway) . . . it steals the air."

of people claimed to have originated the gum process. Possibly the most assertive was John Pouncy, a persevering Englishman, who claimed to have discovered the process in 1858. Ultimately, three men were responsible for the research on which gum printing is based: Mongo Ponton, who discovered the light sensitivity of dichromates in 1838; Talbot, for noting that soluble colloids mixed with a dichromate lose their solubility; and Alphonse Louis Poitevin, who in 1855 added pigment to the colloid. The process was not popularized until the pictorialists revived it at the turn of the century because it was easy to manipulate. There are many variables in controlling this process, and much information is available in print. Some artists feel that it is just too difficult to control. Others praise it as a perfect process for painterly experimentation, and control becomes an intellectual challenge.

Chemistry

This process moves us into a different area of chemistry. Gum bichromate printing depends not on iron or silver salts but rather on the ability of colloids to become insoluble when mixed with dichromates and exposed to light. In this process, the bichromate or chromic acid is reduced to chromium sesqiroxide (Cr_2O_3), which then reacts with excess bichromate to form chromium chromate (Cr_2CrO_6). The chromium chromate is the actual tanning or insolubilizing compound. Remember that heat and humidity affect colloids adversely. There are also some interchangeable terms: "bichromate" and "dichromate" are the same, and "potassium bichromate" is interchangeable with "ammonium dichromate." The former is less expensive; the latter, faster.

The print is made by coating sized paper with an emulsion of watercolor pigment and bichromated gum arabic. It is exposed (contact printed) and then developed by floating in running water. The exposed areas retain the color and image in insoluble layers of gum; the nonexposed portions wash away. This process allows a perfect blending of reward

for persistent meticulous craft and free-wheeling experimentation. And it provides inexpensive archival color photography.

Papers

Gum bichromate printing may be done on any handmade paper or fine art paper surface. For first experiments, however, we recommend a cold press art paper or calendered handmade paper with a fairly smooth surface. It is necessary to have enough tooth or texture to hold the gum in the highlight areas, but most rag papers have this. Handmade papers are advantageous because they may be made very smooth and yet retain an inherent texture highly suitable to gum printing. You will quickly establish your preferences, and, again, images make their own demands for surface.

You need to preshrink your paper in hot water because the beautiful soft colors of gum prints are built up with multiple coatings and exposures. Preshrinking allows for accurate registration. The paper must also be sized to protect the highlight areas from staining during the development of multiple exposures. A gelatin sizing is recommended, but you may use any sizing described in Chapter 3, or spray laundry starch.

Emulsion

The emulsion to be coated on the paper has four components: pigment, gum, sensitizer, and distilled water. It is critical to understand that variables in the amounts of these elements change the characteristics and results to a greater degree than in the other emulsions discussed. But, as you use the materials, you become captivated by the subtle beauty of the process and continue to experiment for your own best formulas. Gum printers are continually involved in the alchemy of their process.

Very simply stated, the process is to mix a pigment and gum solution together and add an equal amount of sensitizer premixed with water.

Frank Lavelle: "#10 Untitled," from the "Family Album Revisited Series," cyanotype and gum bichromate print, 1982. 18″ × 12″. The artist printed on Arches 140 lb. cold press paper and then applied watercolor.

Pigment

We will begin by looking at the pigments.

For experimentation, it is easiest to use inexpensive tube watercolors and a ruler or notched palette knife. You can squeeze out a strip of color on a piece of glass or on an enamel or plastic palette, stopping when you reach the prescribed length. A 1″ strip of paint gives a light color saturation, and it may be varied up to 4 inches for heavy color density when mixed with 25 milliliters gum arabic. When you are satisfied with your test results, use pigments of a higher quality, and you may wish to try powdered pigment in addition to watercolor or gouache (opaque watercolor). Winsor Newton and Grumbacher produce high-quality paints and pigments that give richer color with less tendency to flake. It is easier to be exact if you use the gram scale and either powdered pigments or watercolors. A guide for proportion follows.

In a 25-milliliter gum solution, mix:

	Tube	Powdered Pigment
Alizarin crimson	1.4 g	0.6 g
Hansa yellow	1.2 g	0.3 g
Cadmium yellow	1.6 g	1.2 g
Thalo blue	1 g	0.3 g
Burnt umber	3 g	2.5 g
Lamp black	2.8 g	2 g

These colors form a basic palette that is closest to that of the primary subtractive colors. Hansa yellow is a synthetic color that is close to cadmium and much less expensive. Thalo blue is a dye close to Prussion blue but more stable and more compatible with the cadmiums than Prussian. Winsor Newton calls this color "Winsor" blue. There is a significant variation in these blues, and you may wish to try different brands. The earth colors of umbers and sienna range from a yellowish, red-brown, raw sienna to deep, rich, burnt umber. Used with lampblack, they produce a wide variety of tones and shadow values.

As you vary your palette, you should note that chrome and lake colors (such as chrome yellow, purple lake, and the like) are less permanent than the basic colors listed. The chrome colors may also be unstable with the sensitizer. A special note concerning chemistry: Emerald green should not be mixed with other colors. Also, it is poisonous.

Powdered pigments must be ground with a mortar and pestle or the back of a spoon in a ceramic bowl. Sometimes they float and refuse to combine with the gum solution. You may heat the solution and add half a teaspoon of table sugar to help correct this. If the particles continue to separate, do not use them, because they will stain the paper surface.

Gum Solution

Many formulas are available for making your own gum solution. They are not, however, at all necessary, since 14° Baumé solutions are available from printing supply houses and some photographic laboratories (see Sources of Supply). This solution contains phenol to prevent the souring problems encountered in preparing your own solution. The gum is a light tan, syrupy solution that darkens as it is stored. It is best to purchase it in small quantities and replace it often. Purchasing premixed solutions also prevents having to handle mercuric chloride, an extremely toxic chemical used to prevent bacteria in hand-prepared gum solutions. The gum and pigment are mixed and may be checked in the light for the desired shade. The gum hardens quickly, so this mixture is difficult to store. Airtight containers must be used if storage is attempted. In working with gum, remember that, as you mix and brush it, you aerate it and speed its hardening. Be efficient with your motions.

Sensitizer

The sensitizer is ammonium dichromate (bichromate) and warm water. The pH of this solution should be kept low to retain maximum sensitivity. If it is stored, it may be necessary to reheat it to allow the precipitants to dissolve. It should be stored in a brown bottle. The formula is:

Ammonium dichromate	29 g
Distilled water (80°F)	100 ml

Dissolve the dichromate in 25 milliliters water. Then add the remaining water. Mix 25 milliliters of this solution with 25 milliliters of the 14° Baumé gum solution which has been mixed with the selected pigments.

Coating Papers

The mixture of gum, pigment, and dichromate is brushed onto the sized paper surface. The coating should be thin and even. Colors may be applied over each other in one coating as long as thin layers are used. The papers must be dried in the dark or under low-level safelight. A fan or hair dryer may be used to speed the process. The paper should be used soon after it dries because storage allows the coating to become insoluble. Cool dark storage retards this, but the best results are obtained by using the paper as soon as it is dry.

Exposure

Exposure is by contact printing techniques, and it is faster than other processes. Images appear in 6–10 minutes. If using the sun, it is best to capture reflected light rather than direct sun. The time varies, but approximately 30 minutes should be adequate.

Development

Development should be done immediately following exposure. The dichromate loses solubility with time as well as with exposure. It is desirable to wash it out as soon as possible. The print should be placed face down in room temperature water. Change the water as soon as it clouds with pigment and soluble gum (a yellowish stain). Care must be taken in handling the print, and the water movement should be gentle. The problem is to clear the highlights. It is sometimes necessary to use a very soft brush and gently work over them. The print should be allowed to float face down

in water for 30 minutes. You may lift the print to check that pigment is continuing to rinse off during this time. The temperature of the water may be raised if the print is not clearing. It should then be placed on a screen to dry. Consider this a multiple printing process and recoat the image when it has dried. A 5-percent solution of potassium metabisulfite may be used to clear the print. Do this after the print has dried and upon completion of the final exposure (when doing multiple exposures). Procedures using alum for final clearing should be avoided, since alum is harmful to the paper surface and to the permanence of the image.

Multiple Printing

Multiple printings enhance the image. Three color separations may be done, using the red, yellow, and blue colors previously listed. A note on registration: Outline your negative on the paper surface with a soft pencil and line it up each time. The paper may shrink slightly, but by marking all four sides you come close to perfect registration.

This gum printing process works well in combination with blueprinting. The cyanotype forms a distinct high-contrast background for the soft gum bichromate colors. The painterly characteristics and colors of gum printing lend themselves perfectly to incorporation with traditional art materials. Experimentation is the premise.

CARBON PRINTING

History

The carbon process was developed in 1855 by the French chemist, Alphonse Poitevin. Three years later John Pouncy claimed to have produced the first photographs using these techniques. Their primary objective was to gain permanence and stability. Silver intake prints of this period were extremely fugitive. Employing carbon in the printing meant using an element that was chemically inert and therefore stable and permanent. The prints pro-

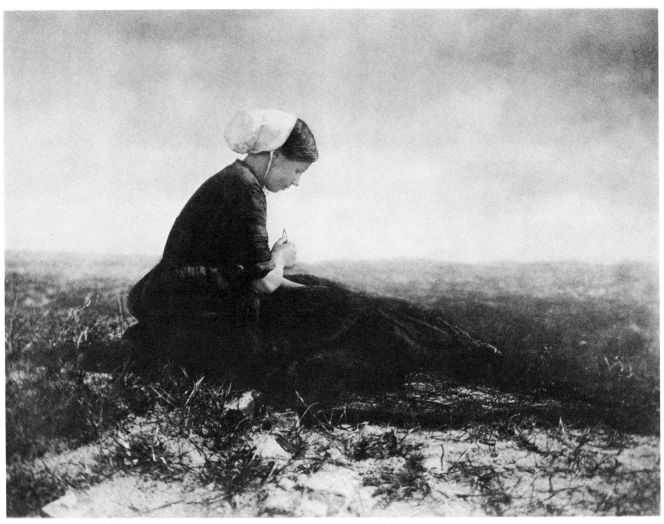

Alfred Stieglitz: "The Net Mender," carbon print, 1894. 41.9 × 54.4 cm. The Alfred Stieglitz Collection. Courtesy of The Art Institute of Chicago.

duced with this method have a very long tonal range, giving good separation of detail in shadow areas.

Chemistry

The carbon printing process relates chemically to gum bichromate in that it involves the use of a colloid (gelatin), which becomes insoluble when mixed with ammonium dichromate. The chemical reaction between these two materials raises the melting point of the gelatin and lessens its tendency to absorb water. Exposure to light produces the reaction that renders the nonimage areas soluble.

Process Outline

The carbon process varies from the other processes discussed because it is printed indirectly. After exposure and prior to develop-

ment, the image is transferred from the original base, called a *tissue*, to the final surface. The tissue is actually a paper base with a thick pigmented layer of gelatin to which ammonium bichromate has been added as the sensitizer. It may be added in the gum layer or coated after the gum has dried. The tissue is contact-printed with a full-size negative in sunlight or a light box. The exposure to light hardens the gelatin: the longer the exposure, the greater the depth of tone in the final print. This transfer is rinsed and then brought in contact with the final paper support. The final paper and the image-bearing tissue are sandwiched between glass and allowed to partially dry. The sandwich is then placed into hot water, and the unexposed gum washes away. The original image-bearing tissue is removed, and the final print, now

transferred to the paper support, is gently bathed in warm water until the image fully appears. Many interesting manipulations are possible using this process. It may be multiple printed up to three times, and any type of properly prepared material may be the final support. It is possible, therefore, to put images on glass, metal, wood, cloth, ceramics, and the wide variety of papers available.

Tissue

The image-bearing paper called "tissue" was commercially produced until the early 1950s, when Autotype in England went out of business. Today tissue is available from Franz Hanstaengl of Munich, Germany, and Dr. Robert F. Green of Fort Wayne, Indiana (see Sources of Supply).

MAKING TISSUE Making your own tissue is not terribly difficult. A good quality smooth surface watercolor paper works well. The gelatin must be floated onto the surface rather than brushed on. Any of the following three techniques may be used. As there are many steps in this process, it is helpful to maintain a good supply of tissues.

One method is to place the tray containing the gelatin mixture into a larger tray of hot water to keep the gelatin liquid. Then place the paper on the gelatin, being careful not to trap air bubbles. (Air bubbles are a problem throughout this process. Whenever two wet objects or surfaces come together, great care must be taken to remove any trapped air.) Then gently and smoothly lift the paper up out of the gelatin, and lay it on a level surface while the gelatin sets up. The paper may then be hung to dry.

The second method is simply to lay the watercolor paper down flat and pour the gelatin onto the surface. It may be spread with a squeegee or glass rod. Again, it should set before it is hung to dry.

The third system is the easiest, once the proper equipment is prepared. A wooden frame is constructed to fit over a smooth board, preferably with a plastic laminate surface. The paper is cut to fit the board, dampened, and brushed into contact. The wood frame is then clamped to the paper and board. Gelatin is poured into this "dish" and quickly poured out again. The unit is placed flat until the gelatin sets up. Then the clamps and frame are removed and the paper hung to dry. It is very important to maintain the temperature of the gelatin at 100–150°F during the coating operations. We suggest using a thermometer to check this. The above methods produce the "tissue" which will hold the image until the image is transfered to the final support.

GELATIN MIXTURE The gelatin must be a thick mixture of 30-percent gelatin in distilled water. You may use cooking gelatin such as Knox or Greys, but it is preferable to obtain gelatin from printing suppliers (see Sources of Supply), because it forms a harder coating. The gelatin should be placed in a cheesecloth bag in the proper proportion of warm water and allowed to stand for two hours. Dry artist's pigment is added to the gelatin. Proportions of pigment depend on the image and may vary from 5 to 30 percent. A 5-percent proportion of glycerine is added to give pliability, and a 5-percent proportion of sugar to help solubility. Ammonium dichromate may be added to the gelatin at this time, but it reacts with the gelatin and may not be stored. We recommend sensitizing as a separate procedure. The paper "tissues" coated with only gelatin are not light-sensitive; stored at 68°F or lower with 50-percent humidity, they will keep for several months.

Sensitizing

Mix:

Ammonium dichromate	6 g
Distilled water	200 ml

This concentration controls the print contrast. Lower amounts of dichromate increase the contrast but decrease light sensitivity. The proportions may be increased to 6-percent dichromate, which produces high light sensitivity with low image contrast.

Dampen the gelatin-coated paper and place it pigment side up in a tray of dichromate solution for 2 minutes, agitating it

Joyce Tenneson: "Heart Back," hand-applied silver nitrate emulsion on Arches 140 lb. rag paper, © 1981. 22" × 30".

slightly to coat it. The mixture should be at 68°F. Remove the paper from the sensitizer and tack it to a board to dry to prevent curling. Drying takes several hours, and high heat should be avoided. It is sensitive to daylight and ultraviolet light, as well as to fumes from solvents.

To speed the drying time, a spirit sensitizer may be prepared, using two parts alcohol or acetone to one part ammonium dichromate and water. The dichromate and water solution should be 4 percent if a 2-percent sensitizer is desired. The percentage of dichromate to the total solution controls the contrast: the higher the percentage of dichromate, the lower the contrast.

Negatives

The negatives for this process should not be too dense, and they should have a full tonal range. Before printing, it is advisable to mask the negative with a ½" border of paper or red lithographic tape. This gives a soluble edge on the tissue, which prevents the picture edge from washing up or frilling. You may also mask the outside of the contact frame if you are using negatives of the same format. You may also wish to print your negative in reverse, remembering that this is a transfer process. By printing the negative in reverse, the final print orientation is correct.

Support Paper

The base paper that is to hold the final image must be coated with gelatin to receive the transferred print. You may use either household gelatin or printer's gelatin, as was used for the tissue. (For methods of application see Chapter 3.) This paper should be slightly larger than the transfer paper and the negative. As you begin to print, you should start to soak this paper. It needs to soak at least 15

minutes. Do so by placing the paper face down in 68°F water. Again, avoid trapping air bubbles under the paper as it is placed in the water to soak.

Exposure and Transfer

Exposure is completed by placing the negative with the base side up in contact with the tissue in a light box. The exact time of exposure varies with the solution of sensitizer on the tissue, but generally it is 3 minutes. Again, making test strips is a good practice. Also, there is a continuing reaction in the gelatin layer, which means that it is hardening even if held in the dark. Therefore, it is advisable to transfer the print fairly rapidly to the final support.

RINSE The tissue is rinsed in 68°F water for about a minute. During this time, the tissue curls up and gradually flattens out. Once it flattens, lift it carefully from the rinse water. This water bath has removed the excess dichromate, which causes the tissue to lose sensitivity.

TRANSFER The final support and the rinsed tissue are placed toward each other against a flat surface. A squeegee may be run over the "pack" at this point to insure good contact and no air bubbles. Sandwich this pack between blotters (printing supply houses carry cotton ones), and top it with a formica board. The stack should be weighted down with rocks or a 5-gallon pail of water. The pack remains in this position for 20 minutes. Next, immerse the pack in warm water (100–110°F), gelatin tissue side up, until this layer dissolves and peels back. If it is sticking, the water temperature may be gradually increased. Pigment oozes out from the edges of the pack.

DEVELOPMENT There is no image when the tissue is removed. It is necessary to place the transfer paper support into warm water (105°F) and agitate it gently. The image mysteriously appears. Nonimage areas have pigment blobs until enough water has made contact and washed them away. It is very delicate at this point, so do not touch or bump it.

COOLING AND FIXING The print is now given several rinses in cool water (not above 63°F). Doing so removes the final traces of pigment and should be continued for about 5 minutes. Acid fixing with alum clears and hardens the gelatin. However, as we discuss in Chapter 5, alum is extremely harmful to paper. A 5-percent sulfite solution may be used instead. However, the print should be dried for a day to harden the gelatin before placing it into this bath. Label these prints carefully and process them one at a time to keep from damaging the surface. Give the print a final wash of 2 to 3 minutes in cool water. A 2-percent solution of formalin may be added to harden the gelatin. Soak the print for 5 minutes, with a last wash in cool water. Hang the print to dry and continue to exercise care in handling. This process provides a wide range of color possibilities and base textures. We recommend it also for its archival quality.

SILVER NITRATE EMULSIONS: LIQUID LIGHT AND GAF

The hand-applied emulsion that most resembles the gray tonality of commercial photographic papers is a silver nitrate solution made by both Rockland Colloid (called Liquid Light)[3] and GAF. Its speed permits it to be used with an enlarger instead of the slower contact printing that the earlier processes in this chapter require. Therefore, you may enlarge any size negative onto surfaces coated with this emulsion. This was the emulsion first used by the authors to develop the Pi System. Silver nitrate emulsions have been found to be highly successful for use with handmade paper surfaces.

Properties

This emulsion comes in gelatin form and is sensitive to both heat and age, so it must be refrigerated unless you are going to use it

Catharine Reeve: "#11" from the "Body Sculpture" series, silver nitrate emulsion on handmade paper, © 1980. 8½" × 12½".

within a few days. When the emulsion is very fresh, it lacks contrast; as it ages, it gains contrast but also requires the use of an anti-foggant (included in the same box as the emulsion). An expiration date is printed on the outside of each bottle—beyond that date, the emulsion is unreliable, and we discourage its use.

Coating Papers

When you are ready to coat the papers, warm the bottle of emulsion in a pan of hot water until it liquifies (test this by *gently* turning the bottle upside down to see if the contents move easily). Do not open the bottle until you are in the darkroom with only a safelight on—the contents will be ruined if exposed to light.

Since the silver nitrate reacts to metal, you need a glass or plastic bowl in which to pour the emulsion. You can also pour it directly from the bottle onto the paper, but you run the risk of its "puddling," and often you get more emulsion on the paper than you want. If you are working on a surface susceptible to stains, cover it with a plastic cloth.

Coat the papers by one of the methods suggested in Chapter 3. Since this emulsion begins to thicken quickly, work fast and pour only a small amount at a time from the bottle. Reheat it as necessary.

The emulsion is practically invisible once it dries. Therefore, mark an X on the back of each sheet of paper to indicate that the emulsion is on the other side. You may also want to indicate by arrows the direction of the brush

Marilyn Sward: "Correspondence with Paper II," silver nitrate emulsion on handmade paper, © 1981. 18″ × 24″.

stroke, if you are using a brush application. The thickness of the emulsion you apply to the paper is important. A medium coat is best, because it is next to impossible to fix and clear a thick emulsion, and it eventually turns brown.

Dry the coated papers on fiberglass screens or hang them to dry in a dark area. (Do not leave the safelight on during the drying time, because it can fog the emulsion.) It takes from 20 minutes to 2 hours for the papers to dry. You can do projection printing once the papers are dry to the point of being sticky.

Store the coated papers in a light-tight box, handling them carefully, since the emulsion scratches easily.

Caution: The emulsion softens at 70°F and above, until it has been through the chemicals. All the chemicals and water washes must be kept under 70°F.

Exposure and Development

Use an enlarger to expose the coated papers. The emulsion tends to be slow, so an exposure time of 20 seconds with the lens at f4 is not unusual. Use test strips to determine the exact time. If you use a contact printing frame, place the frame under the enlarger with the emulsion sides of the negative and coated paper touching one another, negative on top. Determine the proper exposure by making test strips.

The developing chemicals and water must all be between 60°F and 70°F (NEVER above

Buck Mills; "Abandoned Truck," platinum-palladium print, North Carolina, 1979. 4¾" × 3¾". The artist used Crane's writing paper, PS 8111 Kid Finish, because its white surface retains the tonal qualities of the platinum-palladium print.

70°F). A variety of developers may be used; we recommend the following, but encourage you to experiment:

> developer: Dektol (mixed 1 part stock solution to 2 parts water)
>
> stop bath: white vinegar (mixed 1 part vinegar to 1 part water)
>
> fixer: rapid fixer with HARDENER (mix per product instructions)
>
> clearing agent: Perma-Wash (diluted 3 ounces Perma-Wash to 1 gallon water)

Mix the solutions and set up the developing trays. Process in the following order for the recommended times:

Dektol developer	1–2 minutes
stop bath	2–4 minutes (twice as long as the print was in the developer)
rapid fixer with hardener	5–10 minutes (twice as long as it takes the image to clear)
running water wash	10 minutes
Perma-Wash	10 minutes
final running water wash	10 minutes

Special notes: The fixer exhausts more rapidly than usual with this emulsion, so check it often with hypo check and replace as necessary. The clearing procedure is particularly important because the emulsion sinks into the paper surface (especially handmade papers) and requires a longer clearing than normal. We wash, clear, and wash again for at least twice as long as recommended by the hypo clearing agent manufacturer. This is important for the archival stability of the print.

PLATINUM AND PALLADIUM

History

The delicacy of tone and the exquisite rendition of detail has attracted photographers to the platinum process since it was perfected by William Willis in the late 1800s. Platinum papers were made commercially until 1937, when the high cost of platinum made it no longer feasible to market it on any widespread basis. However, such a beautiful process could not be forfeited by the photographic community, and dedicated photographers learned to make the platinum emulsion themselves, using and modifying the early formulas.

Obviously, there are reasons for the constant popularity of the process. The straight-line characteristic curve of platinum gives it a great ability to render the varying tones of a negative in fine detail. Its color ranges from a coal black to warm brown, depending on the developer. The metal platinum is extremely stable, meaning that the platinum print lasts indefinitely. (It thus behooves photographers to take special care that the paper base for this process is acid-free and of archival quality.) And those of us who are involved with the relationship between photographs and hand-made papers find platinum the ideal emulsion, as the platinum lies in, as well as on, its paper substrate (a microscopic examination shows this detail clearly). This blending of the metallic platinum particles and the paper fibers gives platinum prints their fine tactile quality.

As the sensitizing procedures for palladium are the same as for platinum, either metal may be used in the following procedures. Palladium is a less expensive metal than platinum, and it gives brown-tone prints. Many photographers mix platinum and palladium in equal parts for the warmer tonality this yields, and also to reduce costs.

Chemistry

In the platinum process, the paper is sensitized with ferric oxalate and potassium chloroplatinite. The principle is that the platinum links with the photosensitive iron salts. In the early part of the process, the platinum is not part of the reaction—the light converts the ferric salts to the ferrous state. The paper is then placed into a potassium oxalate developer (of the many possible developers, this is

The chemicals for platinum-palladium printing are stored in small brown medicine bottles with droppers.

Leather-ferrule brush used for coating papers with platinum-palladium emulsion.

our preference). The developer dissolves the new ferrous salts, and the ferrous salts reduce the platinum in contact with them to the metallic state. The iron is removed through a succession of weak citric acid or hydrochloric acid baths. (Hydrochloric acid, or muriatic acid, is available at hardware stores.) The image that remains consists entirely of metallic platinum (or platinum and palladium, if you have combined the two metals).

Note that metal is a contaminant in the platinum process. Even the metal ferrule in the brush handle can contaminate and ruin

the emulsion. Examine your equipment to ascertain that no metal comes into contact with the paper or sensitizer (including metal thermometers). If you must use a brush with a metal ferrule, coat the ferrule with rubber cement.

The sensitizer is composed of three stock solutions, each stored separately in brown glass bottles (small brown medicine bottles with droppers work well). You will need medicine droppers, and you should be careful not to interchange the droppers. Label the bottles and store them in a dark place. The platinum

solution keeps indefinitely, and the ferric oxalate solutions last from a few weeks to several months refrigerated.

Warning: Oxalic acid is *extremely* dangerous. See the chapter on chemical safety, and be particularly careful around all the chemicals associated with this process.

Formulas

Mix each solution separately (in normal light).

Solution A

Distilled water (between 85–100°F)	60 ml
Oxalic acid	1.1 g
Ferric oxalate	16 g

Solution B

Distilled water (between 85–120°F)	60 ml
Oxalic acid	1.1 g
Ferric oxalate	16 g
Potassium chlorate	0.3 g

Solution C

Distilled water (70–100°F)	50 ml
Potassium chloroplatinite	10 g
(*not* chloroplatinate)	

It is necessary to heat these solutions to dissolve and mix them. Solutions A and B can be mixed in a glass container on a hotplate or stove. Make certain that the temperature does not go below 85°F. It takes 30–45 minutes for the solutions to dissolve, sometimes longer.

Solution C (the platinum solution) is mixed in the proportion of 5 milliliters water to 1 gram potassium chloroplatinite, should you want to use a smaller amount. Some platinum may precipitate out of solution during storage. If this happens, warm the solution just prior to using until it is dissolved.

If you are using palladium, the solution is as follows:

Solution D

| Distilled water (at 100°F) | 60 ml |
| Sodium chloropalladite | 9 g |

If these ingredients are unavailable, then use:

Distilled water (100°F)	40 ml
Palladium chloride	5 g
Sodium chloride	3.5 g

Wait at least 12 hours after mixing these solutions before using them.

Because the emulsion deteriorates rapidly, once it is mixed you will most likely be able to coat only one or two papers at a time. The emulsion is composed of varying mixtures of A, B, C (and D, if you are using palladium). The image contrast is controlled by varying the proportions of solution B to solution A. The emulsion may be mixed and applied to the paper under low-wattage tungsten (room) light. Do not use fluorescent light.

Emulsion Mixtures

To control contrast, use the following amounts of emulsion mixtures:

For soft negatives:	
Solution A	8 drops
Solution B	14 drops
Solution C	24 drops
For normal negatives:	
Solution A	14 drops
Solution B	8 drops
Solution C	24 drops
For contrasty negatives:	
Solution A	22 drops
Solution B	0 drops
Solution C	24 drops

Solutions C and D (the platinum and palladium) can be mixed in any proportion, as long as the number of drops listed by C in the emulsions remains the same.

Coating Papers

Pin the paper you intend to coat to a drawing board or some other surface, or tape it down at the corners. You may want to mask it, if you want even borders of uncoated paper to surround the image.

Next, select and mix the emulsion you want to use in the proportions indicated in a

Barbara Crane's 8" × 10" negatives drying in preparation for platinum-palladium printing. The notations on the tape on the clothespins refer to the exposure and development for that particular negative. She will later put the tape on the individual negative sleeves for future reference.

The negative on the Aristo Grid light source ready for exposure.

glass dish. Dip your brush in distilled water and squeeze it out. This helps keep the brush from absorbing too much emulsion—remember that platinum is more expensive than gold. After dipping the brush, spread the emulsion across the paper, first horizontally and then vertically. Check to ascertain that the coating is even. Work fairly quickly so that the emulsion does not "puddle" or sink too deeply into the paper. Hang the paper to dry (use plastic clothespins) in a dark area for 10 minutes. Then dry it with a hair dryer at medium heat or over a hot plate (low-level tungsten light will not harm the emulsion at this point). The heat on the surface of the paper should not exceed 110°F. Heating the

paper is an important step, because it pulls the moisture from the hygroscopic platinum paper and promotes a clearer image. Do not touch the emulsion surface until all processes (including printing) are completed—it is easily contaminated. Process immediately.

Exposure

Use a contact printing frame, and insert both the negative and the coated paper, emulsion to emulsion.

Since the platinum emulsion responds to ultraviolet light, sunlight or any ultraviolet lamp can be used for exposure. Sunlight is the fastest, sometimes taking just 1 or 2 minutes. A

In Barbara Crane's darkroom negative and coated paper are in the contact frame ready for exposure. Note the reference tapes on other negative sleeves.

The initial process in the development of the platinum-palladium print. Crane brushes the print immediately upon immersion to eliminate air bubbles.

Crane periodically agitates the print in the first acid clearing bath.

sunlamp takes about 20–25 minutes. You need to work with test strips and trial and error in the beginning, but you can use these first efforts to help determine later exposures.

Development

Develop the print immediately after exposure in a potassium oxalate solution of 1 pound (450 grams) potassium oxalate dissolved in 48 ounces warm distilled water. It is stored in a dark brown bottle and used at room temperature. The developer lasts indefinitely, and it improves with use because of the platinum/palladium deposits. Therefore, do not discard it. If a precipitate forms after much

use, as is likely, decant the clear solution at the top of the developer.

The developer acts almost instantly; therefore, it is important to immerse the print in it quickly and evenly. The developer should be at room temperature and never below 60°F. Develop for only one minute, then clear the print in three successive baths of dilute hydrochloric acid (use 15 milliliters of the acid to a liter of water). For reasons of safety add acid to water, not water to acid. Immerse the print in each bath for 5 minutes, then wash in running water (60–75°F) for 20–30 minutes. An alternate clearing agent is citric acid, which is safer than hydrochloric acid. Make a stock solution of 1:3 parts citric acid to water; dilute

The final step is to wash the print in running water. When several prints are washed simultaneously, they are rotated to insure even washing.

this solution to 30 milliliters citric acid to 1 quart water for the clearing baths. Use four baths instead of three, leaving the print in the first bath for 3–5 minutes and in each of the other baths for 10 minutes. Wash as above.

Air dry the prints on fiberglass screens or hang them to dry. They can be flattened in a dry mount press at 180°F, if necessary.

There are various ways to alter the tone and color of the platinum print, from heating the developer to toning with uranium. For these procedures, we refer you to the books in the Bibliography that deal in much greater detail with this process.

URANIUM PRINTING

Though seldom heard of now, the uranium-based print enjoyed considerable popularity in the latter half of the nineteenth century. Held in a gelatin emulsion, it was as quick and easy to process as the platinotype. C. J. Burnett, given credit as one of the first successful experimenters with platinum, actually learned about platinum through his work with uranium printing, which he was instrumental

in discovering and developing. It is an interesting historical cycle that uranium in those days (mid-1800s) was very expensive, and platinum, much less so. Today, of course, the situation is reversed. Uranium's platinum-like tones were especially pleasing, and, by the use of various developers and toners, the uranium print could be changed to any number of interesting colors. Its reputation for impermanence, although undeserved, unfortunately hindered the popularity of the process.

Warning: The amount of uranium used in photographic printing is not of any concern for health reasons because of its radioactivity—there is far too little to affect you. However, uranium ingested, even in tiny amounts, can cause serious damage to the kidneys. So be especially careful when experimenting with this process, and take the safety precautions outlined in Chapter 3.

Formula

The uranium emulsion is composed of 1 part uranyl nitrate to 16 parts water. The emulsion is brushed or floated on the surface of the

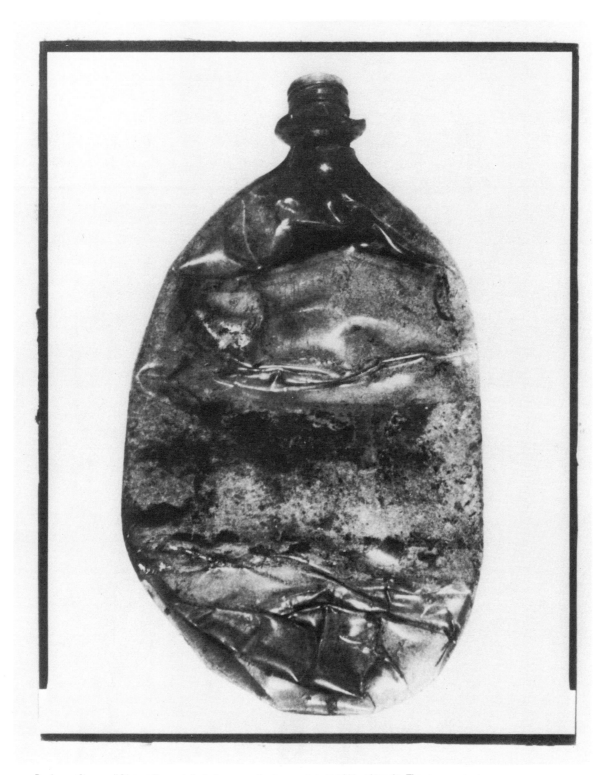

Barbara Crane: "Object Trouvé," platinum-palladium print, © 1982. 10" × 8". This is a contact print from the original negative made with a 50 percent platinum, 50 percent palladium sensitizer.

Mark Sawyer: "Cushing Street," uranium print, 1979. 10″ × 8″.

T. C. Eckersley: "Untitled," Kwik-Print, 1981. 7" × 5". A paper negative cut-out is used to create the top half of this image.

paper and left to dry. (This can be done in weak room light.)

Uranium is sensitive to ultraviolet light, so expose it to sunlight or to an ultraviolet lamp. Exposure times vary; initially, try 10 minutes under the sun and 20–30 minutes under an ultraviolet lamp. Mark Sawyer is a willing and helpful source for information on this process. He is listed under Sources of Supply.

Developers

Develop as follows for the tones and colors indicated. Use water and solutions between 60–90°F.

Red-brown

1 part potassium ferricyanide

30 parts water

Develop in this solution. Fix by washing in water for 10 minutes.

Green-gray

1 part ferric chloride

48 parts water

Immerse the red-brown print in this solution. To fix, wash in water for 10 minutes.

Brighter green

1 part cobalt nitrate

30 parts water

Immerse the red-brown print in this solution. Fix in a solution of 1 part iron sulfate to 1 part sulphuric acid added to 25 parts water.

Gray

1 part silver nitrate

30 parts water

Develop the print in the above. Fix in hypo (not rapid fix) for 2–4 minutes.

Elaine O'Neil: "Breakfast, Lunch, Dinner," Kwik-Print, 1979.

KWIK-PRINT

Another process that allows some of the color experimentation of gum bichromate with a greatly simplified application procedure is Kwik-Print. It comes in kit form from Light Impressions, and it may be used on the base sheets provided or applied to art papers, synthetic fabrics, and many other supports. The kit contains base sheets, process colors of blue, red, and yellow (and "clear" for making colors more transparent). Clear may also be mixed with watercolor paint and pigments to form additional colors. Also included in the kit are a wiping block, pads, and aqua ammonia, which may be used in the developing

stage to remove unexposed color. Regular household ammonia may be substituted for the aqua ammonia. Detailed instructions come with the kit. You may simply wish to order two or three colors to try the process. Acrylic medium or gesso may be used as a base for Kwik-Print.

The medium may be coated onto any paper surface. Gesso and gloss medium significantly alter the surface, so acrylic matte medium is a better choice if you wish to retain the character of the paper.

The coating may be done in dim light, since the materials are not extremely sensitive. Pour the liquid color onto the center of the sheet and quickly spread it around with

the pad. A thin, even coat is desirable. The color may be buffed almost dry with the wipe provided in the kit, refolding the pad if necessary. A hair dryer may be used to speed drying. Dry the sheets in the dark. Remember that the colors used in this process build upon each other, using additive color theory (see Chapter 5). Color separation negatives may be used, and black should be used sparingly.

The sheets are contact printed when dry. They must be printed within 15 mintues of the end of the drying process. Once coated, the emulsion does not keep. The exposure times are very short (1–4 minutes), depending on the color and light source. Assuming a sun-lamp at 3 feet, blue is the shortest exposure time, at 45 seconds; black is exposed for 2½ minutes; magenta, 1¼ minutes; and yellow for 1½ minutes. The exposure times differ for each color and light source.

Develop by flushing the surface of the sheet with warm water. The image is fairly durable, so you may brush over sections lightly to help clear the highlights. Hang the sheets or lay them on screens to dry. Do not use heat to dry them at this point. The sheet may be recoated and the process repeated. It should take no more than 10–15 minutes per exposure. This speed in processing is the primary advantage of Kwik-Print.

Judith Harold Steinhauser: "Rose Valley Light," from the "Leslie" series, sepia toned print, hand-colored © 1981. "I derive enormous pleasure from the process of creating these hand-colored images by extending the photographic process in a tactile, sensual way. Everything in the photograph comes alive, and I experience a sense of immediacy and discovery."

Katherine Pappas Parks: "Walking My Dog," cliché verre print, 1975. 16″ × 20″.

Katherine Pappas Parks: "Boogie II," cliché verre print, 1974. 16″ × 20″.

CLICHÉ VERRE

History

The process of cliché verre has to do with the production of negatives. It was thought to have developed about 1835 in England and was then rediscovered by three French photographers in 1841. Several painters of the Barbizon group used the process, Corot being the most famous. The procedure involves making a glass plate negative. The glass is blackened with asphaltum (traditional printmaking coating), oil paint, or any other opaque material. Then a sharp point is used to scratch or draw into the surface. Other textures and translucent materials may be added to the surface. Even parts of negatives may be attached to the glass. All this becomes the negative, which is contact printed with any of the processes described previously.

We include here artist Katherine Pappas Parks' process descriptions for two works she created. Keep in mind that you may substitute any emulsion-coated handformed paper for the standard photographic papers she uses.

Process

An artist may choose many types of surfaces upon which to work. For example, clear acetate, frosted acetate, flawless clear glass, frosted glass, tracing paper, exposed negatives, and softened emulsion on a negative are all usable. The choice of materials and tools is endless.

"Boogie II" was created by forming the image with sand. For this image, Pappas Parks selected clear glass as a base. The materials used were fine white sand, a brush, and fingers. Sand was poured onto the glass and then manipulated with fingers, brush, and the pointed handle of the brush for the desired image. (The more dense the area of sand, the less light reaches the paper when the print is being made.)

To make the print, unexposed photographic paper was placed under the glass that held the image. Nothing was placed on the sand, for to do so would compress the sand, causing the image to lose its soft smoky quality. Drawings on acetate, however, are usually covered by glass during printing to

90

Catharine Reeve: "Ronne and Karen," from the
Mother/Daughter series, © 1982. 14″ × 11″.

Catharine Reeve: "Ronne and Karen," Sabattier
effect by Jack Leblebjian, © 1983. 14″ × 11″.

insure that they are as flat as possible, thus making a sharp transfer of the image to the paper.

Exposure. Low light and a long exposure gave maximum details in this image. The exposure was made using a 10-watt bulb located 3 feet from the image. Exposure time for the print was 45 seconds on Portalure Kodak paper. The artist selected this type of paper because it has a brown tone and a soft quality compatible with the image.

Process

"Walking My Dog" was made on frosted glass. Similar effects may be attained on frosted acetate. The materials used were tusche crayon, a brush, and liquid tusche.

Tusche crayon may be manipulated to vary the quality and texture of line drawn on the frosted glass. The line may be thick or thin. The pebbly texture of the glass is reflected in the figure and the dog. The liquid tusche was diluted, brushed on, and allowed to dry. Liquid tusche, most often used by lithographers, always gives unique and beautiful washes. It must be used on a textured surface, because it beads on the surface of polished glass or acetate. Here the frosted glass surface made the wash possible.

EXPOSURE The image was exposed with a 10-watt bulb 3 feet from the glass. Exposure time was 30 seconds with the paper placed directly under the glass. Pappas Parks used a high-contrast Agfa paper that has a rich blue-black tone and that she chose to insure that the deep black tones desired in this print were as dramatic as possible.

SABATTIER TONING AND EFFECTS

A final manipulative technique worthy of consideration is the Sabattier effect, commonly though inaccurately known as *solarization*. ("Solarization" actually refers to an hours-long overexposure of the silver emulsion, resulting in tone reversal.) The Sabattier effect occurs when a normally exposed print is exposed to a more concentrated light midway during its development. This exposure causes the previously unexposed or minimally exposed silver crystals to be heavily exposed and to darken, and the crystals that were normally exposed under the enlarger printing to reverse their tones. A silvery gray tone results, with a white line around linear areas in the print. Man Ray (1880–1945) used this technique to create many of his abstract photographs. You can achieve a tonal reversal with most silver-based emulsions simply by turning on a room light for a few seconds during development. (Do not let the image develop too much before reexposing it, however.) It is worthwhile to experiment with this process with negative as well as with positive images.

Doing alternative processes is rather like looking through a window, akin to the same analogy that Tung H. Jeong uses with holography later in this book. We see ever expanding possibilities in combining one process with another, or with two others, or adding a surface texture, or A letter from one of our students suggests the questions—and the hopes—that these processes can generate.

Applying photo emulsion to the thick soft surface of one of the handmade papers which then reveals just a portion of a negative becomes almost a magical experience for me. I've tried coating the whole paper, but that destroys the mystery. It's important that my image sinks into the paper. I want to experience the feeling of peeking through a chink into a whole new world. I do want to make my own paper, and can visualize some very rough surfaces onto which to put my image. And I'd like to introduce blues and greens, but have not quite come to grips with how. At last I have an understanding of Paul Klee's struggle with color. Louva Calhoun, 1982

5

Handmade Paper

Marilyn Sward: "House of Fan," cyanotype, mixed media, handmade paper collage, © 1982. 28″ × 20″. Collection of Caroline and William Frievogel.

In the crafts tradition, there is a kind of law that does not restrain, but leads to absolute freedom. Washi[1]

Throughout the history of photography, the image has most often been borne by paper. The process of hand papermaking provides a means for photographers to gain further control over their images, and it provides an unending system of manipulative expression.

There are at least two distinctly different systems of papermaking: *Western*, as practiced in this country and Europe, and *Eastern*, often referred to as Oriental. The finished sheets differ in their weight, sheen, translucency, texture, and handling. We feel that, to control the surface of your work, you should understand both systems.[2]

HISTORY OF PAPERMAKING

There is some debate as to the exact beginning of papermaking as we know it. Clearly, however, it came from a large number of two- and three-dimensional materials used for conveying information. Some of these materials are papyrus, palm leaves, tapa, bark paper, parchment, and vellum. These materials were used in various parts of the world, and some are still in use today. Yet historically, papermaking began with the first use of the water-leaf papermaking process. When water was first introduced with the fiber, we began the tradition of bonded cellulose that is the basis of papermaking in both Eastern and Western cultures today.

With the reopening of China to Western travelers, papermakers are finding papers dating back 2,200 years or more. The beginning of papermaking is generally credited to Ts'ai Lun in 105 A.D. in the court of the emperor of China. This papermaker took out patents for the technique in his name and promoted the craft. He used treebark, hemp, fish nets, and old rags in the process. The thin sheets were made by macerating the materials into individual fibers, which were then mixed with water and lifted from a vat on a frame covered with a fine cloth surface. The cloth allowed the water to flow through, leaving the fiber interwoven on the surface. Ts'ai Lun became known throughout China as the patron of a craft he had probably not discovered but rather developed. The Chinese guarded the process until around 600 A.D., when it traveled to Korea and Japan.

The Japanese have made a distinction between two styles of papermaking. They call the process first developed by the Chinese and later used by the Europeans "tamezuki." They refer to the process used today in Japan as "nagashizuki." Today papermaking in Japan is a revered tradition. The word for paper, "kami," and the word for God are pronounced identically in Japanese.

In 751, Arabs of Samarkand forced Chinese prisoners to divulge the secrets of their craft. The process was then carried from Egypt and Morocco to Spain, and in 950 a mill was established. In Italy in 1276, Fabriano founded a mill that still produces fine art papers. Hemp and flax were the primary fibers used in these early European papers. When animal sizings were introduced in 1337, the surface and character of paper changed. One of the finest papers ever produced is found in the Gutenberg Bible from the years 1450–55. This was a time of great interest in book printing in Europe, and many beautiful examples remain today as a credit to the quality of these early papers. In the late 1600s, the French persecuted the Protestants, some of whom were papermakers. They fled to England and Holland, helping the fledgling industry to flourish. Another important development was the invention of the Hollander beater in 1712. Prior to this, rags of flax and

Perhaps the first papermakers were the wasps.

later cotton were left to rot, and they were pounded into pulp with the use of mill-driven stamping machines. The Hollander was able to cut and separate the fibers and pound them in water to make pulp at a much faster rate, with less waste. In 1690, papermaking was established in America by William Ritten-house, who set up a mill in Pennsylvania.

Papermaking continued to be refined, and several notable developments occurred. John Baskerville wanted a smooth sheet of paper to produce his copy of *Vergil* in 1757. He worked to design a different mold surface of mesh wires, which greatly improved the even quality of each sheet. In 1807, Nicholas-Louis Robert, while working with Leger Didot in Annonay, France, developed a machine that allowed paper to be formed in long continu-ous rolls. The patents were filed in England, and Sealy Fourdrinier provided the financial backing. The machine that mechanized pa-permaking bears his name. Pulp is poured out onto the continuous belt screens and shaken from side to side as it moves along. In this way it duplicates the hand papermaker's ac-tions. This machine, which helped to begin the Industrial Revolution, is still in common use in papermills today.

Papermaking was refined and mecha-nized from this point to the present. Bleaching and wood pulps were introduced in the 1860s.

By using this readily renewable, available resource, the paper industry began its great-est period of expansion and growth.

In the late 1800s, three advancements helped photography and photomechanical processes to develop. The first was smoothing the surface of the papers, a process called *calendering*. This mechanized the old system of polishing the paper with a smooth stone. In the process of calendering a sheet of paper runs between highly polished rollers, giving the surface sheen and smoothness. The sec-ond development was the use of fillers that would close the interstices between fibers. This gave papers greater opacity and in-creased the reflective quality of the surface. The final and most significant advancement was the development of coated papers formed by adhering clay coating to the surface with casein adhesive, further increasing the pa-per's reflective quality.

Today in this country, we consume ap-proximately 620 pounds of paper per person each year. This paper is produced primarily in mills in the Northeast and in Wisconsin, and the fiber is largely wood pulp. As a backlash from this industrialization and with serious thoughts to permanence and the fine craft tradition, a revival of hand papermaking began in the late 1960s. By the mid-1970s it had become epidemic. Interestingly, much of the activity traces back to John Mason in England, Henry Morris of Bird and Bull Press in Pennsylvania, and Walter Hamady in Wisconsin—all in areas of industrial paper production. These men have advocated fine papers and have written for and trained a generation of papermakers, thereby inspiring them to continue the craft. Today hand mills and studios are found in most major cities, as well as in many colleges and universities across the country. These mills and studios produce fine papers, and also often sell the materials necessary to make your own paper.

The contemporary revival of hand paper-making could not be discussed without men-tioning the lifetime of caring research done by Dard Hunter, whose documentation and love of the craft inspired people to pursue, refine,

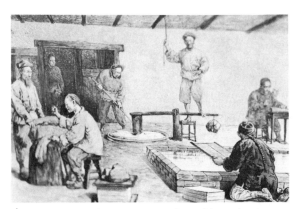

Chinese papermakers prepare pulp and form sheets. Illustration from *China: Its Costume Arts Manufacturers*, London, 1813.

and rediscover an aesthetic inherent in paper, both as a two-dimensional support and as a three-dimensional medium. His reference materials, collected samples, and tools of the craft are housed at the Dard Hunter Museum of the Institute of Paper Chemistry, Appleton, Wisconsin.[3]

FIBERS FOR PAPERMAKING AND THEIR CHEMISTRY

To understand and enjoy papermaking, you should know something of the fibers and chemistry involved in the process. Please understand that paper chemistry is a science, and we touch only briefly on it here. We begin by considering the various fibers used to produce paper. Fibers are grouped into five general categories, based on how they grow. (The following fibers are all natural as opposed to manmade. They are fibers from living plants rather than synthetics, such as nylon and polyester.)

Cotton

The first and most common are the *seed hair* fibers. Cotton is in this group, and it is widely used in the production of modern "rag" papers. Traditionally "rag" referred to fabric scraps of flax or cotton cut up for processing. Today, in commercial processing of cotton, a short fiber remains on the seed and is recovered separately by the industry. This fiber, referred to as *linter*, comes in blotter-like

sheets that are reprocessed and used by hand papermakers as well as by large paper companies to produce fine art paper. There are several outlets for this fiber across the country (see Sources of Supply).

Cotton's advantage for papermaking is its pure cellulose content. Cellulose, the most plentiful organic substance on our planet, is a by-product of the most ancient process known to life: photosynthesis. Cellulose is the basis of all natural fibers and a necessary component in the process known as papermaking. Cellulose is also a carbohydrate, which contributes to its affinity for water.

Cotton, being pure cellulose, is free of a complicated structure known as lignin, which is present in many other fibers. Depending on the processes used to remove lignin during

A contemporary stamping machine manufactured by Lee McDonald, Charlestown, Massachusetts.

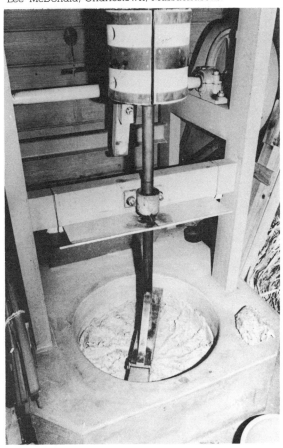

Fourdrinier machine producing commercial paper at Rhinelander Mill in Rhinelander, Wisconsin.

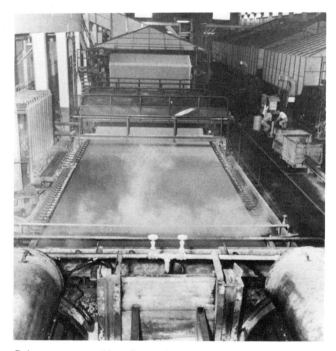

Pulp coming out of headbox onto wire screen.

Super calender puts high finish on the sheet, giving it a glossy appearance. This machine is making glassine by applying moisture, heat, and pressure. These photographs of commercial paper production are courtesy of the Rhineland Mill, Rhinelander, Wisconsin.

pulp production, it is potentially detrimental to the finished paper. Another advantage of cotton cellulose is that it bonds easily. In the process of making pulp, the cellulose and water come in close contact and attract each other. This process forms new configurations (see illustration). Today hand mills use sheets of linters, half stuff (partially processed cotton fibers), garment cuttings, and rags to obtain cotton cellulose for pulp production. Cuttings and rags are cooked and rinsed to remove sizings, dyes, and dirt.

Wood

Wood pulp, a stem or trunk fiber, is the second major group of cellulose material used in paper production. Wood is the most common fiber used in commercial papermaking. Almost all common paper products—as well as books, newspapers, and writing materials—are produced from wood pulp. It may be chemically pulped to have as low as 2-percent lignin.

Bast

Bast fibers, the third group, are the usable fibers from inside the bark of various bush-like plants and stems or stalks of other plants. The Japanese and early European papermakers used bast fibers. The Japanese used fiber such as mitsumata, gampi, and kozo. Hemp and flax were used in Europe. Early clothing in Europe was made from flax, and, as the garments wore out, they were brought to the paper mills, where they were cut and then allowed to rot and soak. This process, known as *retting*, softened the structure of the fiber, allowing it to be stamped into pulp. (Work in these mills was hazardous: "Fiber filled the air and vermin crawled the floor.") These fibers were extremely long and produced flexible, strong papers with good sheen.

Leaf

Leaf fibers form the fourth group used for papermaking and include such plant sources as iris, yucca, and sisal.

Dard Hunter (1883–1966). Dard Hunter is credited with the revival of hand papermaking in this country. His love of the craft and materials and his pursuit of technical knowledge led to the extensive collection in the Museum of the Institute of Paper Chemistry, Appleton, Wisconsin, and re-kindled interest among contemporary artists. Photo courtesy of the Dard Hunter Paper Museum, The Institute of Paper Chemistry, Appleton, Wisconsin.

Grass

Grass or straw fibers, the final group, are used commercially but less frequently by hand papermakers.

We recommend that you obtain a copy of Lilian Bell's *Plant Fibers for Papermaking* to obtain information on processing plants for pulp. She gives a complete description of converting these fibers into paper. In addition, Jacob Christian Schaffer from 1765–1771 wrote a treatise on the subject of alternative materials for papermaking and included such things as cattail and burdock stalks, tulip and linden leaves, corn husks, thistles, moss, and vines. He occasionally used some cotton fiber in the pulp to aid sheet forming. We recommend cotton as a cellulose source largely

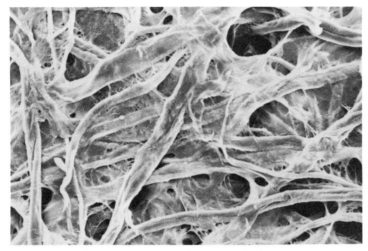

Cotton fiber beaten in a Hollander beater showing collapsed walls of fibers. Magnification 370×. Scanning electron micrograph courtesy of Odell T. Minick, Department of Pathology, Northwestern Memorial Hospital, Chicago, Illinois.

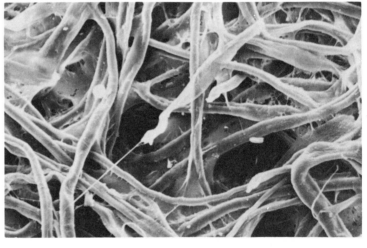

Cotton fiber beaten in a home blender shows fiber less fully processed. Magnification 370×. Scanning electron micrograph courtesy of Odell T. Minick, Department of Pathology, Northwestern Memorial Hospital, Chicago, Illinois.

because of its ease in pulping. Cotton fibers are thin-walled structures that collapse easily when beaten for pulp.

PAPER PRODUCTION

Fiber Processing and Pulping

As a photographer, you should have some background knowledge about paper production. The various techniques used control the finished surface, the dimensional stability (how much the sheet will swell or shrink), and the archival properties of the sheet. These considerations affect the choice of the process used to produce papers for the photograph. The terms used in the production of paper often refer to the final sheet. For example, "rag" commonly meant that the pulp came

from processing old cloth. Now, however, its meaning is more closely "nonwood natural fiber." The fibers are generally boiled or cooked, either alone or with soda ash. Afterwards, the fiber is washed in clear water to remove the caustic. This fiber is then beaten in some manner, ranging from hand beating with a mallet, as is done in Japanese papermaking, through a range of beaters, blenders, and paint stirrers.

The Hollander beater is the most commonly used equipment in hand mills. Pulp produced in a Hollander will have greater strength and a smoother surface. All the various machines separate the fibers and hydrate them. Hydration allows more water to enter the cellulose, ultimately creating a tighter bond.

Cotton beginning to flower in a field in Arkansas.

Kenaf crop growing in Texas. Courtesy of Northern Regional Research Center, U.S. Department of Agriculture.

Sheet Formations

The pulp is then placed in a vat. Cotton and flax are simply poured in, but Japanese fibers are pulled apart in small clumps and tossed into the vat, and then agitated with a "mase." (A "mase" is a large, wooden comb-like device for stirring fiber.) To prepare for sheet formation, the water in the vat and the pulp fiber must be well mixed. In commercial production, the pulp flows from the vat onto a continuous sheet of screen, which vibrates slightly from side to side as it moves along, creating a definite grain line and directional strength. As the screen moves, it passes through rollers (Dandy Rolls), which press the pulp into sheets. Thickness, pattern texture, and watermarks may be added at this time.

The grain line (or the predominance of forward movement) is important to photographers, because images should be printed parallel to the directional line to minimize distortion in multiple registrations. It is interesting to note that the pouring of pulp onto a screen in this manner closely parallels an historic tradition of poured pulps in hand papermaking.

WATERMARKS Sometimes, watermarks are formed in the sheet. Linear watermarks are made by attaching wire to the surface of the screen. The raised wire causes areas of thinner pulp when the sheet is formed, and these areas allow light to pass through when the sheet is held up to a light source. Traditionally, watermarks are the

Papermaker, circa 1780. Note the board across the vat used to place mould for draining. This board is called a horn or asp.

It rotates through the vat, picking up sections of pulp and depositing them on felts. The divisions (wax strips that resist pulp) of the cylinder are placed at intervals and determine the size of the finished sheets. This process is similar to handforming and produces papers called *mould-made* papers, which have an even grain in all directions.

CALENDERING, COLD PRESS, AND FELT SIDE During calendering, the papers and felts move through rollers, which further control the surface. The calendering rollers may be heated, producing *hot press* paper, which is characterized by a hard, smooth surface. *Cold press* allows more felt imprint, yielding a pebbly surface. After the paper is dried, it must be cut or torn into sheets. The sheets are bound and packaged *felt side* up, which is the side that was up or away from the screen as the paper was processed. The felt side is also the side on which watermarks and chopmarks (embossing stamps) read correctly. In either case, the felt side is important to the photographer because, when papers are dampened, the texture and pattern are increased. The pattern of the screen that was subtle in the dry sheet becomes pronounced in the damp sheet, thus possibly affecting the image printed on that side. The pattern may not be undesirable, but it should be a matter of choice.

ARCHIVAL CONSIDERATIONS

Perhaps the strongest argument for understanding paper, its content, and its method of formation lies in the fact that in understanding is the ability to determine the archival qualities of the sheet. One villain of paper is acid, either its presence or its ability to form. The Technical Association of the Pulp and Paper Industry (TAPPI) defines permanence as ". . . the degree to which paper resists chemical action which may result from impurities in the paper itself or agents from the surrounding atmosphere." The system for measuring acid is expressed in the measurement of positive hydrogen or pH on a scale of 1 to 14. A pH between 6 and 8 (preferably 7 exactly) is considered neutral. A pH of below 6

marks of the mill or even of the individual papermaker who forms the sheet. During times of social unrest, watermarks frequently conveyed messages and protests. Letters and manuscripts are often dated by confirming that their paper was produced by a specific mill in operation during a certain time period. Many legal cases involving forgery and plagerism have been settled by examining watermarks. Today, watermarks still indicate the manufacturer: Rives, D'Arches, and Cranes. To ascertain if there are watermarks or subtle patterns that may affect the placement of the photographic print, hold the paper to the light.

MOULD-MADE PAPER The mould machine, another commercial machine, is a cylindrical, screen-covered machine divided into sections.

An historic watermark created for the Chicago World's Fair in 1933, showing a linear watermark.

Linear watermarks are formed using brass wire.

Linear watermarks are sewn to the wove surface of the papermaking mould. This mould was constructed by Frederic Burgess of Maidstone, Kent, England.

This intricate watermark uses patterns of light and dark to create realistic imagery. To make this type of watermark, the image is first carved in wax. Negative and positive dyes are made and the screen is annealed to form the contours of the image. The uneven surface controls the distribution of pulp when the sheet is formed.

is acidic and above 8 is alkaline. Papers in these upper and lower ranges are undesirable because they deteriorate over time.

Deterioration of paper is characterized by a change of color, brittleness, and general physical breakdown. Accurate acidity may be measured by tearing up one gram of paper and putting it into a beaker of 70 milliliters of deionized water, boiling it for 1 hour (hot extraction), or mashing it and letting it stand (cold extraction). The water/paper mixture is then measured with a pH meter. A simple, less accurate method is to wet the paper with distilled water and lay litmus paper against the surface. The color change is then compared with the chart provided. If the paper is not acid, it has fulfilled the first criterion.

The next question is whether or not there

was anything used in the production of the paper that will produce acid over time. Alum-rosin sizing, for example, is such a material. Sulphur dioxide from polluted air is converted by the sized paper to sulfuric acid, which speeds the physical breakdown of the cellulose. Cellulose is a hydroscopic material that absorbs moisture readily. That moisture brings airborne pollutants. However, if there is no sizing or other substance in the paper to interact with the pollutants, the paper has greater permanence.

Trace minerals are another serious problem. These may be present in the form of heavy metals such as iron and copper oxides. These minerals come through the pipes that bring water to the vats holding the pulp.

You can control these elements in the

paper you make by means of water testing, filtration, and inert sizings. When you purchase fine art paper, pH ratings and sizing component listings are available. Andrews, Nelson, and Whitehead has such listings, as do the Tamarind Institute in New Mexico and the Conservation Department of the Fogg Museum in Boston.

MATERIALS FOR PAPERMAKING

With this technical and historical information, you can better understand the papers you purchase. But how do you produce your own?

To make sheets of paper with good inherent strength and fine surface characteristics requires pulp produced by mechanical beating. This pulp may be obtained from local hand mills, or for experimentation you may produce your own.

When making paper for photography, the materials you use are adaptations of the commercial and historical processes. Archival considerations, internal structure, chemistry, and surface characteristics all remain important. The following is a list of basic equipment that may be embellished with your own time, money, or local papermaking facilities.

1. high cellulose content fiber

2. vat or tubs and buckets
3. mould and deckle or Japanese mould and su
4. papermaking felts (similar to etching blankets), or old wool blankets
5. home blender, paint mixer attached to a power drill, or beater
6. helpful: large stirring paddle, sponge, stiff bristled scrub brush, measuring cup, quart jar
7. sizing (Hercon 40 or Aquapel)
8. press

Additional items for Japanese papermaking:

1. large stainless steel or enamel cook pot
2. caustic soda (Arm & Hammer Washing Soda) or soda ash (If you wish to avoid caustics, fibers may be processed by retting.)
3. wooden mallet
4. two pieces of wood (coated to resist water) or formica larger than finished paper (at least 1" greater in each direction). Sink cutouts from lumber yards work well.
5. formation aid (PNS or root excretions from tororo-aoi or okra)
6. two spools of thread, different colors

Laid papermaker's mould and deckle of mahogany with brass fittings. Note the chain lines (wire running perpendicular to the bottom of the mould). These moulds were made by Lee McDonald, who provides friendly advice and fine papermaking supplies for papermakers across the country.

Wove surface papermaking mould and deckle by Lee McDonald. Each mould is numbered and dated.

WESTERN PAPERMAKING

After you gather the necessary equipment, you can begin the process by making pulp. The fibers you use may be any that are high in cellulose, and you will want to try several for the variety of surfaces they provide. Initially, however, we recommend the use of cotton linters in the medium grade. (See Sources of Supply.) These should be dampened by immersing them in a bucket of cold water overnight. One linter should yield at least ten finished 8½" × 11" sheets of paper. After soaking the linter, pull off a corner and tear it into small pieces 1" square or smaller. Fill a one-cup measure loosely with pieces of linter. Add water to your blender until it is within 2" of the top. Add 1 tablespoon sizing and run the blender for 1 second. Stop the blender and add the linter fiber. Process on medium speed for approximately 30 seconds. If you are uncertain about whether or not it has run long enough, you can take out ½ cup and put it into a glass jar ¾ filled with water. Shake this and see if the fiber separates into a cloudy mass with no lumps. This procedure duplicates a "freeness" test and indicates that your pulp is ready.

Empty the blender into a large bucket and repeat the process until 4 or 5 gallons of pulp are obtained. Next fill a plastic laundry tub with 12 to 15 gallons of water. (A word about water: To make paper with a neutral pH, high water quality is necessary. You should test your water supply and check with your city as to its chemical properties. Corrections can be made, filters or purifiers may be added, or you may want to use distilled water for limited production.) After the vat is filled, add 8 cups of pulp. The amount of pulp may be varied, but this is a good beginning proportion. The ratio of pulp to water in the vat is a determining factor in the thickness of the final sheet. Consistency is maintained by adding one cup of pulp to the vat after each sheet is formed. Papermaking may be accomplished in smaller containers using proportionally less fiber, as well as by pouring rather than dipping the pulp onto the screen.

Next take the mould and deckle in hand.

Standing in front of the vat with one hand on each side of the mould and deckle, arms extended, place the mould and deckle perpendicular to the water surface at the rear of the vat. The mould and deckle (they act as a single piece of equipment) is drawn down under the water surface toward the bottom of the vat and pulled forward. With a scoop-like motion, raise it toward the water surface parallel to it. Just as the mould and deckle emerge from the water, give it a slight shake (more like a jiggle) from side to side and front to back. The mould and deckle has now captured a layer of fibrous material evenly distributed across the screen surface. Hold the mould and deckle parallel to the water for 30 seconds to 1 minute to allow the water to continue draining.

The deckle is then lifted off, and the mould is taken to the "couching" area—that is, any waterproof tabletop or hard surface. Dampen one of the pieces of felt or blanket and set it down. If water drainage to the surrounding floor is a problem, place the felt in a large photo tray. If the tray is used, a piece of ¾" upholstery foam rubber should be set in the bottom of the tray prior to the felt. The rubber prevents the pattern of the tray bottom from appearing in the paper. Now you are ready for *couching*, the process of transferring the mat of fiber from the surface of the mould to the surface of the felt. To do so, set the long edge of the mould against the felt (mould perpendicular to felt) and gently rock the mould down onto the felt.

The paper fiber is now sandwiched between the felt and the mould. Apply pressure to the back side of the mould, and gently raise the mould from the felt, starting with the side that was placed down first. Do not lift the mould straight up; instead, use a slight rocking motion to raise it. The pulp sheet has been transferred from the mould screen to the felt by this action. Now place another piece of dampened felt over the sheet of pulp. If no press is available, this sandwich may be ironed dry with a household iron. If you have a press, you may continue the process and build a stack or *post* of six to eight sheets of paper and felt. Remember, to keep the fiber in

Pulp is stirred and mould and deckle are grasped firmly. The vat is a simple laundry tub available at hardware and plumbing stores. The woods are courtesy of Northern Wisconsin.

The mould and deckle are held at the back of the vat and dipped in an even, continuous motion.

The mould and deckle are pulled toward the papermaker without completely submerging the frame. As soon as the surface clears the water, the mould and deckle are gently rocked back and forth and front to back to even the distribution of the pulp.

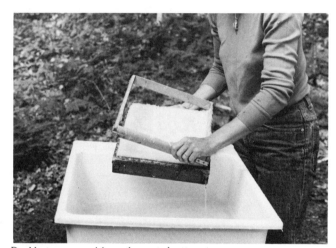

Deckle is removed from the wet sheet.

The mould is couched to transfer the wet pulp from the screen surface to the damp felt. Note the support ribs on the back side of the mould.

The sheet of paper (pulp at this point) has left the screen and been transferred to the felt in preparation for pressing.

Old bookbinders' presses work well to dry paper. This example is from Paper Press, Chicago, Illinois.

suspension, stir the pulp slurry each time you return to the vat. Next insert the post of sheets in the press and apply presure. Remove the post from the press and separate each sheet from the felt. Spread the papers out on an open surface to begin drying. When these sheets are barely damp, they may be returned to the press (this time without the felt) and repressed. This helps to insure flat sheets of finished paper.

These semi-damp papers may be placed in a photo dry mount press at 170°F to finish drying and to heat set the sizing. Care should be taken to cover the top and bed of the press with felt. The standard foam bed pad should be removed.

An alternative for insuring flat sheets is borrowed from Japanese sheet forming. In this process you use a large board or any flat waterproof surface. Sink cutouts from lumber yards are inexpensive and have smooth plastic laminate surfaces. Particle board sealed with polyurethane also works well. The water-leaf pulp on its felt is lifted up and put pulp side down against the board. A print braier or rolling pin is then rolled over the back of the

felt to transfer the paper to the board. After tight contact is made, the felt is peeled back, exposing the paper attached to the board. The board is then set at a 45° angle against a wall, preferably outdoors in the sun, for the paper to drain dry. If no sun is available, heat lamps or household fans also hasten the drying time.

Another method is to make four or five separate moulds and simply allow the fibers to remain on the screen propped at an angle until dry. Paper dried this way has a light pattern of the screen on one side and a pebbly surface on the other. The rough surface is caused by the fibers contracting and drying unevenly (without the direct contact restraint of the screen). When the paper is dry, you can see it lighten, and you feel no moisture on the surface. Once dry, one corner is gently lifted back, and the sheet of paper is peeled from the surface of the screen. The finished sheets are stacked and saved to coat with various sizings and emulsions. (See Chapter 3.) If you wish to further smooth the surface, you may use distilled water in a plant mister and gently redampen the sheet. Place this dampened sheet between two smooth

cotton cloths and press with a medium-hot iron, or place in a photo dry mount press as described above. Another alternative is to dampen them and run them through an etching press without felts. These processes have the effect of calendering or smoothing the sheet. These sheets may be used for the photographic processes in Chapter 4 and with many of the systems in Chapter 8.

ORIENTAL PAPERMAKING

In the Orient, papermaking is a way of life, perhaps based in part on this ancient saying:

> . . . Encircle life with beauty until it enters and rests within. . . . Sukey Hughes'

Papers made using "Western" methods are called *tamezuki* in Japan. The Japanese methods, called *nagashizuki*, involve different materials and methods.

> . . . Freely allow the materials to be and express themselves. Then body, mind, and heart are in harmony with materials, work, and product, and the papermaker becomes paper. Sukey Hughes'

The process of Japanese papermaking, *nagashizuki*, is a slow, beautifully reflective process, and the finished sheet mirrors the care and attention given to detail.

FIBER PREPARATION The first consideration is the fiber and its preparation. Traditional Oriental fibers are available (see Sources of Supply). Some of these, such as abaca, may be purchased in sheet (linter) form and processed with Western methods. Also, it is very possible to gather your own milkweed, cattail, flax, kudsu, iris, and the like, and process the fibers. Please refer to Lilian Bell's book for further information on processing indigenous plant fibers. The directions given here use *kozo*, the fiber the Japanese consider "masculine" because of its tough strong characteristics.

Kozo is one of three mulberry fibers commonly used. The other two are mitsumata, the delicate "feminine" form, and gampi, "the blend of strength and beauty." Gampi is difficult to obtain, as it only grows wild. All these fibers are processed in a similar manner and are used to produce the paper the Japanese call "washi." The kozo fiber we obtain in this country has been steamed from the inner woody stem of the branch—the outer black bark and some of the inner green layer have been removed. This fiber is soaked overnight and then cooked, using the following process.

Enough caustic and water (in the proportion of 1 tablespoon caustic to 1½ gallons water) should be added to the cooking pot to cover the fiber. The caustic and water should be heated and stirred until the mixture is well-dissolved and boiling. Add the fiber, cover the

Removing piece of handformed paper from the screen surface. This piece incorporates several types of paper and a cyanotype photograph. The collage was completed while the paper was wet.

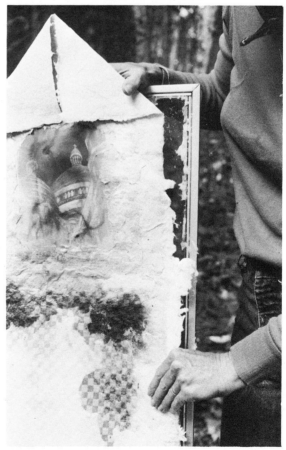

pot, and reduce the heat. Simmer this mixture 2 hours, until the fiber becomes loosened and easily pulls apart. Cool and rinse the fibers in cold running water for at least 15 minutes. A cheesecloth bag may be made to hold fibers during this washing stage. It is important to rinse all traces of caustic from the fiber, as this can raise the pH of the paper if allowed to remain. Also, fiber spoils easily and quickly if not used at this point. It may be kept in the refrigerator or frozen to protect it from mold. However, the finest paper is produced from fresh fiber.

Next you must "pick" the fiber. This is the process of removing all the small dark specks, any imperfect areas, and the greenish outer layer. A small pair of scissors and the edge of a knife are good tools for this process. Separate this debris and save it to add to sheets in which you want texture. The Japanese consider the scrapings "chiri" or wastepaper and use them for protective wrapping paper.

BEATING Beating is the next stage of processing. It should be done on a hard, smooth surface that does not chip or flake into the fiber. Pile a fist-sized portion of fiber on the board and pound it for 20 minutes or until the fiber, when pulled apart, is no longer than ¾". If the fiber starts to become dry during beating, sprinkle additional water on it. You may also pick additional impurities as you beat. The larger the surface of your mallet, the faster the beating will be completed. A freeness test may be made if you doubt that the fiber is ready.

FORMATION AID The vats used for nagashizuki sheet forming contain a viscous formation aid derived from the hibiscus plant (tororo-aoi). Preparation of this formation aid is the next step. If you are using natural substances, such as okra root or the traditional tororo-aoi (root seeds and instructions are available through Carriage House to grow your own), the roots are soaked overnight to produce a thick, mucous substance. This mucillage is added to the vat in the proportion listed below to help disperse the long fibers and slow the drainage of water

through the surface of the screen. Okra is processed in the same way, but the mucillage forms quickly (10 minutes).

A synthetic substitute for these roots (PNS) is available through Lee McDonald (see Sources of Supply). One-quarter teaspoon of PNS is added to 1 quart of water 24 hours before use. Slowly add it directly into a flow of cold water. Then shake the mixture until the granular white particles are no longer visible. If the mixture is very thick, additional cold water may be added. It produces a substance that is clear, stringy, and slow moving.

VAT PREPARATION Fill the vat approximately one-third with cold water. Then quickly dip a clump of beaten kozo (about the size of a baseball) into the water to wet the fiber. Pick small pieces of fiber from the clump, and throw them into the vat. When all the fiber is added, reach into the vat and stir it vigorously with both hands to disperse the fiber.

The prepared formation aid is added next—slowly. The formation aid controls how the fiber is dispersed on the surface of the screen (su) as the sheet of paper is formed. If too much is added, the drainage takes too long; too little causes the fibers to form rapidly and unevenly. If you add approximately ½ cup of formation aid at a time (exact measuring is difficult) until the water in the vat drips slowly off your fingers, you should have it in correct proportion. This is approximately 500 milliliters. You may wish to add some formation aid and then dip a sheet to test it before adding more. If you wish to use internal sizing, we recommend Aquapel (see Chapter 3).

SHEET FORMING Before you begin to form final sheets, arrange the place where you will prepare your post. Do so by placing a plastic laminate board on a table. Then cover the board with a dampened felt or blanket at least 1" larger in all directions than the screen surface. Next, cover the felt with a smooth damp cotton cloth of the same dimensions. Japanese papermaking moulds and the su or screen surface are available from Lee McDonald (see Sources of Supply). The su is presoaked in a bucket of water for one-half

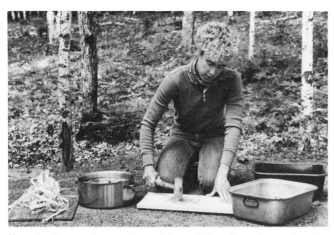

Kozo dry fiber and containers of rhetted fiber. Pounding action prepares fiber for adding to the vat.

Fibers are separated and added to the vat.

Formation aid prepared in advance is added to the vat. Note that it forms long strands.

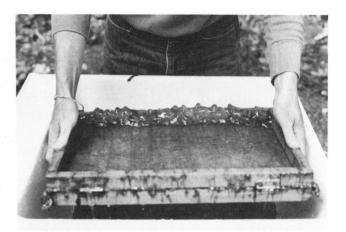

Fiber and formation aid are tossed back and forth in a wave-like motion over the surface of the screen.

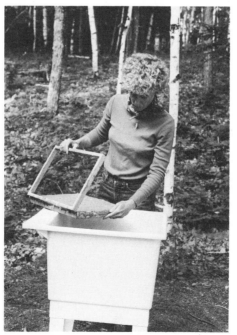

Oriental mould, deckle, and loose "su" surface.

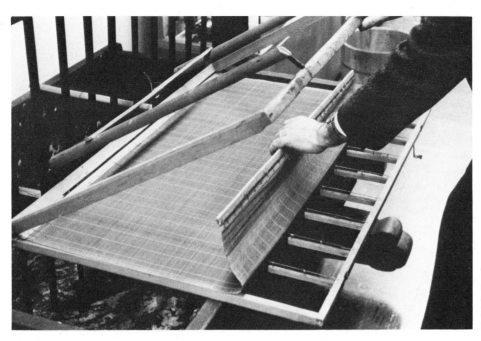

The deckle is hinged on the Oriental mould and is lifted to remove the su. Courtesy of The Dard Hunter Paper Museum, The Institute of Paper Chemistry, Appleton, Wisconsin.

hour and then placed in the mould, which is clamped tightly shut and held in both hands. This is dipped halfway under the surface of the water, working from the front toward the back of the vat, so that some of the pulp and water are scooped up. The slurry is then tossed lightly back and forth across the surface of the su with the remainder of the slurry being "thrown" off the su and back into the vat. This process is repeated, but the tossing action is from side to side the second time. Each directional action is repeated twice. This action layers the fibers in opposite directions, making an extremely strong, dimensionally stable sheet.

Next, open the mould, lift off the su, and carry the su to the dampened cotton cloth. The bottom edge is placed down, and the su is rolled forward, bringing the fiber into contact with the cloth. Slight pressure is applied to the back of the su, and then it is lifted again with a "rolling" back motion from the end that was first set down (closest to you). Take a length of one color of thread and lay it across the short end of the sheet. Then repeat the sheet-forming process and use the second color thread. This thread allows you to determine one sheet from the next when they are separated for drying. The sheets are placed directly on top of each other, and the formation aid and the internal cohesion of the individual sheets keep them from bonding. Formation

aid is known as the "magic" ingredient in Japanese papermaking. No more than twenty sheets should be placed on a post until you are extremely proficient. The post is then covered with another smooth cotton cloth and a damp felt, and it is allowed to "rest" overnight.

DRYING The next day the remaining board is placed on top of the post. Over the next hours, one of two things may be done. A 3-pound rock or weight may be added each hour until 24 pounds of weight is accumulated. Or a 5-gallon bucket may be placed on the board and 2 quarts of water added each hour until the bucket is full. This should make the cotton and felt wet but not dripping. The post is left under the weight overnight or for approximately 12 hours. If all this has been done carefully, the sheets should now separate from one another easily. The threads placed between the sheets help the separation of one sheet from the next. (If they do not, repeat a shortened version of the pressing process.) To separate the sheets, hold the end nearest you and slowly lift the sheet away from yourself. Once the sheet is free of the post, lay it against a smooth surface and brush it into tight contact with the surface by using a wide brush and stroking the paper from the center to the edge. This action is similar to pasting wallpaper. If a sunny spot is available, the sheet will dry completely in less than an hour.

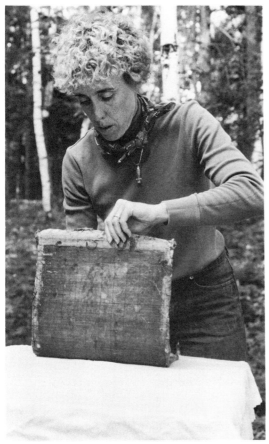

Kozo fiber against surface of the "placemat" su.

Su is rolled back, depositing fiber on damp cloths.

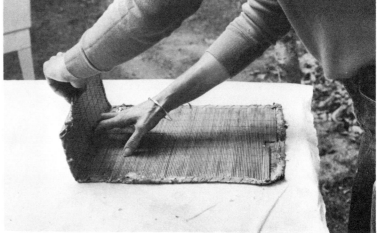

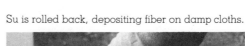

Rocks are placed on the Oriental post, adding pressure to aid in removing water from the sheets as drying begins.

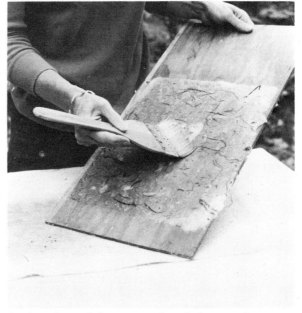

Brushing Oriental sheet against board after partial drying in a post.

Powdered pigments with mortar and pestle
for grinding.

It may then be gently peeled from the board.
These sheets have a sheen and flatness of
surface unavailable in Western papers. The
process, though long, produces paper with
very special beauty.

> Tradition is a strong resilient warp through
> which the new and living vision of each gener-
> ation is woven. Sukey Hughes[1]

VARIATIONS AND MANIPULATIONS

We have discussed the basic processes for
making beautiful natural sheets of hand-
formed paper. Once you have tried the tech-
niques, you will become interested in some of
the possible variations and manipulations of
that paper surface. Specific papers may be
created to enhance an image or to provide
visual dialogue about an image.

Color Preparation and Theory

The first consideration is color. Until this point,
the sheets have been white, or they have
borne the inherent color of the fiber. There are
perhaps as many theories on producing color

in paper as there are papermakers. We will
indicate our preferences and some of the
other options available.

We have successfully used artists' pig-
ments (available in powdered form from
Grumbacher, Winsor Newton, Graphic
Chemical, and most art supply stores). These
pigments are added to the pulp during the
beating process. Aequous pigments (pigments
dispersed in water) are available (see Sources
of Supply), or you may make your own. Pour
a small amount of pigment into a mortar and
grind with the pestle until all lumps are re-
moved and a fine powder remains. If you do
not have a mortar and pestle, use a glass
bowl and the back side of a spoon. Four or
five drops of water are added to the powder
and mixed. Additional water is gradually
added to form approximately 1 cup of color. It
is sometimes helpful to add pulped fiber to this
color mixture and then put the combined
mixture in the blender with the remaining
pulp. This procedure helps to disperse the
color evenly. In a home blender, it is easy to
see the color as it is added.

The intensity of color in the dry sheet will
be approximately half the intensity of the wet
pulp. Inorganic colors work well. They blend
easily and have less tendency to fade, al-
though blues and reds will lighten with time.
These include all the cadmiums (reds and
yellows), chrome colors, ultramarines, um-
bers, and iron oxides (see Chapter 6 for pig-
ment hazards). These pigments are quite
stable. To visualize the stability of pigments,
you should think of them as microscopic rocks
sitting amid the cotton fibers of the paper. The
fibers do not absorb the pigment. Dyes, on the
other hand, are absorbed, making changes in
the paper more likely. You may wish to ex-
periment with traditional natural dyes from
berries, plants, barks, and the like. However,
some of the mordants, such as salt, necessary
to obtain hues from these materials, are harm-
ful to paper. Care in washing should be used.
A wide range of chemical and direct dyes are
available and in use by papermakers. Fading
and bleeding are the major problems with

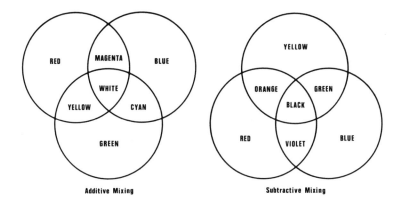

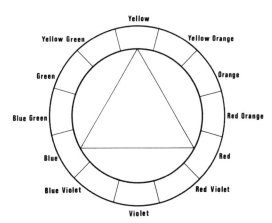

Color wheel showing additive light wheel, subtractive pigment wheel, and twelve-part wheel for pigment. Illustration by Jeanne Reilly.

various individual types of dye and/or particular colors within the types. Therefore, the best practice is to try the dye and test it for your own purposes.

It is important as you proceed to work with color to understand that it is both light and pigment, and it is also psychology. What we perceive and what we feel can be influenced by the artist. Color must be carefully understood. From the Babylonians in 1900 B.C., to Newton and Goethe in the 1700s, to Edwin Land in modern times, there have been theories and systems of color to prove or disprove. Color as light is one area, and color as pigment is another. Yet they are not entirely separate. Color in pigment is controlled by light's reflective qualities. For example, when pigment is added to water the color deepens because more light is absorbed by the combined material. The greater the number of

separate particles the light must pass through, the more opaque the color becomes. Therefore, a thin wash of water and pigment appears transparent, while several layers are opaque.

Pigment is therefore known as *subtractive*: It takes out certain colors of the spectrum so that we see what remains. The primary colors in pigment or the subtractive system are: red, blue, and yellow. These colors are often divided into a twelve-part wheel containing three primaries (red, yellow, blue), three secondaries (orange, green, purple), and six tertiary colors. The secondary colors are referred to as *complements* of the primary colors when they are positioned across the wheel. For example, the subtractive complement of blue is orange. The remaining six tertiary colors are red-orange, yellow-orange, yellow-green, blue-green, blue-violet, and red-violet.

Catharine Reeve displaying a variety of her photographs printed on handmade paper incorporating sheet forming processes, such as layering, embedding, multiple couching, and color. Photo credit: Michael Roberts, Midland *Daily News*, Midland, Michigan.

The relationships of colors create particular perceptions. Sign painters may use red and green together because our eyes do not focus well on complementary colors. The way in which we see color was used by the French Impressionists. While using pigment, they layered colors next to each other according to theories not of subtractive color (pigment) but rather of reflected light (additive color theory). The Impressionists would place pure colors next to each other (red and green would produce a reflected visual yellow), rather than blending two color pigments (red and green mixed would make a muddy brown). Light is referred to as additive color and the primaries are: red, green, and blue. This is known as the Young-Helmholtz theory. These additive colors are again placed on a wheel with their complements, and the combination of colors of light yields white.

We have a strong psychological need to balance a color with its complement. Therefore, yellow light is balanced with blue. Gray takes on the complement of the color next to it, so gray next to yellow appears blue-gray. Placed next to each other, complementary colors intensify. Yellow next to blue is stronger than yellow alone.

Color is emotional and symbolic as well. Yellow-gold was used for the cross (honor and goodness). Blue was purity and truth. The Virgin Mary would be depicted with a blue (purity) cloak over her red (love) gown to signify that her love was pure. Today, color

Barbara Lazarus Metz: "Untitled," cyanotype, film, pastel on cast and handmade paper, 12″ × 9″, © 1982. Therma-Fax transfers were used to produce this image (see Chapter 2). The relief figure was cast in a mold, using colored pulp. Note that the loose edge heightens the sculptural qualities of the image.

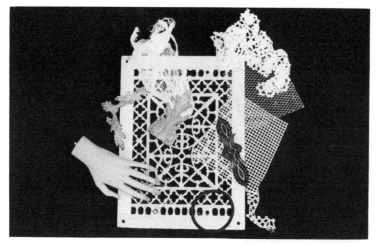

A variety of objects which may be placed on the vacuum table to make embossments on the paper surface.

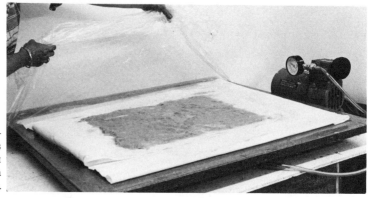

The damp paper is couched over the objects on the table. A thin plastic sheet is laid on top of the paper, allowing a vacuum to form as water is removed with the pump.

retains psychological meaning. The Wizard of Oz has a cowardly yellow lion, and we sing the blues. Arguments and theories change as scientists study color. It was while trying to prove the Young-Helmholtz theory that James Clark Maxwell produced one of the first color photographs. The field today has unanswered questions, and we suggest several books in our Bibliography. Whether you use color as light, as pigment, for emotion, or for historical significance, you will have some awareness of how and why it is working.

Being aware of how to color the pulp and why to select certain colors, we can proceed to study other variations and manipulative possibilities.

Laying in Color

Images may be created using colored pulps. A deckle may be clamped to the mould, or a simple mould may be inverted. The mixed pulp is strained to remove most of the water and placed on the screen in a desired pattern.

Landscapes, symbols, and abstract patterns may be produced in this manner to enhance or provide a color background for a photographic image. Another suggestion is to form a sheet of one color and drip other colors of pulp across the surface. This provides a random pattern of color. These sheets are then couched and pressed, or air dried on the screen surface. A chemical known as CMC (carboxymethyl cellulose) may be added to the pulp to increase its flow.

Multiple Couching

After forming one sheet of paper, another full or partial sheet of paper may be placed on top of the initial sheet. Doing so can produce color changes or add shapes and textures. For example, after couching a white sheet, the mould might be dipped in a green pulp only deep enough to cover one-third of the surface. This might then be couched onto the first sheet to form the "landscape" of the final image. Templates or patterns may also be formed. A

118

piece of plywood or even cardboard may be cut out to form an image and then placed on a mould. For example, if you want triangular sheets, the form would be cut from the center of a board the same size as the mould. Then the board with pattern would be placed directly on top of the mould as the sheet of paper is formed. This shape may be couched as a single sheet of triangular paper. It may also be couched on top of another rectangular sheet to give a triangular image. The procedure may be repeated with a variety of shapes and colors. This method can provide very subtle patterns of color and shape in a single sheet of paper.

Embedding

Dried natural materials and found objects may be added to the paper by couching the initial sheet, laying the objects down in the desired arrangement, and then couching a top sheet over the surface. If you wish to clearly see the objects you have added, a very thin top sheet should be used. It is also possible to hold the objects in place with bits of pulp placed over them. However, if you plan to use emulsions for your photographic processing, it is best to encase the objects with a top sheet of paper. Another possibility is to embed objects or colors and, prior to pressing, cut or tear away part of the top sheet to expose underlayers. This technique generally withstands photo processing.

Pouring

Borrowing the system used in Nepal, a simple screen may be used upside down and pulp poured in and trapped on the surface. A more even distribution of fiber results if the screen is held slightly under water. Then the screen

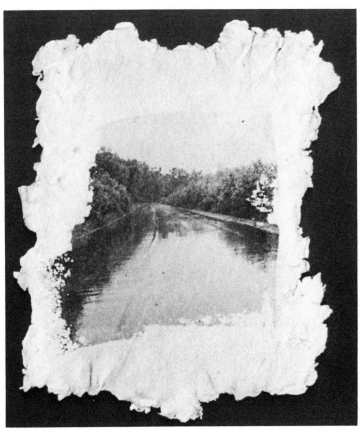

Catharine Reeve; "Tittabawassee River Road," photograph on handmade paper, silver nitrate emulsion, © 1980. 9″ × 12″.

may be agitated after the pulp is poured. A thick sheet may easily be formed in this way. The screen may then be lifted from the water and set at a slight angle to drain and dry. Objects may also be placed on the screen surface prior to pouring in the pulp and removed after drying. This forms a very simple embossment or, if the items are allowed to remain, an embedding.

Deckle Edge

Forms or shapes may be added to the deckle to exaggerate the shape or add color. A geometric pattern may be added, for example, or the deckle may be removed and the sheet formed on the mould without the deckle. This makes a less regular surface but gives a beautiful loose exterior edge.

Additives

Fibers of other natural materials in a less processed state may be added directly to the vat, layered on the surface of the sheet, or couched between two sheets. Also, pieces of string and other natural materials may be held on each end and dipped through the vat, capturing pulp. These may then be added to the paper surface.

Joining Sheets

Paper made of high cellulose content fibers sews easily. Sheets may be formed, printed upon, and then stitched together, either by hand or machine. This provides interesting varieties of "paper quilts." Papers may also be redampened and joined at the edges to form larger sheets.

Vacuum Forming and Embossing

The use of a vacuum table and/or etching press can give greater dimension to the surfaces. In both cases, objects are placed on a flat surface and paper formed over and around them.

The objects to emboss the sheets are placed on a vacuum table covered with plastic (to seal the surface); water is extracted, using a vacuum pump. This allows the artist to use highly dimensional objects in large sheets. The etching press also may be used to emboss finished sheets. The sheet is redampened and placed on top of an object on the bed of the press. Then the object and paper are passed through the press. In both methods the impression of the object remains in the final sheet of paper.

This paper may either be new pulp or a redampened finished sheet. For example, a photographic image could be made using cyanotype. Then the sheet could be dampened and formed over objects relating to the image or even an old picture frame. This picture frame would then give the image a self-frame. (See book cover.)

This list of experiments and possibilities does not end. Potential for enhancing, embellishing, altering, and manipulating both the finished photographic image and the surface prior to printing are endless. An invitation to open your mind and expand your vision lies in the papermaking process.

6

Traditional Art Materials in Combination With Alternative Processes

It is this sense of the persistent life force back of things which makes the eye see and the hand move in ways that result in true masterpieces. Techniques are thus created as a need.

It is very possible that you know all of these things and know them to be true. I simply recall them to you, to make them active again, just as I would like you to recall them to me, for sometimes our possessions sleep. Robert Henri[1]

Traditionally, photography has stayed within its own format and materials. Expansion into the area of fine art materials and techniques takes the photograph beyond another boundary. Paint and drawing materials can create line and flat pattern to add to and combine with those elements in the photographic image. In this chapter, we place the photograph into the plastic arts tradition. The photograph becomes formal composition and structure, and it blends with the art materials for strength and balance. The resulting tension between the photograph and the flow of the painting and drawing techniques can lend added dimension to the image.[2]

BASIC ART SUPPLIES AND TECHNIQUES

For the processes described in the following paragraphs, you may purchase the necessary supply of brushes and paints at any art supply store. We recommend a small variety of brushes for experimenting.

For general work, the least expensive bristle brushes are adequate. Brushes come in a range of sizes: Low numbers refer to small brushes, higher numbers to larger brushes. We recommend starting with three brushes—sizes 3, 5, and 10. For interesting effects you may want to purchase a fan brush, such as a #6 white sable made by Robert Simmons Co. For applying acrylic mediums, we recommend the short bristle Chinese Peacock brushes.

Small tubes of oil, acrylic paints, and watercolors are best for trying the processes we describe until you know which medium is most helpful to you in expressing your particular concept. You will also find it necessary to have small bottles of linseed oil and turpentine.

We speak frequently of a "wash," a thin and very liquid application of light color to the paper surface.

For those of you with no previous experience in these art processes, we make the following suggestions:

1. Care of your brushes is important. Wash them after each session in the proper solvent and then with soap and water (do not use hot water), rinse very well, and store them with the bristles up in an open jar.

2. When working with paints, be aware of the color wheel (see Chapter 5). For example, any combination of the primary colors (red, yellow, and blue) can yield a shade of gray. These grays can complement the natural gray tones in the photograph.

3. To thin paints with mediums or vehicles, pour a few drops of the medium or vehicle (linseed oil, turpentine, water, or the like) into a container and add a dab of paint. Mix until you achieve the desired consistency. Liquitex makes a turpentine substitute called Permtine, which is odorless and can be used to dilute oil paints and mediums. Also Photo-Flo helps to disperse pigments or paints when brushed onto paper surfaces.

Oil-Based Materials

OIL PAINTS AND MEDIUMS The oil paints traditionally used by photographers for most hand coloring are Marshall oils. Oil paints

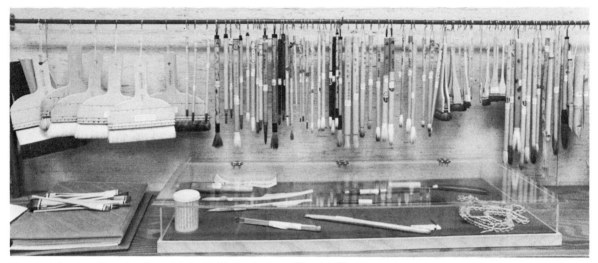

A wide selection of brushes from Aiko's Art Materials, Inc., Chicago, Illinois.

and oil-based mediums have previously been used in limited ways by photographers. Here we are interested in the use of oil paints in their tube form, as available in art supply stores. Oil is a very plastic and slow drying medium. It adheres to the surface of photographic paper, and it may be either used straight from the tube or thinned with turpentine or linseed oil to form a lighter wash of color. It is advisable to make test strips and try various techniques of brush work and paint thickness. Larger concentrations of turpentine may tend to eat into the surface of photographic papers, creating unusual effects. Paint used without mediums may be applied to the surface to block out or fill in areas and to create linear and feathered effects.

Oil paints and oil washes may also be applied to nonphotographic papers before or after images have been printed on them. Entire images or parts of images may be painted on these papers to blend with or to accent the photograph. The painting may be done in layers of color to build luminosity. One color is brushed on and allowed to dry before the next color is added. Oil washes containing large amounts of linseed oil blend and bleed colors on papers such as Rives BFK. By combining 1 part oil color, 2 parts linseed oil, and 3 parts turpentine, a wash is made that imparts a transparent, parchment-like appearance to Oriental papers, such as Natsume and Kinwashi. These oil-treated papers may then be used for printing or collaged over or under all or part of the photographic image.

Spray Enamel

Another oil-based paint is spray enamel. Good grades of these paints are available through art supply stores. Spray paints may be used in combination with masks to color specific areas of a photograph or "feathered" in to create delicate edges with subtle blending of shapes and tones. Another unusual effect may be created by crumpling a sheet of paper (lightweight Chiri and Kitakata Oriental papers work well) and then spraying it with one or more colors. When the paper is dry, unfolding it reveals gradations of color that appear highly rendered. These papers may also be collaged or printed on. The density and distribution of color with this technique is controlled by the distance at which the spray is held from the paper and the movement or lack of movement of the spray.

OIL CRAYONS In addition to oil paints, we suggest trying oil-based crayons. These crayons come under several trade names; we prefer cray-pas or Sakura. Small sets of these are available in most stores, and art supply

houses carry larger varieties. These crayons may be used alone or in combination with any medium used in oil painting (turpentine or linseed oil). Laying a wash of oil or turpentine over a sheet of paper prior to drawing gives these crayons a smooth, fluid effect. By placing a small amount of turpentine in a cup and using a knife to shave the crayon into it, liquid colors may be made to match the color of the crayon. This may be used to fill in parts of the photographic image for flat areas of color. The washes of these colors made with turpentine adhere well to the photograph's surface, and they dry faster than washes made from oil paint. In making washes with oil or acrylic paint, a medium we recommend is Liquin, manufactured by Winsor Newton. It blends with both water and oil-base drawing/painting materials and aids in using them on photographic paper surfaces. It works exceedingly well with cray-pas and is faster drying than conventional oil mediums. Another technique with oil crayon is to place the printed photographic, fine art, or handmade paper, image side up, on a warming tray set at low heat. The crayons drawn on the slightly warm surface blend and melt to form interesting effects.

Rita DeWitt: "True or False? Thoughts have a magnetic energy," hand-colored Xerox collage, © 1982. 22¼" × 30". The artist's images are made on the copier, collaged onto a larger sheet of gray paper, and hand-worked with oil paint and pencil.

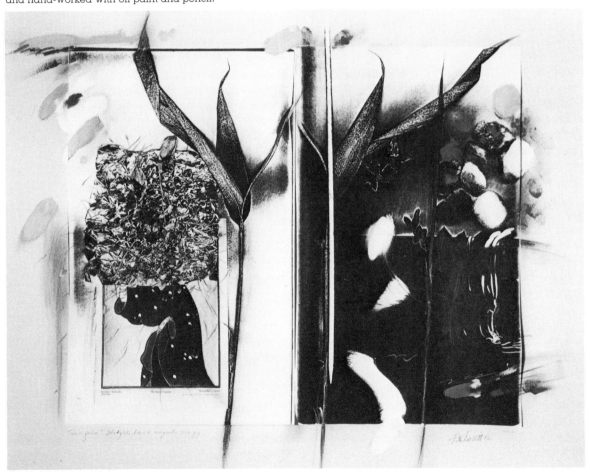

Laying a wash of oil or turpentine over a sheet of paper to draw with oil crayons gives a smooth, fluid effect.

Lithographic Materials

Another effective oil-based drawing and painting material comes from the printmaking process of lithography. The materials are the same today as the ones used and published by their inventor Alois Senefelder in 1818. It is: 8 parts wax, 2 parts tallow, 5 parts soap, 4 parts shellac, and 3 parts lampblack. We include this formula for your use and experimentation because it produces a material that adheres well to the photographic, fine art, or handmade papers used today. Also, it may be varied by substituting finely ground pigments for lampblack. Senefelder's ingredients form the base for all tusche and litho crayon preparations.

A wide variety of novel effects can be produced through use of these drawing materials, but keep in mind that the relationship of technique to image should be a matter of careful consideration. Lithographic crayons are ¼″ square and may be sharpened with a razor blade. They range from the softest, #00, through the hardest, #5. They may be dissolved in distilled water or turpentine to produce washes. Lithographic pencils are also available for fine line work. Made by William

Korn, they come in grades 1–5 and are wrapped in paper that is peeled away for use. Sharpened with a razor blade, these pencils work well to form very fine lines on photographic, fine art, and handmade papers. Another material from this process is lithographic tusche, and it is available in solid or liquid form. It may be further thinned with litholine, turpentine, or distilled water for brush work and laying in flat patterns. Gum Arabic medium (available at art supply stores in liquid form) acts as a resist or mask for tusche, and it may be applied to areas where the photographic image is to remain. Another form of tusche is autographic ink. Because of its high grease content, it works well on photographs. It may be used to form fine linear effects or thinned to produce a warm brown wash. "Rubbing ink" for lithography is manufactured by William Korn and comes in soft, medium, and hard grades. It is applied by wrapping a piece of soft cloth around the finger, rubbing it across the slab of ink, and dabbing in soft areas of black. The inks and tusche may be diluted with distilled water for use in an air brush to achieve effects similar to those obtained with spray enamels. Although lithographic materials work well on pho-

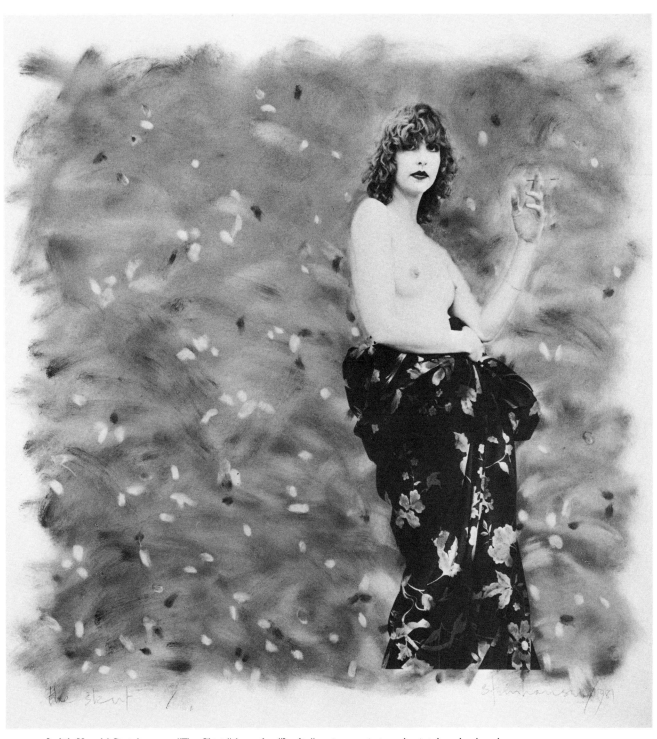

Judith Harold Steinhauser: "The Skirt," from the "Leslie" series, sepia-toned print, hand-colored, © 1982. 16" × 16". "Hand-coloring is a means of changing the surface of an image to suit your own ideas. You can be quite literal with it, or delight in the never-ending quality of the color to create illusions and enhance emotion."

Harold Jones: "Breckenridge, Colo.," white ink and gelatin silver print, © 1979. 19½″ × 15½″.

Lithographic crayons and tusche.

tographic papers, they may also be used on drawing and handmade papers prior to or after printing the images.

Pastels

Oil pastels are available for creating subtle, soft variations of color. Pastels come in many types with varying degrees of hardness. Grumbacher makes oil pastels in a wide range of colors, and they are available at art supply stores singly or in sets. The oil base in these pastels makes them work well on either the art paper surface or photographic papers. As drawing materials, they are less effective than oil crayons on traditional photographic papers. However, by pulverizing them with a mortar and pestle, scraping them with a knife, or grinding them with a spoon, the powder of the pastel is obtained. This powder may then be rubbed on the surface of the photograph, providing a wide range of extremely subtle color variations. Remember that, when a ground pigment is obtained, it may become airborne. Several colors, such as emerald green, cobalt violet, magenta, and mauve, are arsenic-based and highly toxic. Another group, including flake white, jaune brilliant, and Naples yellow, are lead compounds and, again, very toxic. Pastel colors may be "fixed" or made permanent by spraying the surface

with damar varnish or "nonworkable" fixative, available under various brand names from art supply stores. If you wish to use these pastels on art papers prior to printing a photographic image, you may do so by coating the paper with acrylic matte medium after using the pastels or carefully sizing with Argo starch (see Chapter 3). This method would be adaptable in the Kwik-Printing, emulsion printing, and cyanotype procedures detailed in Chapter 4.

Pencils, Drawing Materials, and Silver Point

Traditional drawing materials and materials to heighten or accentuate linear elements in the final work include:

1. Prisma color pencils,
2. fine line permanent felt and nylon tip markers,
3. lead pencils and sticks,
4. water color pencils and inks,
5. Chinese marking and grease pencils,
6. Oriental ink sticks and brush painting colors, and
7. conventional drawing inks used with quill or continuous flow pens.

Jack Sal: Untitled, cliché verre toned silver print, © 1981. 8″ × 10″. The artist uses his drawings made with oil stick, litho crayons, inks, or acrylics on various translucent papers as negatives. These negatives are placed on printing out paper in a contact frame and exposed to sunlight. The exposure time, which may be as long as several weeks, creates a variety of hues and tones.

Traditional inks and pencils have archival permanence; many of the liquid marking pens and dyes do not. [Keep in mind the archival considerations of light permanence.] This is not to suggest that certain materials cannot be used, but rather that the artist should understand and be fully aware of these properties. Drawing materials may be used to make complete images to add to the photograph, parts of images to surround the photograph, or to develop underlying texture and pattern for the photograph. The placement of photographs among drawn images may be done most successfully on nonphotographic papers. Drawing papers such as Aquabee, Arches

Text, Dutch Etching, and Roma work well. Internally sized handmade paper may also be used. Cyanotype, Van Dyke, Kwik-Printing, and gum printing may all benefit from such combinations. The drawing helps to define and accent images in these processes.

Drawing materials may be used to give further emphasis in solarizing. A transfer may be used to place the drawing in areas prior to printing, or drawing may be added after printing. (See Chapter 2 for instructions on preparing the transfer.)

Prisma drawing colors added to color Xerox and machine printing work to heighten the image. These pencils come in a complete

range of colors. Hard and somewhat waxy, they must therefore be used on strong paper surfaces. They do not work well on handmade papers and soft Oriental papers. One of the real advantages of alternative photographic printing processes is the fact that they use traditional artist's and handmade papers. This makes it possible to incorporate the full range of drawing materials used for hand coloring, toning, or adding linear elements.

When rag papers are coated with a ground of gesso, silver point drawings can be made. A smooth layer of gesso is applied with a wide brush and allowed to dry. The photographic image may be printed after the surface dries, using any of the processes in Chapter 4. Then a point is made by sharpening a silver wire and inserting it into an etching needle holder. Silver wire is available from jewelry stores or jewelers supply houses. The drawing done in this manner tarnishes if not coated with fixative, but the tarnished color is often desirable. Gold and platinum

points may also be used, and these do not tarnish. Drawing with these points may also be done before the image is printed. This type of drawing uses an historic technique to produce delicate linear quality.

Water-Based Materials

INKS AND DYES The Chinese and Egyptians developed inks at approximately the same time (about 2500 B.C.). These inks were similar to our India ink, which is a mixture of carbon with a binder, such as gum. Later Roman inks were sepia in tone and probably produced with nut galls. Chinese ink today comes in sticks that are rubbed with water on stone blocks to produce the liquid ink. For photographers who wish to use ink prior to printing an image, waterproof India ink dries to a finish that withstands processing. Colored inks, and products such as Dr. Martin's Dyes, also provide liquid drawing materials, but their permanence is not as great.

Kay Kenny: "Suzanne and the Elders," gum bichromate, ink, pastel, acrylic, and watercolor on paper, 1981. 22¼" × 14⅝".

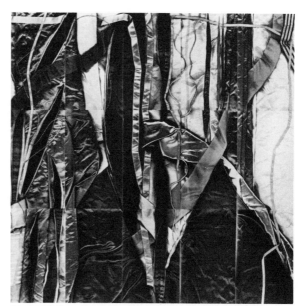

Garie W. Crawford: "Sansevieria," color Xerox, 1982. 40½" × 41".

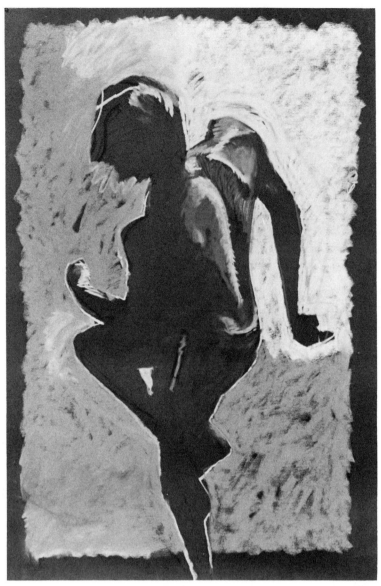

Peter Hurley: "Untitled," photograph with pastel on paper, 1982. 44" × 30". "I employ the camera as a sketch book. It has the ability to freeze figures on the half-beat. The photograph is the mechanical foundation; the drawing is an emotional response to the camera's qualities of framing light and action."

ACRYLIC PAINTS AND MEDIUMS The complete range of acrylic water-based paints may be used in much the same manner as oils. Their advantage is their quick drying characteristic. By applying them to the surface of the photograph with palette knives, combs, and old toothbrushes, you can create textures and patterns with the paint. Once these patterns have been formed and dried, washes of other colors may be added. It is also interesting to use the acrylic metallic colors. These may be used as underlayers to add luminosity to the surface colors. Liquitex gel medium may be added to the pigments: the greater the proportion of gel, the thicker and more transparent the color becomes. The colors may be thinned with water and used with small brushes to make fine opaque lines that adhere to pho-

tographic papers. Acrylic paints are the best of the conventional artists' colors to use directly on the photographic paper surface.

WATERCOLOR For use on artists' papers and handmade papers, watercolor paints provide beautiful translucent color. They are perhaps the most difficult to control, and tubes of watercolor pigment are quite costly. We recommend Winsor Newton for clarity of color. We also suggest that the inexperienced painter begin by trying single color washes. If you wish to mix two colors, the use of burnt umber and Prussian blue in washes gives a wide range of tones without danger of becoming muddy. Another color that works well with photographic images is neutral tint—a rich gray-black.

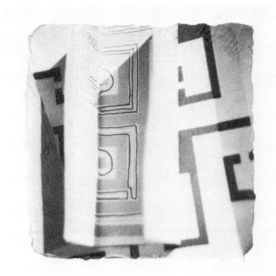

Nancy Rexroth: "Maze," Cut Paper
Series, SX-70 Polaroid transfer, 1982.

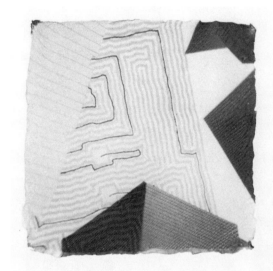

Nanch Rexroth: "Maze," Cut Paper
Series, SX-70 Polaroid transfer, 1982.

Keith Smith: "Untitled," series of drawings, watercolor and color Xerox. © 1982. 11″ × 18″.

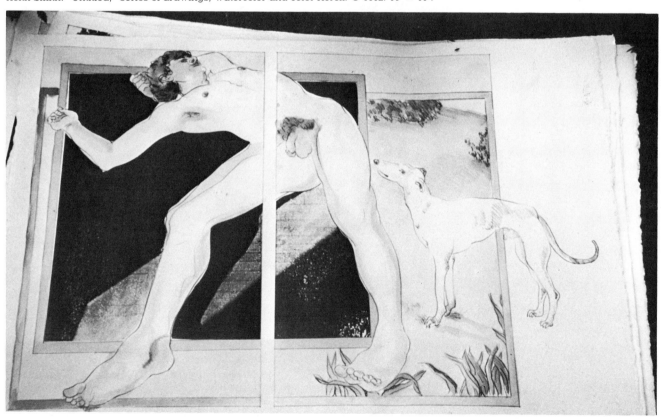

Brush and ink border on bond paper,
11″ × 14″, used as a paper negative
by Judith Harold Steinhauser
for the print in 6-13B.

Judith Harold Steinhauser: "Black Iris,"
photogram with paper negative
border, © 1982. 11″ × 14″.

Gel medium used to collage Marilyn Sward's cyanotype photograph to handmade paper. Acrylic and other drawing materials were applied to the surface, and Maskoid was used to retain highlights.

These colors all work beautifully with gum bichromate printing techniques and with hand coloring for emulsion prints on hand-made paper. Soft papers and images are enhanced with watercolor. We suggest purchasing one large sheet of at least 140-pound watercolor paper, Arches or Rives hot press (smooth), to make a series of tests of these various techniques. The weight in American papers refers to the number of pounds in a ream of five hundred sheets.

Gum Arabic makes a good medium to use with watercolor, and it may also be used as a resist by painting it on the paper and allowing it to dry. Another good resist for watercolor is Maskoid, a liquid rubber product that may be brushed or poured onto the paper prior to painting. We recommend the gray Maskoid for this, not the red photomask. Pickling salts (available in 5-pound bags at most supermarkets), when dropped into wet washes of watercolor (such as Prussian blue), leave tiny star-like areas of paper showing through the color.

GOUACHE Like watercolor, gouache is available in tubes. It is an opaque water-based pigment and less costly than watercolors. It works well on both photographic papers and art papers, and it may be combined as flat pattern areas with drawing.

EGG TEMPURA The term "tempura" derived from an attempt to distinguish painting done using a water-based medium from fresco painting done by applying pigment directly. Egg was commonly used as the medium in this painting. We give a brief description of this type of painting because, with these techniques, colors retain much of their inherent character and give a brilliant, luminous quality to the artwork.

The technique is not simple, and it takes some practice. The results, however, justify the patience. Egg tempura produces a great depth of tone when given a final coat of varnish or transparent glaze, and it is non-yellowing. The pigments for the egg tempura process may be prepared ahead. Grind powdered pigment, using a mortar and pestle, and mix with a small amount of distilled water. This paste mixture should be stored in small screw-top jars. The process begins by separating the egg yolk from the white. The yolk is then rolled onto a paper towel to dry the surface. Next it is carefully placed in the

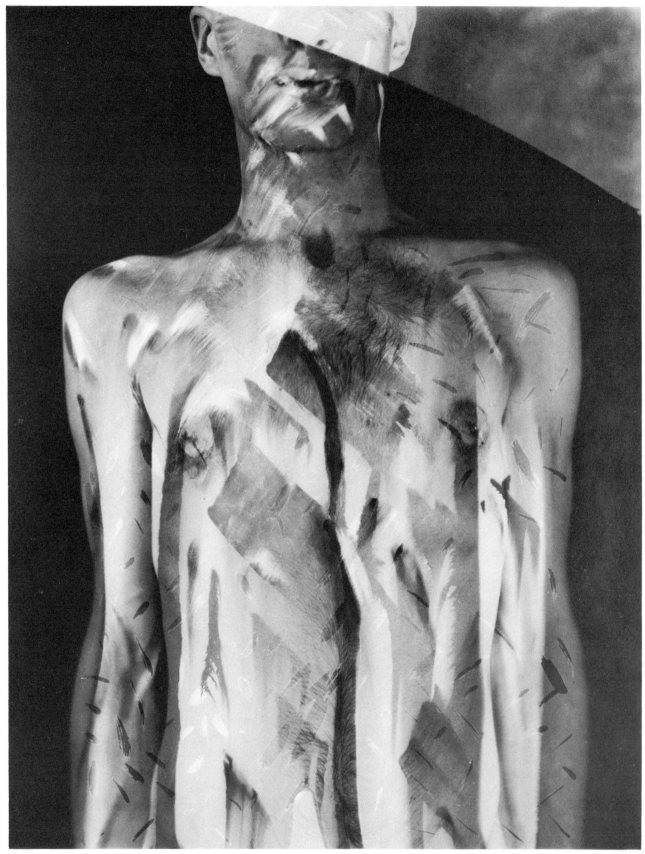

Luciano Franchi de Alfaro III: "Torso," toned silver print, 1980. 20" × 16". The print was bleached, redeveloped, and toned selectively in blue and copper toner.

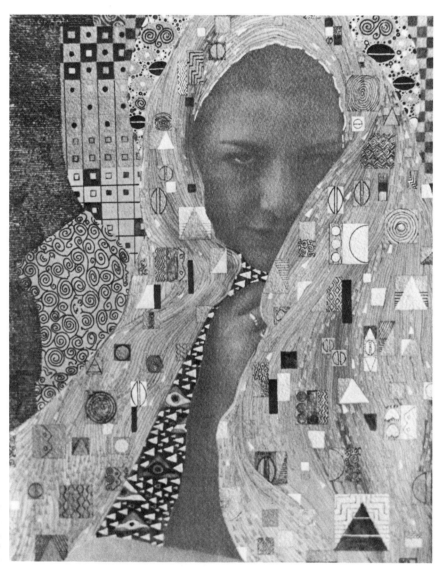

Gerald A. Matlick: "Susan—
Impression #1," liquid photo
emulsion, pencil, ink, and
watercolor on d'Arches 140 lb.
rough watercolor paper, 1981.
$12\frac{1}{4}'' \times 9\frac{3}{4}''$.

palm of one hand and gently lifted by the
thumb and forefinger of the opposite hand.
The skin is pierced and the yolk is allowed to
flow out into a cup. Just prior to use, an equal
portion of yolk and color paste are combined.
Once the pigment is mixed with the egg, it
cannot be kept for more than a day. It is best
applied to a fairly stiff surface that has been
gessoed. The brush used (red sable water-
color is best) should be dipped in water with
each application. Short hatch-like strokes are
easiest. A small mixing palette is essential,
since water must be added to the egg pigment

mixture. When the surface is finished, a final
coat of gel medium or transparent varnish is
applied.

Special Materials for Use With Resin-Coated Papers

The plastic paper surfaces of commercial
printing papers present some special prob-
lems and some interesting alternatives.

Any plastic-based pigment, such as acryl-
ic, works well on resin-coated paper. To use
dry pigments, pastels and pencils, it would be

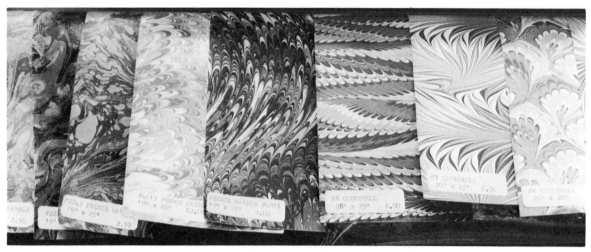

Aiko's in Chicago carries a variety of marbled papers that add colorful patterns to collage.

advisable to print the image on one of the fiber photographic papers. Edwal toners and dyes may be used, although they offer only a few colors. Caution must be taken with blue because it is highly heat-sensitive. To understand working with these materials, you should know that the toners attach physically to the silver halide crystals, whereas the dyes are absorbed into the paper surface. For surface alteration, the resin-coated papers may be varnished on the back and front by applying a thin layer of varnish, allowing it to dry, and then adding a second and third coat. Two other coloring materials you may wish to try with these papers are Flashe paints and Kodak tinting colors. Flashe paints are designed for use in animation painting on nylon, and they attach to resin-coated paper. Kodak tinting colors are in paste form and provide a semitransparent coloring material. The kits, however, are somewhat costly.

COLLAGE

Another area of artistic manipulation for photographers is *collage*. Historically, Bracque and Picasso became masters of collage, which is the blending of different materials on the surface of a work of art. Their use of this medium to define and resolve theories of painting established collage as a fine art technique. Contemporary artists Robert Rauschenberg, Robert Motherwell, Jasper Johns, and Andy Warhol have made extensive use of collage, often using photo silkscreen and commercial photographic images in their work. The heritage of collage, from the large vivid cutouts of Henri Matisse to the small sensitive works of Anne Ryan, is rich with possibilities for the contemporary photographer. The innovative ideas in this medium are endless.

Papers and materials for collage may be adhered to each other by using acrylic mediums. Gel medium, a heavy-bodied substance, adheres thick papers easily. When used on translucent papers, it makes them more transparent. The gel medium causes a visible spot if applied to thin papers merely to hold one to another. Matte medium is thinner in consistency but, as its name indicates, dries to a dull finish. This is an advantage when working with lightweight Oriental papers. For the Japanese paper, there is "Yes" glue. which is an archival bookbinder's paste available from paper suppliers.

VARIATIONS IN PAPER SURFACE

Another option for collage is to experiment with making your own effects on paper surfaces. Four techniques seem to offer possibilities for expansion and provoke ideas for experimentation. These techniques are:

A stick used to swirl a small amount of Sumi ink on the surface of a water bath. Here, a sheet of handmade paper is gently lowered onto the water-ink surface.

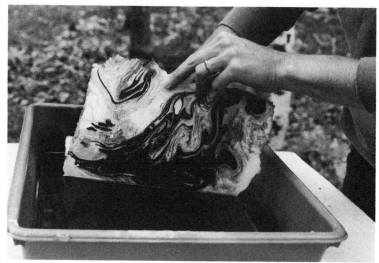

The ink pattern is absorbed immediately by the paper, and the paper is lifted from the waterbath.

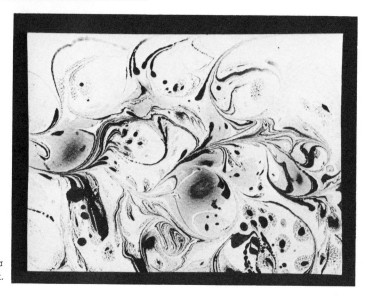

An example of an oil-resist print that yields a similar pattern to Sumi ink.

Christopher James: "Glass/Façade," handworked silver print, A/P 1980. "My work begins with a black and white print that is toned to different degrees with sepia and/or selenium. While wet, following the toning and wash, they are given additional color with silver—replacing mordant dyes, organic dyes, and watercolors. They are air dried, and more color is built up with wax, lead, and oil pencils. Selected areas are then painted with enamels and lacquers to add dimensional illusion and heightened color."

1. oil-resist printing,
2. encaustic,
3. veining, and
4. monoprinting.

Each of these techniques varies substantially, depending on the paper used, so we suggest trying a wide selection, from heavy watercolor papers to the lighter Oriental papers.

Oil-Resist Printing

The first of these processes, the oil and water print, produces very dramatic effects on paper. The oil and water print is a form of monoprint done with a minimum of equipment. It may be used under or around the photographic image to create unusual and mysterious areas of color or of black and white. You need an enamel or glass pan 2–3" deep and the width and length of your paper plus at least an inch on each side. You should

have small glass jars to store your colors, a brush, an old toothbrush, a comb, stirring sticks, oil color, rectified turpentine, newspapers to dry prints, rubber gloves to protect your hands, and water. Have all your materials close by and your paper to print spread out, so that you can easily reach one sheet at a time.

Once set up, this process is very fast. In a jar, mix 1 part oil color to 6 parts turpentine. This may be a single color or blend of colors. The consistency should be liquid but not thin. There must be a high concentration of pigment to make a good print. Also avoid lumps because they sink in the water. Fill the pan half full of water and pour some of the oil color mixture over the surface. You may move the pan, creating a wave effect to work the color across the surface, or you may swirl the brush or comb through it to further distribute the color. You may also dip the brush directly into the color and tap it against your other

hand to fling the color in small spatters across the surface of the water. A similar pattern can be made by using an old toothbrush filled with paint and running your thumb along the bristles to spray the paint onto the water. You may use any of these techniques until you have a desirable pattern on the water surface.

To print, hold your paper at both ends directly over the pan and lower it to just touch the surface of the water. If you submerge it, you get a different print on each side. Remove the paper and allow it to dry print side up on newspaper. If you have printed both sides, clip it to a clothesline to dry. Oil is slow drying and should be left for at least 24 hours before being considered dry. Some papers may need to be dried between printing blotters to prevent curling edges.

If you wish a traditional marbled paper, your tray should be filled with Haltex or sodium alginate (see Sources of Supply). The paint is applied in the same manner; the sheet, upon being lifted from the tray, is placed against a flat board raised at an angle and squeegeed to remove excess Haltex. Then it is rinsed in clear water and allowed to dry as above. Another material to try in a water bath is Japanese Sumi ink. It is dripped and swirled on the water surface to provide patterns of black and gray, which have a "photographic" quality.

Encaustic

Encaustic is the process of using hot or cold wax as a painting medium. The Egyptians used this technique to decorate their homes and even used it in creating objects and jewelry for their personal use. It is exciting to become aware of how this process makes a thoughtful transition from and a tie with the past. Encaustic provides a rich surface and great color luminosity. It also gives archival permanence to the objects and surfaces that it covers. The heightening of color and quality of permanence make this technique particularly interesting for adaptation by contemporary photographers.

For the hot wax process, you need the following equipment:

1. a small metal box hot palette that is heated by light bulbs and that has wells to hold each color (you may also use a hot plate with low heat control and a metal muffin tin);
2. dry pigments;
3. solvents, such as turpentine and Damar varnish medium;
4. white beeswax (sold in 3″ discs with a very high melting point);
5. oil painting brushes;
6. razor blades; and
7. foil.

Set the tin pan on the hot plate and break up half a disc of beeswax into four containers in the tin. As this melts, add ½ teaspoon powdered pigment and mix with a small stick to blend. Turpentine and Damar varnish may be kept in the remaining two containers. The varnish and turpentine are used to mix with the wax for thinner applications.

Dip the brush into the wax and quickly spread it onto a heavy paper surface. If thinned, it may be applied in numerous layers. Colors may be allowed to dry and others added on top. Areas that become too thick may be scraped down with a razor blade. Photographs and other papers may be added on top of the wax and a new coat applied to encase them. Hot wax tends to make paper more transparent in much the same manner as oil washes. Therefore you may wish to treat certain papers with this process with or without the addition of colored pigments. For treating entire sheets of paper with hot wax, you can place a metal 11″ × 13″ pan over the hot plate and melt a small amount of wax as a layer in the bottom. Papers may then be dipped on one or both sides and set on aluminum foil to dry. To collage sheets of heavily waxed papers, it is necessary to use acrylic mediums. Gel medium works well because it is highly transparent and viscous. It holds papers of varying thicknesses. After a collage is complete, lay it on a flat surface, cover it with aluminum foil, and place weights on top for several hours until the gel sets.

Cold wax is liquid, and it may be used as a medium with oils, acrylics, and drawing

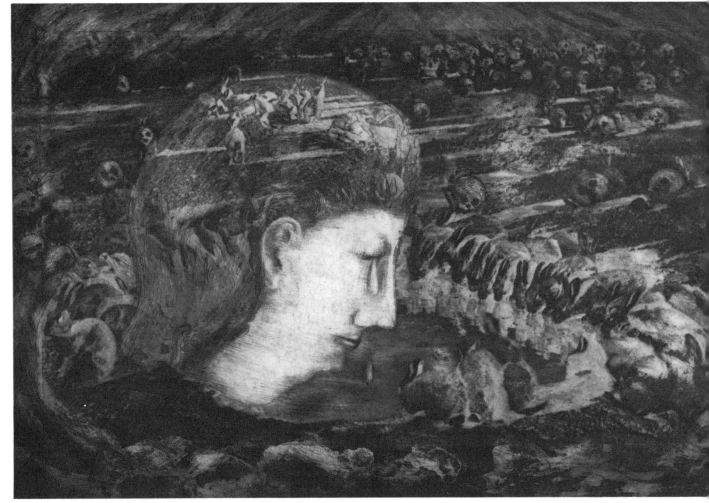

Vera Berdich: "The Pool of Tears," color intaglio, 1962. 12″ × 18½″. The artist combined a photo engraved image with other etching techniques, mainly aquatint, dry point, and mezzotint. The subject is based on the story of *Alice in Wonderland*. Courtesy of the Art Institute of Chicago.

inks. Dorland's and Bocour's wax emulsions, available in jars, can be mixed with color until the desired intensity is obtained. They may be applied with a brush or soft rag. Each coat should be allowed to dry before another is applied. This technique is good for use with heat-sensitive photo papers that would be damaged with hot wax techniques.

Veining

Veining works well with the encaustic process and with other papers. Papers that are crumpled and then flattened absorb inks, watercolors, and oil washes easily along the fold lines. In the case of waxed encaustic papers, the fold breaks the wax surface. This allows the color to be absorbed by the original paper. These papers make interesting additions to photo collages. Acrylic paints may be brushed onto sheets of printing paper (such as Rives BFK), allowed to dry, and crushed; then the same color veining technique is applied. These papers may be coated with emulsions and printed, forming a veined textured background for the photographic image. The ratio of artist's color to medium for veining should be 6 parts medium to 1 part oil, watercolor, or

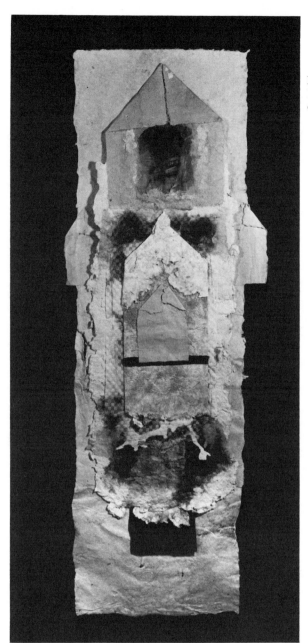

Marilyn Sward: "Wings from the Platform of Reality,"
handmade paper collage with cyanotype,
© 1982. 60″ × 20″.

Robert Rauschenberg: "From China #1," photogravure
on handmade paper, © 1983. 20¾″ × 26⅜″. Courtesy of Iris
Editions, Publishers. Photo credit: Zindman/Fremont.

Michael Brakke: "Make Exact Open Hander," photograph and acrylic on textured industrial brown paper, 1980. 65⅝" × 130⅛". Courtesy of Marianne Deson Gallery, Chicago.

acrylic paint. Powdered pigments, powdered charcoal, graphite, or powdered oil pastels may be rubbed over the crushed papers to create other veined papers. These papers should be fixed with nonworkable fixative, and they may then be coated with a thin layer of acrylic matte medium.

Monoprinting

The fourth system for giving papers texture and color for collage is to use any of the following simple monoprinting techniques. Monoprinting is by definition any one-of-a-kind print. It may be done by using a glass palette. The color used may be gouache (opaque watercolor), watercolor, or acrylic. The color is mixed with water into a thin wash and spread out onto the glass; thicker images and patterns may also be drawn on the glass. The color may be rubbed, blended, drawn into—whatever is suitable for the image or collage you plan.

The paper is then placed face down on the glass and rubbed on the back side with your hand, with the flat edge of a wooden spoon, or with a printing braier. Each of these produces a slightly different effect. Additional color and texture may be obtained by sprinkling dry pigments onto the slightly dampened glass and then printing the paper. Second and third printings from the glass also vary the effects. Shapes and textures may be saturated with water-based paints or inks and printed in this manner. Found objects may be glued to cardboard or bristol board and used for monoprints. You may wish to try such things as sandpaper, cheesecloth, screening material, woven fabrics, ropes, and strings. Multiple techniques may be used if the paper is dried between printings.

We hope through words and examples we have touched your most experimental core with this chapter, and that you will enjoy a sense of discovery in combining these techniques with the photographic image.

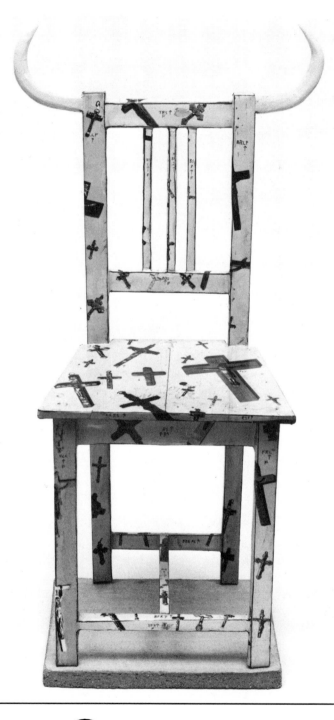

7

Contemporary
Photographic Forms

Opposite page: Margaret Wharton: "Sacred Bull," 1981. 19″ × 9¾″ × 6¼″. Collection of Allen and Sherry Koppel, Chicago. Photo credit: William Bengston.

Patterns of wholeness have been created throughout the ages in all parts of the world, in crafts, arts, and architecture, giving tangible form to the intangible order that unites the diversities of this world. György Doczi[1]

Explorations in photography have led artists to alter the form as well as the surface of the photographic image. Contemporary photographic forms frequently incorporate materials and methods that are not photographic, and thus some artists are confronted with the question, Is it a photograph? Knowing the vehicle for the imagery, is, of course, important, but the true focus is on the whole—on the integrity of the piece as a work of art. Therein lies its real definition. Process terms cannot define an image as a work of art.

CONTEMPORARY PHOTOGRAPHIC FORMS

We present here an overview of the work of a variety of contemporary artists working with photographic forms. Frequently such work requires a significant amount of time, care, and attention to detail before or after the initial photographs are printed. The length of time involved can encourage carelessness. This seems an appropriate place to call to mind historian Barbara Tuchman's comments on the importance of quality: "Quality, as I understand it, means investment of the best skill and effort possible to produce the finest . . . result possible. Its presence or absence in some degree characterizes every man-made object. . . . You do it well or you do it half well."[2] The same care and attention at the end, as well as at the beginning, of the work serve both art and artist well.

Montage, Collage, and Layering

Montage, collage, and layering may involve negatives or prints, all sorts of papers and found objects, and a variety of processes. With so few limits, it is especially important to keep in mind photographer Barbara Crane's words: "The process is only a tool for strengthening an image. Going beyond the material is what it is all about. The image must lead you at all times." In other words, there is a real danger in being seduced by process and thereby becoming careless about the integrity of the image. You need to be able to articulate, at least to yourself, why you are using the process and how it alters and strengthens and completes the image. Barbara Morgan's photomontage, "Nuclear Fossilization #1, 1979," is about the horror of nuclear destruction (one of Morgan's major concerns). It is an excellent example of combining image and process to produce a powerful visual metaphor.

Procedures for doing a montage or collage include sandwiching negatives, printing one image on top of another, multiple in-camera exposures, and combining photographic prints with one another and/or with other materials. The prints may be layered in a variety of ways, and they may incorporate any or all of the fine arts mediums mentioned in the preceding chapter. The binders in collage are important: wheat paste (see Chapter 9), Yes glue, or an acrylic medium work well (described in Chapter 6). Some artists find it preferable or necessary to rephotograph their compositions, while others feel that a certain energy is removed by rephotographing.

Misha Gordin combines different methods of multiple negative printing to assemble his photographic collages. He works conceptually, first sketching out an idea, then finding the location and models and making the props, and finally taking the photographs. The Russian artist says of his work, "I strongly believe in the unique power of the photograph as something being subconsciously

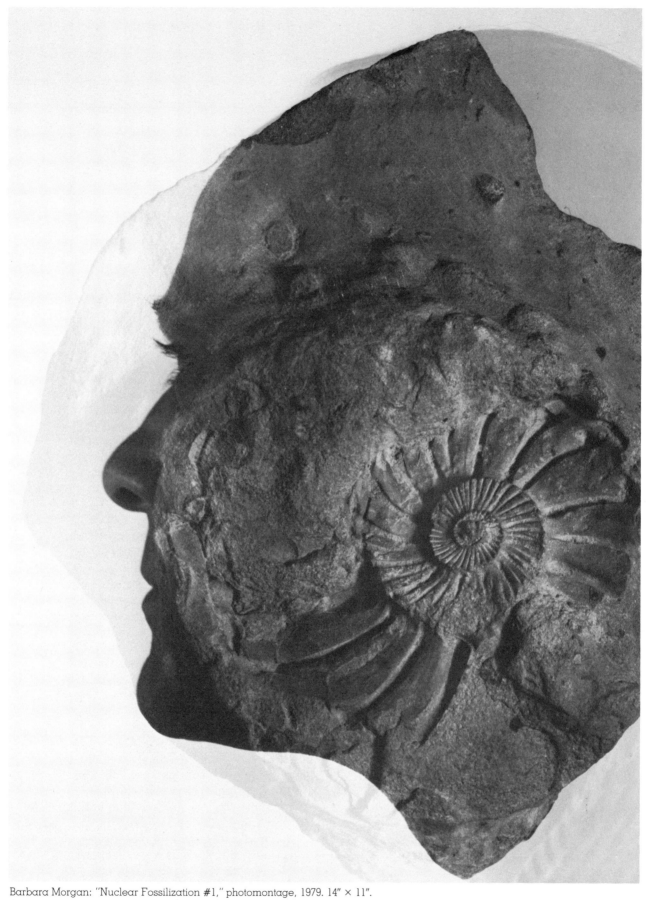

Barbara Morgan: "Nuclear Fossilization #1," photomontage, 1979. 14″ × 11″.

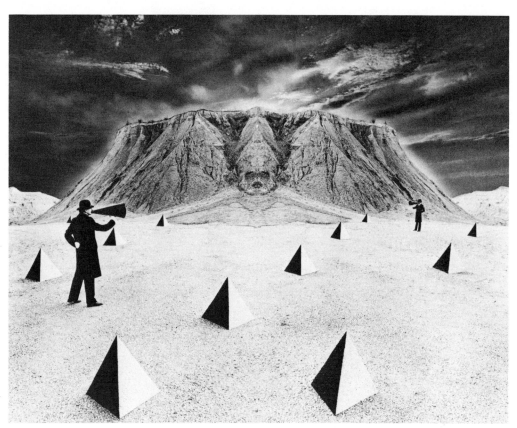

Misha Gordin: "Cul de Sac,"
photo collage, 1979.
16" × 20".

perceived as reality which had to exist. There-
fore, I work only with objects that lend the
maximum credibility to this existence. They
are the realization of my thoughts that I can-
not express otherwise."

For artist Mary Ahrendt, the re-
photographic process is an essential step to-
ward a final statement about her self-portraits.
Ahrendt immerses herself in a liquid dye
solution and then takes self-portraits with Po-
laroid SX-70 film. The Polaroids are copied
and enlarged to 24"–36" photographs (a lab
does this), mounted on low-density plastic or
acrylic sheeting, and abutted vertically, be-
tween three and six images to a piece.
Ahrendt then coats parts of her body with
powdered pigments and this time presses her
body against the enlarged photographs, leav-
ing a deposit of pigment on the color prints.
These final images are three to four times life
size.

Images can be combined in many ways.
Two are illustrated by Joyce Neimanas. "Un-
titled" shows the combination of two prints
that are cut and stapled, with the staples
protruding forward. She describes the second
image (see pg. 57) as a "constructed photo-
graph formed by collaging numerous SX-70
photographs to produce a 32"×40" picture of
'common' domestic scenes. Each SX-70 repre-

sents a rather 'realistic' view of an object, but
the collaged whole suggests a fracturing of
space not unlike looking through a kaleido-
scope at a broken mirror."

The Photograph as Mural

The photograph as mural again offers an
almost unlimited array of subject, form, and
presentation. A mural can be as simple as
one image blown up very large and mounted
on masonite or used as wallpaper. It can be
several prints juxtaposed, combined, or abut-
ted. Or it can be as complicated as Barbara
Crane's black-and-white "Chicago Epic"
mural, which is a film collage involving 78
negatives *in toto*, 38 used in the basic struc-
ture. She estimates that she used 500 sheets of
4"×5" film and many rolls of 35mm film to
reach the final image.

Concentrated attention to consistent tech-
nique, composition, and the relationship of
the parts to one another, as well as to the
whole, is particularly important when working
with multiple images. Crane worked with
"controlled chaos" as a basic visual concept,
depicting surprising juxtapositions along a
horizontal axis from one end of the mural to
the other. Her criteria were form, specific
content, the quality of light, and an aware-

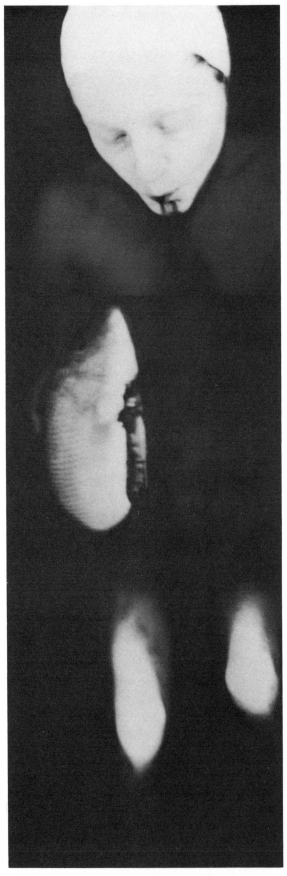

Mary Ahrendt: "Fire from a motel window," 1981.
2½' × 7½'. Courtesy of Marianne Deson Gallery, Chicago.

ness that "every time you change the basic
structure you put the mural out of balance."
Crane also cut out and layered film, gauze,
hair, and printed matter for parts of the mural,
and drew into the emulsion side of some
negatives with a pin. To maintain similar
tonality, she kept a clear blue sky as an
exposure control and consistently used the
same film at an identical ASA, with all film
processed alike.

When she finally had the collaged nega-
tive images arranged as she wanted, she
taped them to a ¼" thick sheet of glass, using
clear tape and film splicing tape. A sheet of 6'
long photo paper was laid on foam rubber
carpet padding, the glass containing the
negatives was placed on top of that, and
weights were put around the edges of the
glass to keep the negatives flat against the
paper. A ceiling light was used for the ex-
posure. The print was processed by being
rolled and unrolled, as in a scroll, in large
trays, using a weak developer with extended
development time to keep the development as
even as possible. The finished print was then
sent to a mural company, where it was copied
on 11"×14" negatives and printed in six sec-
tions. Next the prints, while wet, were wrap-
mounted on tempered masonite and coated
with plastic for protection. (The mural hangs
in the interior of the Chicago Bank of Com-
merce, Standard Oil Building.) The finished
mural is 4'×24' long. Such a complicated
process in the hands of an experienced artist
like Crane is actually visual choreography.

Whenever you are working in an area
where you need or want the finished product
to conform to a predetermined size or space,
such as photo murals and screens, you save
considerable time by using a proportion
wheel, available at any art supply store.

Often artists take a concept and develop a
technique designed to execute the idea. Art-
ists Philip Lange and Keith Smith collaborate
in making their photo screens. Both are con-
cerned with extending the concept of the
book, seeing it as both furniture and environ-
ment. Thus their photo screens are really
based on the small Japanese fold books. The

150

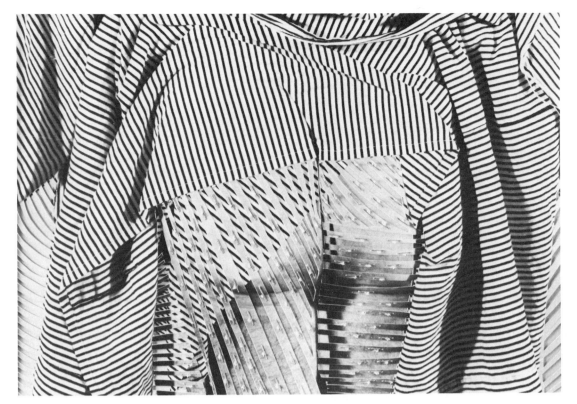

Joyce Neimanas: Untitled, photographic collage, 1981. 16″ × 20″. Collage, silver gelatin print. From the collection of Mr. and Mrs. Strauss, Denver, Colorado.

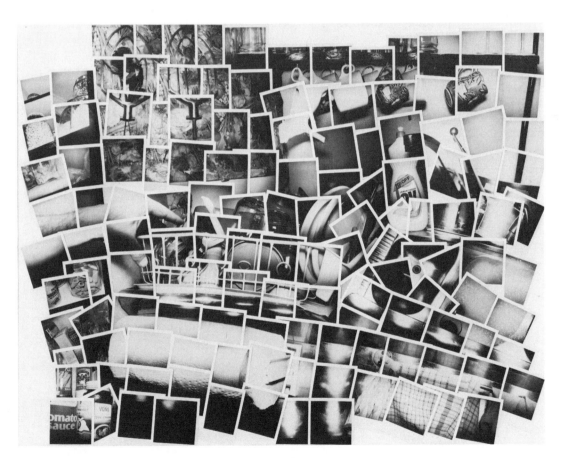

Joyce Neimanas: Untitled, SX-70 collage, © 1980. 32″ × 40″.

photo screens are printed on photo mural paper, and they are often altered by various processes, including drawing, applied color, painting, collage, and sewing. The rhythm, mood, and energy of the work dictate the processes they add, if any. The images are then mounted in panels in wooden frames, sandwiched between the wood backing and the glass. The panels are hinged, so that the screen stands in angles, reminiscent both of Japanese screens and of the small Japanese books from which they originate.

Photography and Fabric

It is interesting to look at the original and even improbable ways in which photographic artists have extended the boundaries of the medium.

Elaine O'Neil has used a variety of processes to produce photographic images on fabric, including mailable stuffed postcards and bed-sized quilts. The postcards start with 35mm black-and-white negatives. She then makes a 4"×5" internegative and prints it on cotton, using the cyanotype or Van Dyke brown process. The image is manipulated by painting, embroidering, applique, and any other surface-altering technique she finds appropriate. The final image contains batting, as do her quilts. Of the latter O'Neil says:

With the quilts I have used every size and type of negative I have; the color Xerox segments are from 35mm slides; in some cases I used a cardboard stencil. The image is first printed onto the cotton. Next I cut out the individual pieces and assemble them. The assembly process is usually in segments first, then the segments are arranged (I might at this point make more segments to improve the overall design), and then the sections are united. With the quilts, as with all the work I do, the piece as it evolves determines its final form.

Barbara Lazarus Metz combines a photogram technique with the cyanotype process and layers of diaphanous materials to create photo hangings up to 20' high. The hangings have an ethereal quality, in part due to the combination of flowing swirls of silk, the choice of imagery (the female body), and the soft tones of the cyanotype. Each piece is composed of two or three layers of material, hung one behind another. These are often in motion because of the slow currents of air in the exhibition space. The effect of several of these multilayered pieces hung in one space is fluid and lyrical. Metz's particular concerns with the hangings involve soft focus, shifting planes, beautiful colors, the idea of transparency, and the concept of layering itself—of images, of ideas, and of emotions. Metz believes that working within the confines of

Barbara Crane: "Chicago Epic," photographic mural, © 1976. 4′ × 24′.

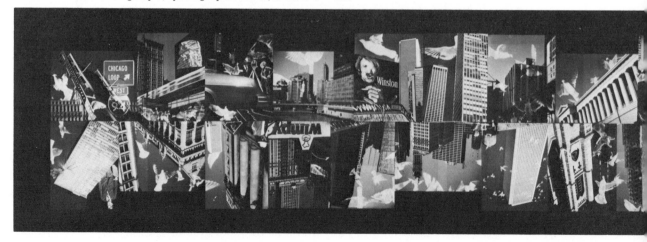

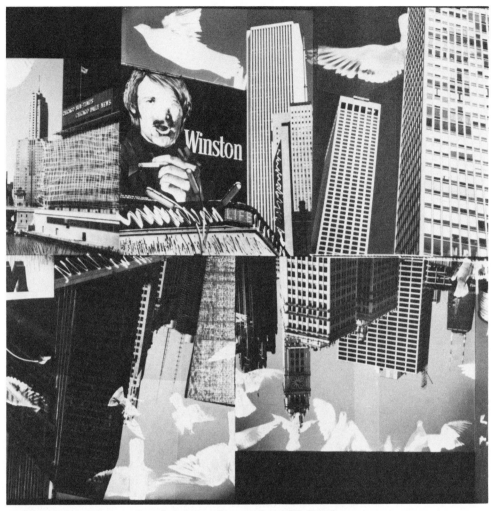

Barbara Crane: "Chicago Epic," photographic mural, © 1976. Detail.

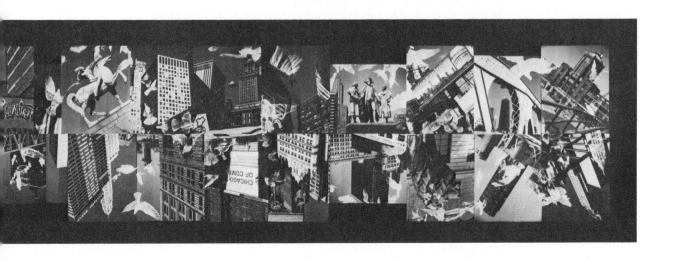

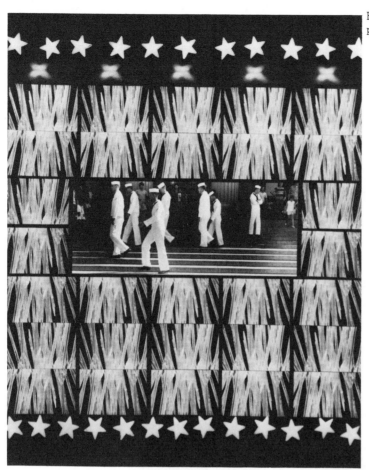

Barbara Crane: "Bicentennial Polka,"
photographic mural, © 1975. 8′ × 8′.

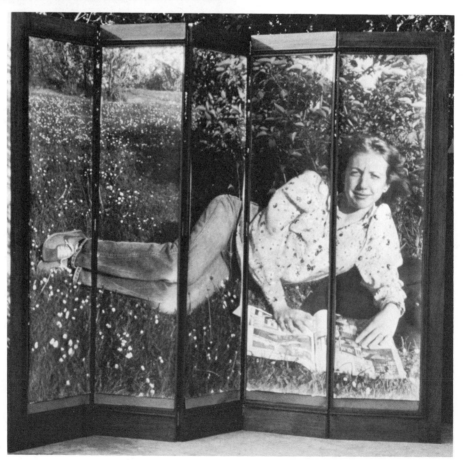

Philip Lange and Keith
Smith: "Untitled," photo
screen, © 1981. 8½′ × 10¾′.
Photo mural paper,
oil painted.

Elaine O'Neil: "Snake Dreams Quilt,"
cyanotype quilt, 1981. 65″ × 95″.

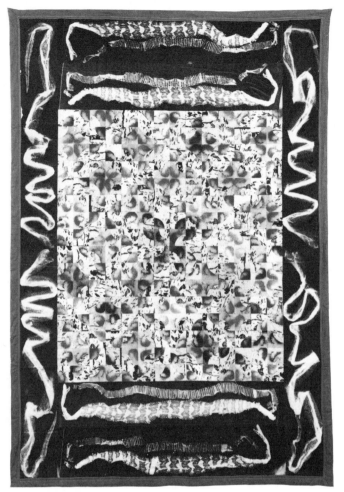

Elaine O'Neil: "Snake Dreams Quilt," detail.

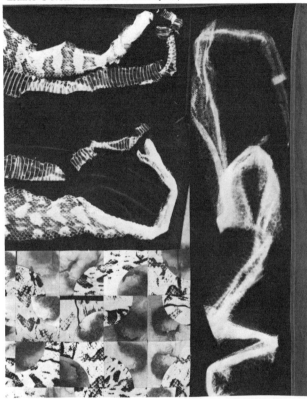

Elaine O'Neil: "St. Louis Arch,"
mailable stuffed postcard,
1979. 3″ × 5″.

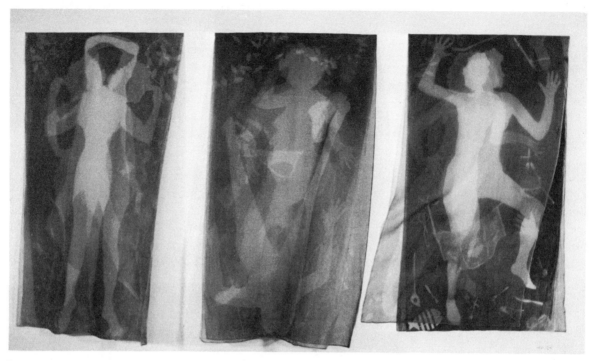

Barbara Lazarus Metz: 'A,' 'B,' 'C,' cyanotype on three layers of silk organza and Swiss cotton organdy, © 1980. Each 3' × 6'.

chemicals and defined procedures still leaves room for spontaneity. "I use machine-processed images and Kodalith films as well as actual objects to create the shapes. Mixing various photographic processes provides a wide range of possibilities for my continuous stimulation and exploration."

To make the hangings, Metz coats sheer silk fabric with a cyanotype solution, using a large, soft, Japanese paste brush. (*Caution:* Read the chapter on safety hazards before working with any cyanotype process.) The shapes she then prints on the fabric are real bodies or life-size drawn and cutout figures plus Kodalith films, Therma-Fax transparencies, and various objects. Before printing, she lays out any preceding, completed images to see how they will relate to the new one, making alterations as needed. She then contact prints the image, which takes 6–10 minutes in sunlight and 45 minutes or longer under 500-watt photoflood bulbs. The image is then developed in running water for 15 minutes. To alter the color, it is bleached with

Clorox or ammonia solutions, washed, and redeveloped in tannic, gallic, and/or pyrogallic acid solutions. (See Chapter 4 for detailed descriptions of these solutions and colors.) Metz finishes the images by attaching the layers at the top with heat-activated polyweb, and then cutting and hemming the bottom edges of each layer to the same length. The free-hanging pieces are then sewn onto metal rods; Velcro is attached to the wall pieces for hanging.

Photography and Three-Dimensional Materials

Many of the artists represented in this book work in several disciplines, and this multidisciplinary approach offers almost unlimited opportunities for creativity. Again, we believe that whether an image is defined precisely as a photograph, separate from any other art, is irrelevant. The overriding concern is the content and communication of the final piece. Because photographers have the added prob-

lem of working in a medium that is a tool for recording "straight" reality, we have often felt outside the mainstream of "art" even when employing our medium in an artistic way. In meeting, interviewing, and reviewing the artists whose work appears on these pages, we discovered that many of them had studied and worked in other disciplines—painting and drawing, watercolor, printmaking, sculpture—and that these artists had greater ease and more freedom in working with alternative processes. It would be helpful if photographers were encouraged to learn other techniques (drawing and perspective, painting and printmaking, even sculpture), and if other artists were taught the capabilities of photography for expressing artistic vision.

Margaret Wharton has gained considerable renown for her anthropomorphic chairs, sculptures derived from ordinary chairs that she takes apart and reconstructs. This method of reconstruction emphasizes the chairs as the medium for her communication rather than the object of it. The chairs were always chairs, but Wharton sees them in metamorphosis. She uses any material (paint, wire, feathers, glass, glitter, wood dowels, and so forth), as long as it helps her form and complete her message; several of the chairs are made from photographs. Hers is an unusual and adventurous use of photography.

Wharton's concern is to keep the original chair as the vehicle for meaning in her work, so she begins with it. When she is reconstructing a chair with photographs, she first re-

moves the outer surface of all parts of the chair, using a saw. She lays these surfaces out in order on a flat plane, then puts articles on the chair parts for variation. She then photographs the entire surface in color and has the photograph enlarged to whatever size she wants. Next she cuts out the separate parts of the photograph and assembles them into a chair structure, folding and gluing them around wood inserts that she has made for the inner structure. Her execution of this work is meticulous, and it is through both this care and her original concept that her chairs have a life and spirit of their own.

Clay was originally the prime concern of artist Martha Holt, and photography was only a documentary tool. Gradually, she began to see a possibility of relating the two, and now she constructs objects that combine clay and photograms and that she refers to as three-dimensional paintings. Holt works to synthesize aesthetic and intellectual responses through emphasizing the object as form and how an altered environment affects the form. She uses photograms and clay as the basic mediums to record the original impressions of the objects. "The process of building these pieces begins with paper on which I've written, drawn lines, and so forth," she says. "The paper is torn up and collaged down onto a plywood panel. Hand-colored photograms are glued onto the paper and the entire surface is coated with a clear polymer resin. Clay objects are then glued onto the resin surface and a black aluminum frame is glued around the

Barbara Lazarus Metz: "Continuum," cyanotype on silk organza and china silk, © 1980. 18″ × 9′.

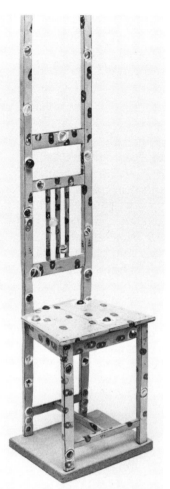

Margaret Wharton: "Saturn," photo chair, 1980. 28" × 7½" × 6". Collection of the artist, Chicago. Photo credit: William Bengtson. Courtesy of Phyllis Kind Gallery, Chicago and New York.

Margaret Wharton: "Saturn." Detail. Photo credit; William Bengtson.

Martha Holt: "Spellbound," clay, photo, paper construction, 49" × 61". Photo credit: Mark Perrott. Courtesy of the Theo Portnoy Gallery, New York.

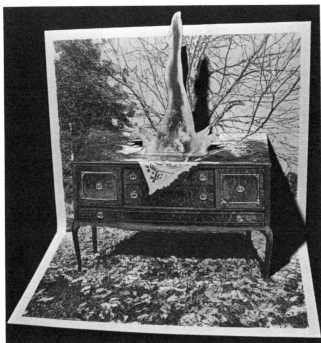

François Deschamps: "Leg," folded Van Dyke brown print with watercolor, 1977. 11" × 14".

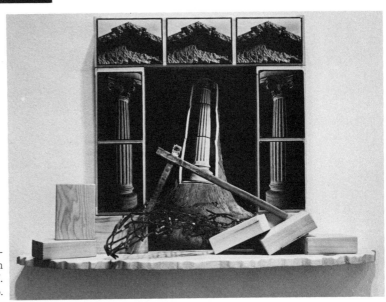

Adam Siegel: "Temple One," black and white photograph mounted on rag board, then gator board, then attached to a wooden frame, © 1981. 6' × 8' × 3". Courtesy of Frumkin and Struve Gallery, Chicago.

Laslo Vespremi: "Photo Installation," wood and photo paper, 1981. 8' × 34' × 7'. From the installation at N.A.M.E. Gallery, Chicago.

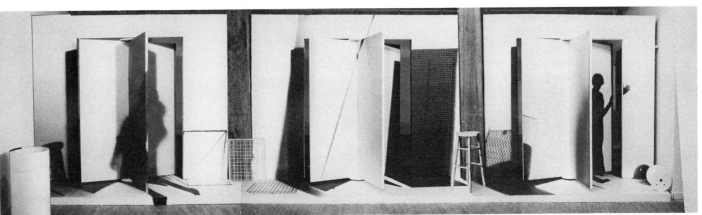

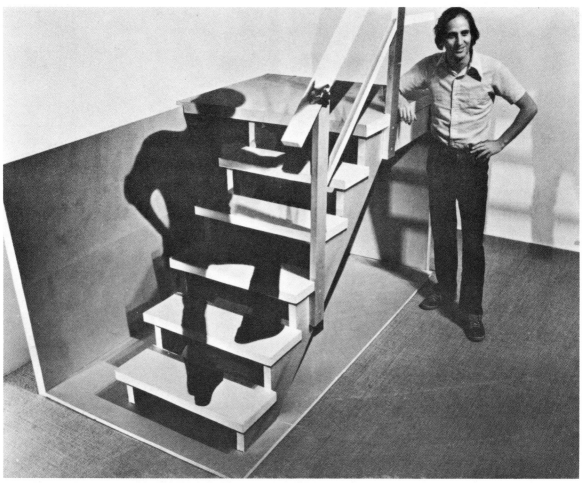

Laslo Vespremi: "Staircase," wood and photo paper, 1977. 6' × 8' × 4'. Courtesy of Carl Sollway Gallery, Cincinnati, Ohio.

edges." Holt works in pairs of images, repeating very similar objects in the second image, but in a different arrangement.

François Deschamps constructs "folding photographs," similar to the pictures in a children's pop-out book. He selects an image, coats Arches paper with Van Dyke brown emulsion, and prints the image onto it. He then watercolors the image. The image is cut and folded in such a way that it folds flat like a thin book when closed and becomes three-dimensional in selected areas when opened.

Concepts in Time and Space

Hungarian-born Laslo Vespremi has developed a method of photo construction that he refers to as "photo environments." Taking his

inspiration from the Bauhaus, Vespremi experiments with photograms, not only putting an object on photo paper, but also wrapping the object in it. He uses a positive printing photo paper manufactured by Kodak, and the results are sculptural photograms. The concept has evolved so that now he covers chairs, staircases, and even entire rooms with the photo paper. He uses existing props and also constructs them (wood panels with wooden revolving doors, for example). Because the positive printing paper comes in rolls 24"×100', the work can be as large as Vespremi wants. To make the actual installation, Vespremi covers everything in the room (the walls, the objects in the room) with the photo paper. He then exposes the room to a strong light, sometimes putting people (including

160

Gillian Brown: "Furniture Installation,"
1980. 5½' × 6' × 6'.

Gillian Brown: "Furniture Installation." Detail.

Gillian Brown: "Untitled Installation,"
1980. Colorful wallpaper and furniture. 6′ × 8′ × 6′.

Gillian Brown: "Untitled Installation."
Detail.

Gillian Brown:
"Untitled Installation."
Detail.

Gillian Brown: "Furniture Installation." Detail.

Gillian Brown: "Furniture Installation," 1980. 5½′ × 6′ × 6′.

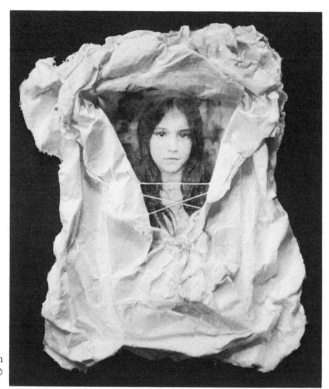

Catharine Reeve: "Sura I," silver nitrate emulsion on sculpted handmade paper with string and acrylic, © 1983. 20″ × 16½″ × 3″.

Charles Arnold, Jr.: "Shell Serrate," haloid Xerograph, 1970.

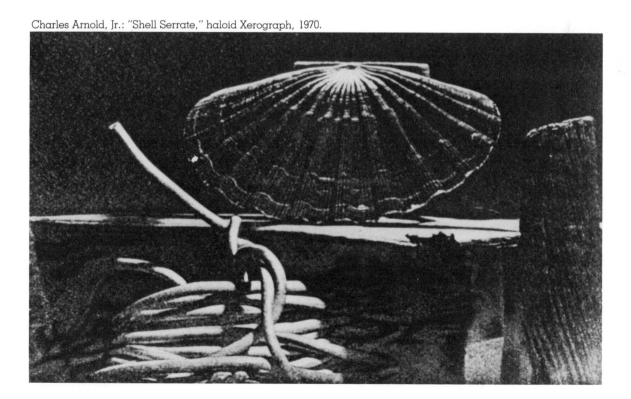

himself) in the room. The exposures can be as long as 45 minutes or much shorter, so ghost-like blurred shadows appear along with well-defined shadows, depending on whether the people move during the exposure. The paper is developed in a plastic wading pool and then replaced in the room.

Vespremi's idea came from a Hiroshima photograph that showed a shadow of a man on the wall. The shadow was made by the blast of the atomic bomb. Says Vespremi, "It was not a shadow of a person anymore, but a record of an event." Using this idea, inspiration from Moholy-Nagy and György Kepes, Vespremi's photo environments become three-dimensional walk-in photographs "where time seems to stand still and shadows of persons or objects, present or absent, still cast shadows in a permanent way. From my best pieces I can derive the satisfaction of finding a magical way to freeze the even flow of time within this very special area."

Concept and the possibility of extending our perspective of dimensions in time and space underlie Gillian Brown's photographic installations. Brown states of her color installation "Birthday Party":

> The part of the scene which seemed to most suggest a snapshot was painted in tones of gray. When viewed from the correct angle, this gray portion corresponded exactly to a black and white Polaroid print which was lying on the table; it is the three-dimensional counterpart of the snapshot and phenomenologically is meant to lie between the actual and the photographed.

In the untitled installation of the chair and wallpaper, Brown reverses the idea of two- and three-dimensional space:

> In this installation the photographic objects have been printed so that they become out of focus as they recede in space from the foreground, which is in focus. The property of being out-of-focus is in a sense actualized in the three-dimensional objects (one must focus on unfocused objects), and two-dimensional photographic space (with a narrow depth of field) is actualized in three dimensions.

A willingness to extend the form and meaning of the photograph—a receptivity to change—characterize the artists who are working with innovative contemporary photographic forms. As Judith O'Dell, Executive Director of the Alden B. Dow Creativity Center at Northwood Institute, says, "There is an element of risk in every creative moment, a time when one must take the responsibility of crossing the threshold to success or failure. If we refuse this risk, no progress can be made."[3] The artists who venture beyond the traditional boundaries in a search for untried means of conveying content are risk-takers. They must have the personal integrity to acknowledge failure as well as success, aware that their dedication and effort may yield no visible results. All experimental artists are aware of this risk; it is the possibility of discovering unexpected connections and new understandings that propels them forward.

All we need do is never set up limits to our fulfillment, never to stop in fear of the receding tide; for spirit is that which moves from crest to crest, even though it fills the deepest abysses. In spirit, heights and depths are one. Dane Rudhyar[4]

8
Photography of the Future

Sonia Landy Sheridan: "Drawing in Time," one of a large series, EASEL4 software by John Dunn, computer graphics, Chromemco Z2-D, on disc, size indeterminate, © 1982, color.

> *. . . creating a new theory is . . . rather like climbing a mountain, gaining new and wider views, discovering unexpected connections between our starting point and its rich environment. But the point from which we started still exists and can be seen, although it appears smaller and forms a tiny part of our broad view gained by a mastery of the obstacles on our adventurous way up.* Albert Einstein[1]

Maybe the artist of tomorrow will be the true representative of the synthesis of art and science that we have seen begun in this decade. The artists whose work we felt would be stepping stones into the future are exploring technology or science in one aspect or another. They are learning to combine the tools of technology with the capacity for image-making toward a greater whole and a more complete meaning. Often, art is about evolution, its aim being to reflect our present state and help us to understand it. Technology in the hands of a creative individual offers the possibility for expanded awareness through a dimension we've never had available to us before.

Instead of assuming an adversarial position, the artists in this chapter relate in a dialogic manner to technology. They are learning how to use the new systems that continue to emerge and to enlarge these systems in whatever way they need to communicate meaning. Some of them are actually inventing new technology.[2]

XEROX AND OFFICE MACHINES

Photography is a natural meeting ground for science and art, because it is the art form most dependent on a scientific system through which to express an artistic vision. Recent technology has offered a wide range of new instruments that produce pictures of one kind or another. Most of these instruments were intended for office and business uses, but far-sighted artists saw their potential in an imaging mode. The instant print offered by office copiers and machines ultimately removes the focus from the immediate object as art (because anyone can push the button and get a print) to a broader understanding of the processes and purposes of art. The capability to pursue a visual concept to its resolution through generating successive images in a short span of time enhances this understanding.

Many artists are exploring this aspect of copy machines. Some of their imagery appears in previous chapters. Carl Toth illustrates the use of machines as image as well as process. Toth's color Xerox collages are made by cutting and mounting copies of objects he has placed on a Xerox machine. He is particularly concerned with the illusion of spatial deception, with the relationship of traditional cameras to the copy machine, and with the inherent qualities of the copy process.

Canadian photographer Evergon shares the following information for those who want to work with the Color Xerox 6500 machine:

> For all intents and purposes this machine is a camera.
>
> *Paper* Xerox paper is high in acid content. It can be replaced in the machine with a 70 or 80 pound text of better quality. I use Mohawk Super Fine in white and off white most of the time. This is purchasable from the Ailing & Cory Company in the N.E. United States. You can have it cut down to legal size stationary (8½" × 14").
>
> *Colors* The colors are thermoplastic powders that are melted onto the paper.

Color Control The initial color breakdowns are magenta, amber, and cyan. On the dials that control the amount of color of each, 3.5 is considered normal. I always start my first print there and then make changes in the different amounts to suit what I want in the image.

Contrast Control No Contrast on the machine is actually high contrast. The rest of the dial will regulate the amount of contrast from light to dark with a screen pattern.

Archival The National Archives of Canada has tested the color permanence for up to 100 years and has found no noticable change. On good paper, you have an archival print.

Surface Prints should not be stored in plastic or acetate sheets as they will adhere to the plastic surface. Also, prints should not be stored in or near extreme heat.

"Business" One of the real advantages of these prints is that they are made for the business world. They fit in shipping and business envelopes, attaché and briefcases, filing folders and filing cabinets. Because of the 8½″×14″ format everything is stabilized.

Multiples Just set the dial for the number you want; once the image is worked out, making the edition is easy.

Slides Color slides can be projected onto the machine. These can be worked with flat collage imagery as long as they are placed under the special glass for slide projections.

Degenerations Each copy of a previous copy becomes more graphic or high contrast and less photographic until it breaks down completely as a recognizable image.

Silicon Transfer Sheets If you wish to work on large format, images can be printed on a Silicon Transfer Sheet and then ironed (350°) onto drawing paper or fabric. This image is reversed. Some companies make a reversal S.T.S. to be printed on first and then ironed onto the standard S.T.S.

If you're working with a still life on the platen (glass), you may want to cover the surface from behind with a white plastic or fabric. This will flood light back into the machine and lighten the background. The same goes for portraits. The further you are from the platen, the darker the print due to lack of light. There is only a ¼″ to ½″ focal range above the platen surface.

If you have questions, write:

Evergon
P.O. Box 34, Stn. A
Ottawa, Ontario
Canada K1N 8V1

GENERATIVE SYSTEMS

Sonia Sheridan

Sonia Sheridan is one of the foremost artists working hand-in-hand with industry to expand the province of the artist. It was she who coined the term "Generative Systems" and who founded the first Generative Systems Department (at the School of the Art Institute of Chicago). Sheridan founded Generative Systems to provide artists with an area appropriate to the modern media-communications era. She felt that the implications for art of high-speed information systems and the energies employed in these systems were enormous—but largely ignored by artists. In energy use, for example, artists emphasized chemicals and light, while magnetics, heat, electrostatics, and sound were almost totally unused.

"I created courses called "Process" in order to explore manually, mechanically, and electronically the meaning and implications of tapping various energies," Sheridan explains.

At the manual end of the spectrum students worked with hands and mind, while at the electronic end of the scale they dealt with total

Carl Toth: "Untitled," color Xerox collage, 1981. 17" × 26". By manipulating the machine, varied effects were created, such as fading, cast shadows, texturing, color manipulation, and a limited sense of depth in the objects themselves.

communications systems: still-imaging systems (often copiers), video, transmission facsimiles, and computers. I encouraged them to assemble, invent, and create their own systems or fields of inquiry. Now, years later, it is my students who are providing me with exciting new systems: John Dunn, with his elegant EASEL computer graphics systems; Greg Gundlach, with a revolutionary 3D photographic system. To the "Process" course I later added Homography, a search for meaning through the study of the dimensions of time. This course was the closest to my heart, and was perhaps most intimately linked to my own work.

From my first teaching day in 1951, I have interwoven my own work with my school lessons. My private work therefore has included hand experiments with various energy sources, extensive machine experimentation, alternating tactile systems, and mass education projects. At the same time, throughout the years I have continued the drawings and watercolors in which, I find, nascent ideas are

adumbrated in a unique way. Time has been a primary theme in such work, and, of course, time relates directly and easily to the latest information processing and media equipment.

I also began working with scientists very early in my career. My relationship with scientists bloomed fully in 1969, when I met Dr. Douglas Dybvig, one of the inventors of the 3M Color-in-Color System. This relationship is still going strong today, and enriches my own work and the possibilities for teaching and sharing information that are essential components of the discovery process. This art-science interaction also provides a way to strengthen and extend the networking of unique individuals. I have long felt that such networking constitutes a rich basis for creative work. Thus I have engaged in and encouraged interactive projects, publications, mail exchanges, and the like."

Sheridan very much exemplifies the dialogic character mentioned at the beginning of this chapter. She is extremely sensitive to the tensions between art and science, hand

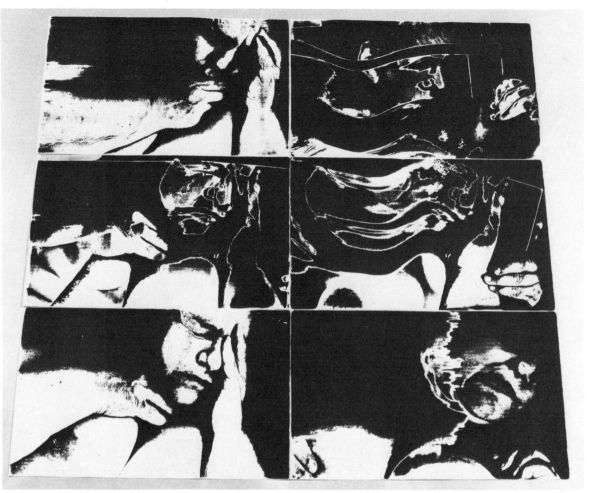

Sonia Landy Sheridan: "Sonia through Sonia in Time," selections from series, 3M VQC with Color-In-Color powder, © 1974. Each 11" × 8½". Photo credit: Michael Goss.

and machine, subjective and objective, inner image and outer world. She says that these tensions are not ominous, but healthy and natural challenges. They call for resolution by creating new syntheses (and new and different tensions) that will bring artists and nonartists alike a better understanding of the world and our places in it. "The voyage to discovery is not necessarily linear," she explains, "but, rather, a convoluted trip in time and space. Each such trip is a search, a voyage into another dimension, a Yin-Yang journey from past to present, from private to public."

Generative Systems Workshops

Sonia Sheridan's belief in the potential of modern information systems as vehicles for artistic discovery and personal evaluation is echoed by other artists/teachers. Peter Thompson, who directs the Generative Sys-

tems Workshop at Columbia College in Chicago, notes that it does not function apart from the concerns of people.

He states that modern information systems may seduce the user into exploring the methodology of machines rather than exploring issues of deeper meaning. "What is central to our concept of Generative Systems is not the simple use of the information systems which the Workshop has in abundance, but, rather, something more fundamentally human: the premise that each person has a story to tell, and that the action of telling increases both self and community awareness. Rapid-feedback information systems greatly increase the kinds of action a person may take, and also the amount of feedback with which a person must deal. It is precisely at this point that we experience the twin dangers of mistaking the 'actions' of the machines for our own, and of limiting our actions to a prolific but sterile

Sonia Landy Sheridan: Assembled pages from the catalogue "Energized Artscience: Sonia Landy Sheridan," the Chicago Museum of Science and Industry, © 1978. 11" × 8½". Photo credit: Michael Goss.

Sonia Landy Sheridan: Three pages separated from "Assembled Pages" from the catalogue "Energized Artscience: Sonia Landy Sheridan," the Chicago Museum of Science and Industry, © 1978. 11" × 8½". Photo credit: Michael Goss.

Sonia Landy Sheridan: "Stretching and Compressing in Time," 3M VRC remote copier, © 1976.
60" × 10". Photo credit: Michael Goss.

exploration of the methodology of information systems. It is important that we take on the decidedly unglamorous and difficult responsibility of bringing our actual concerns into relationship with this increased feedback. And that is done away from the machines; that is done by reflecting on the meaning of what has been created, and on the meaning of what it was we wanted to tell. The spector of the media junkie—addicted to the machines and detached from what it was he wished to say—can become an embodied reality in any of us who deal with rapid-feedback information systems. When that happens, the machines have closed down artistic possibilities rather than enhanced them."

Mary Dougherty, co-director of the Artists-in-Apprenticeship Program at Columbia College, suggests that working and thinking with rapid-feedback systems can contribute to the formation of a context that nourishes both individual and collective creative processes. "These tools permit expression without a long apprenticeship to technique. In giving form to their personal images and through the naming of their experience, users gain self-confidence in their creative abilities. At the same time, the ease of technical mastery forces users to go beyond 'how' an image is made in order to face 'what' the image means and 'why' they made it. It is my belief that the real possibilities of rapid-feedback imaging systems as art-making tools are realized when they encourage us to engage in the making process with the awareness that through this

process we are creating aspects of ourselves and our world. This is not a glib call for the democratization of the arts which does not recognize levels of pursuit, but rather, a recognition that regardless of the level, engagement in the creative process relates purpose and meaning to life."

Other Computer-Generated Imagery and Imaging Systems

Tom Porett works with the computer as an imaging tool, creating singular images, performance works that combine the computer-generated images with electronic music, and installation works that operate continuously in a gallery or museum environment. He begins with photographic and hand-drawn imagery and views the computer as one electronic translator of that imagery. Porett believes that the basic understanding essential to working effectively with a computer revolves around the concept of the word "virtuality." "The computer is a machine without an explicit function save its ability to emulate some other machine or function. It can, within reason, be configured to become virtually whatever the user desires it to be, if given the right instructions. It is precisely this adaptability to be molded and shaped into a tool that makes this device so important."

Porett works with a graphics tablet and a digitized video camera. He alters the images extensively once they are in the computer, combining them with other images, adding or

subtracting color, altering size and/or letting the computer generate random images from the original ones. He believes that the flexibility to think and act visually with the computer parallels traditional plastic media and yields a new synthesis of the means available to the artist.

The computer printer also offers an opportunity for artistic interventions. A variety of printers are available, such as monocolor dot matrix printers, multicolor ribbon dot matrix printers, and jet spray ink printers, all of which can be controlled from the computer. The printer ribbon can be re-inked with stamp

Jno Cook: "5a" from "Motordrive," a book of silver prints, 16 pages, produced for a Generative Systems Workshop in 1980. 9″ × 12″. "By the time I first noticed how the surface of the bed changed during the day I had already attached a clock motor to a discarded half-frame camera. We soon became oblivious to the flash that went off hourly for days and weeks. I continued the surveillance of our bed as depot. *Afterimage*, Summer 1980. Courtesy: © Generative Systems Workshop, "On change and exchange."

Peter Thompson: an untitled print from the "Screens Series," Xerox 400 Telecopier, 1974. 7″ × 10¼″. Pen and ink drawing converted into a print by means of editing on the telecopier. This print is part of a series which accompanies an autobiographical novel by Peter Thompson.

Mary J. Dougherty: an untitled print from the series "To My Father," Haloid Xerox print, 1976. 10½″ × 14″. The carbon-based image was brushed before bonding.

Tom Porett: from "Softlands," computer-generated image, © 1982. 3" × 8".

pad inks. You can also use color carbon paper to translate colors onto the printout paper. A variety of paper surfaces can be used as the printing paper. Handmade paper adds the dimension of texture to the computer imagery, as well as the sense of the "hand-made" to the "machine-made." This blending of the most ancient form of communication with the most modern has wonderful potential. The addition of fine arts mediums to the computer typography works very well on a handmade paper base, as well as on conventional printout paper.

Printouts can be done on other rag papers, too, such as 100-percent cotton rag stationery (Crane's, Old Council Tree, Southworth). A rag paper base is important to the stability of the print, as in any other art-on-paper medium (see Chapter 9). Porett emphasizes that a major factor with computer-generated imagery is that you can mold and

discover visual ideas by molding the tool—that the artist can create ways of combining software and hardware into a new form. Many of his pieces, particularly "Image Fictions," are programmed to react to audience response, which then becomes part of the image fiction. Thus the computer, artist, and audience are all ultimately participants in the work. Such work, Porett feels, "represents an interaction of sentient being and machine intelligence in a new kind of symbiosis."

The availability of sophisticated technology presents the artist who knows how to use it with a limitless field for exploration. Sheila Pinkel combines diverse systems, letting the basic concept evolve through the process. Sometimes the combination of artist, idea, and machine working in a generative systems method leads to profound conclusions.

Pinkel's series, "Manifestations of a Cube," began with the recognition that the

175

simpliest of objects has infinite potential for form in nature. She began by making black-and-white photograms of a simple glass cube. Ultimately she had hundreds of photograms, which she organized into an exhibit over an 8'×20' wall to give the impression of visual music.

Pinkel continued to explore the cube through the cyanotype process. Then she used the color Xerox machine, and finally a computer scanning system.

> I had several photograms scanned by computer at the Image Processing Laboratory at the University of Southern California. The information was recorded on electromagnetic tape and transferred to a computer-linked color television set. Color was permutated through the gray levels of the image on this set. I controlled the speed of permutation and color combinations and ultimately made a five minute, 16mm color sound film, "Intuition," of the color permutating in the cube. I also constructed a two-dimensional artwork consisting of sixteen per-

mutations, made by projecting color slides taken off the television set into a color Xerox machine.

Pinkel transformed the cube yet another time via Xeroradiography (X-ray Xerox). The complete body of work from the various technologies was exhibited as an installation, with a prism included so that there could be yet one more permutation.

The conclusion Pinkel then reached about this complex and intricate artistic journey is a good example of what can occur when technology becomes a tool for the artist.

> Originally when I thought about this body of work I made an analogy with Plato's Parable of the Cave, the various cube images being the shadows on the cave wall. Then I tried to synthesize the broader content that this series held for me, since I felt that something else had been revealed by this body of work. I realized that each technology had transformed the cube according to its own laws, revealing yet

Sheila Pinkel: From "Manifestations of a Cube," photogram on silver paper, © 1975. Each section is 5" × 8".

Robert Heinecken: detail from "Inaugural Excerpt Videograms," 27 Cibachrome color prints, 1981. 48″ × 180″. Courtesy of Light Gallery, New York.

another aspect of the possible reality of the cube. The kind of visual statement from each technology which I ultimately determined to be a complete artistic statement was governed by the nature of the technology plus my intuitive aesthetic response to the process. I began to feel that this body of work was also a cultural model describing the various artistic expressions being done during a specific moment in history. I substituted the word "artness" for the word "cubeness," "socio-economic group" for "synthesizing mind," and "technology" for "materials or equipment used by each group." I felt that each group produces its own form of art at any given moment relative to their concept of art, their prevailing cultural concerns, and whatever materials they have to work with, and that in order to understand an historic moment we must look at the spectrum

of these artistic statements. The sum total of these statements ultimately reflects the culture. Such a structure, then, provides a broader base for understanding viable artistic statements than does the pyramidal structure that usually acknowledges only the artwork of one socio-economic class.

Ultimately, Pinkel's concept and conclusion resulted in a cross-cultural exhibit of photography in Los Angeles, juried by representatives of the major ethnic communities in the area. Pinkel believes that the cube concept functioned finally as a model for culture, and that "decentralization of aesthetic priorities is the crucial recognition in both the cube model and the multicultural art model. . . . This investigative approach to

artmaking has discovery inherent in the process, every aspect of the experience a continuous adventure."

VIDEOGRAMS

Robert Heinecken's interest in sociopolitical commentary has led him to create a new kind of photographic form from a familiar creature of technology, the television set. He uses the television screen as the source for his "Videograms," a term coined by him to describe his photographic pictures produced directly from the video-generated image on the screen. In complete darkness, the light-sensitive material (Cibachrome color paper) is held in contact with the outside surface of the television's glass covering of the cathode ray tube. The television set is then momentarily activated, creating a latent image in the photographic paper without intervention of lens or camera. The images are not seen or visualized prior to exposure. They are determined randomly, and each picture is one-of-a-kind. In this sense, they are similar to the photogram, a method where objects are placed on light-sensitive materials, thus interrupting the light and creating patterns, silhouettes, and images. This new work follows in the continuum of Heinecken's interest in the sociopolitical meaning of the mass media as source and subject of this aspect of his work.

Whenever any new thing, be it idea or product or art, is presented for the first time, its newness has to be assimilated before its meaning and its potential become clear. In art, it has frequently taken more than an artist's lifetime for her or his work to be understood and valued. We had the fortunate opportunity to ask Robert Heinecken what he wants this new work of his to accomplish and what his hopes are for it. His answer offers insight into his work. It also reminds us to ask these same questions of other nontraditional art as we guide ourselves through its newness to its meaning. In response to the question about what he would want his Videograms to accomplish, Heinecken replied:

I would have an interest in the kind of intellect in them. The sense that it is interesting to see that photograms, if that's what I call these, are made in a lot of different ways. Sunburn is a kind of photograph. Let's say that to open one's mind as to what constitutes a photograph would be one motive, but not a very big one. One of my hopes would be to insist on an understanding of my imagination and my conceiving the method of the Videograms, which any artist would want. Finally, I believe it to be political. To think of not just Reagan but of political people in general as media people, interchangeable with celebrities—no old-fashioned moral or ethical positions about politics, but just images from blurry, fuzzy people. So if the viewer got to that point, that's the relationship I'd want him or her to grasp, but that's asking quite a bit.

HIGH-VOLTAGE PHOTOGRAPHY

High-voltage photography (sometimes referred to as Kirlian photography or electrophotography) as an art process is an unusual and infrequently explored terrain. More often associated with metaphysical research, this process offers new territory for the photographic artist. The technique records luminous corona discharges created in darkness when a high-voltage, high-frequency electrical charge is applied to organic or inorganic material. Varying degrees of conductivity produce varying intensities and kinds of light— visible light as well as infra-red, ultraviolet, and low-energy X-rays. Many forms of electromagnetic energy are produced in these reactions, forms that could be recorded by other instruments (AM radios, thermometers, ionization chambers) and that provide a wide variety of results on photosensitive materials. The blue-violet patterns that appear on the surface of the object are delicate streamers and veins of electricity following the paths of least resistance to ground. These luminous effects can be manipulated but never completely controlled. High-voltage photography delineates the energy pathways across an object much as the electron microscope reveals inner cellular structure.

Artist Mary Jo Toles has been working in this area extensively, moving from documentary information as ritual to complicated abstract visions. In the process she has adapted the various apparatus to her own needs and actually extended the concept of high-voltage photography. We are indebted to her for all the following material on high-voltage photography. Places to purchase the equipment mentioned are listed in Sources of Supply. (Information by H. S. Dakin on safety hazards and precautions follows the process description.)

HIGH-VOLTAGE PHOTOGRAPHY

by Mary Jo Toles

In high-voltage, or Kirlian photography, there is no outside light source. Light is produced by the object being photographed in the form of a luminous corona discharge caused by electrically charging the object. This process produces electromagnetic energy ranging from radio noise through infrared, visible, and ultraviolet light, along with low-energy X-rays. This energy is not entirely visible to the human eye. The film records infrared, visible, and ultraviolet light, depending on film sensitivity.

Some of the most remarkable applications of this process involve prints of living tissue. The "phantom leaf" effect is a well-known example. Allegedly, photographs taken using the high-voltage method have shown a whole leaf after a part of that leaf has been cut away. The part that has been removed is less distinct but still visible. Numerous metaphysical claims have been made on the basis of these experiments. In fact, high-voltage photography has also been used to investigate the claims of a number of individuals who appear to have unusual bioenergetic powers.

In terms of simple image-making rather than scientific research, high-voltage photography is limited but still quite fruitful. The method can be used with any film or paper that is sensitive in the infrared, visible, and ultraviolet ranges. A medium-speed film or paper is best for getting a clear image. It is also recommended that experiments be made with black-and-white materials before attempting color. Some knowledge of the special properties of color film and paper is useful in understanding your results. Check carefully the manufacturer's product information. Polaroid film is very useful for testing because the results are fast and the film is highly sensitive. Note that Polaroid color film has an electrically conductive backing on the negative, which makes results vary from conventional color film.

When using a color process, the image falls in the blue-violet color range. Filters are useless for varying the color of the image. They simply replace the object as a source of luminous discharge. However, the background color can be varied by filling in with other light sources such as a color enlarger, phosphorescent materials (which usually record as green), or gas-filled tubes, such as neon and fluorescent placed in close proximity to the apparatus. These tubes, of course, do not need to be connected. They glow when the atmosphere is charged.

No material is a perfect nonconductor. Objects chosen do not necessarily have to be good conductors of electricity, but the intensity of the corona discharge is greater with metals and other highly conductive materials.

The process is relatively simple, but precautions should be taken with living objects (including yourself). First, an object is placed on film or paper that is lying on an insulator such as a glass plate at least ⅛" thick. Under the insulator is a metal plate that is connected to a high-voltage power source. The entire apparatus should also be insulated (placed on a nonconductive foam pad, for example). The object is either connected to a ground or placed beneath a metal plate that is connected to a ground. The ground wire can be attached either to a grounded metal receptacle plate or to an unpainted water pipe or radiator.

The power source that is attached to the metal plate can be one of a number of things. A vacuum tube tester used for checking neon

tubes, a tesla coil, or a small neon transformer works well. Elaborate equipment can be designed and built to vary frequency, pulse rate, and voltage. Schematics are available.

Two things are important with regard to the power source: It should provide alternating current, and it should be activated by either a manual switch or an automatic timer.

Exposure time varies, depending on the subject, the power source, and the film or paper. Make tests.

SAFETY HAZARDS AND PRECAUTIONS IN HIGH-VOLTAGE PHOTOGRAPHY

by H. S. Dakin[3]

The high-voltage supplies described in this chapter are limited in power output capability, and they can produce serious injuries only under very unusual conditions. When they are used with properly designed electrode-insulator-object assemblies, and when all lead wires are properly insulated, subjects feel little or no electric shock during exposures in making high-voltage fingerprints or similar observations.

Nevertheless, several minor health hazards must be considered in the use of any high-voltage photographic apparatus:

1. Electric shock to the subject or operator from faulty power line and ground connections or from the improper insulation of wires.
2. Electric shock to internal organs of persons or animals with surgically implanted electrodes and leads extending out through the skin. A current of only 0.02 milliamperes, although far below the threshold of perception, can cause heart fibrillation if applied directly through the heart through an implanted electrode.
3. Exposure of dark-adapted eyes to ultraviolet light and X-ray emission from a corona discharge.
4. Exposure of skin and surrounding body tissue to ultraviolet light and X-ray emission from a corona discharge.

5. Increased concentration of ozone in air produced by a corona discharge.

The precautions necessary to minimize these hazards are, in the same order:

1. In line-operated equipment, use grounded power connectors and adapters, and check for ground faults. To minimize ground fault currents and high-voltage currents near the heart when making high-voltage fingerprint exposures, ground the wrist of the hand being photographed, and avoid body contact with other grounded or line-powered metal objects (such as plumbing or lamps).
2. Do not operate the apparatus in the presence of persons or animals with implanted electrodes or implanted inductive pickup devices.
3. Require the use of glasses made of standard optical glass (opaque to ultraviolet light) by all persons making frequent and close observation of corona discharges.
4. Limit the exposure of skin areas to about 1 minute per day, unless otherwise directed by a physician. X-rays, while theoretically present, are not found in biologically significant intensity, because the conditions necessary for high-intensity X-ray production (hot cathode, high current, heavy metal target) are not present.
5. The exposure time limits, as noted in entry 4, and normal room ventilation are sufficient to keep the ozone concentration to a safe level, well below the 0.5 to 1.0 parts per million concentrations, which produces throat irritation and other more toxic effects.

The effect of frequency on the interaction of electrical currents with living organisms needs to be mentioned, due mainly to the "skin effect" and to the diminished sensitivity of nerve and muscle tissue to frequencies above about 10 kilohertz (KHz). A useful indication of the interaction of currents with living organisms is the "threshold of perception current," measured with cylindrical electrodes

EQUIPMENT AND PROCEDURES FOR PRODUCING HIGH-VOLTAGE ARTWORK

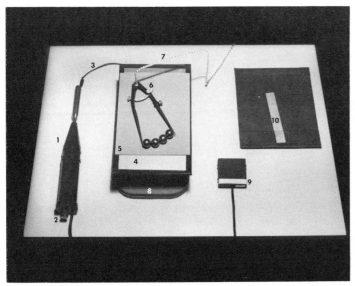

Small vacuum tube tester can be used as a source of high voltage. This device, a small Tesla coil, uses household current (117 volts A.C.). It can be switched on and off with a footswitch or a darkroom timer. A dial control on the bottom provides a coarse adjustment for voltage output. Photo by Mary Jo Toles.

Key to elements:
1. Vacuum tube tester as a source of high voltage. This unit is basically a small Tesla coil.
2. Knob for coarse adjustment of voltage.
3. Wire to underside of metal electrode plate.
4. Metal electrode plate covered with single strength glass plate (at least the full size of the metal plate).
5. Photographic paper.
6. Object to be documented.
7. Ground wire connecting the object to ground.
8. Insulating foam pad under metal plate to prevent current from flowing through the table to the operator.
9. Footswitch for timing exposure (tester is connected to footswitch that is plugged into electrical outlet).
10. Photo paper envelope should be nearby, particularly if you are working in total darkness with color sensitive paper. Keep unexposed paper away from high-voltage equipment while in operation, as it will fog or expose paper even in the light-tight package.

A gas tube transformer as a source of high voltage can provide 9,000 to 15,000 volts from household current depending on the size (check the metal label giving this information on the side of the transformer). The current can be switched on and off with a footswitch or a darkroom timer. Precautions must be observed in using this apparatus for use with living subjects. Photo by Mary Jo Toles.

Key to elements:
1. Neon transformer as source for high voltage.
2. One of the electrodes should be capped off and secured away from the equipment.
3. The other wire electrode is attached to the underside of the metal electrode plate.
4. Metal electrode plate covered with single strength glass placed on an insulating foam pad.
5. Polaroid negative removed from the package.
6. Object with ground wire running to ground.
7. Polaroid package that contains the paper to which the negative is transferred. The negative is slipped back inside after the film has been exposed (the side of the film with the attached chemical packet should face the smooth surface of the transfer paper).
8. Wire from neon transformer to the timer.
9. Darkroom timer plugged into electrical outlet.
10. After the film has been exposed, it is processed normally through the rollers in this Polaroid film holder.

Precision solid-state high-voltage device for use on small objects (approximately 4″ × 5″ inch film format). This equipment, using household A.C. current, was marketed by Edmund Scientific and schematics are available. The unit allows you to control: high-voltage frequency, pulse width, pulse rate, and exposure time. Hookup for use with an oscilloscope is provided, which is very useful for accurately monitoring wave forms. Internal timing device can be bypassed for use with darkroom timer or footswitch for long exposure times. Photo by Mary Jo Toles.

Key to elements:
1. Precision solid-state electrophotography power supply.
2. Wire connecting power supply to underside of metal electrode plate.
3. Metal electrode plate (maximum size is approximately 6″ × 6″ inches), covered with single strength glass plate.
4. Sheet of 4″ × 5″ photographic film (emulsion surface up toward the object being recorded).
5. Object portion of a small living plant).
6. Ground wire touching plant and connected to ground.
7. Box for holding exposed film should be kept nearby because with film you will usually be working in total darkness.

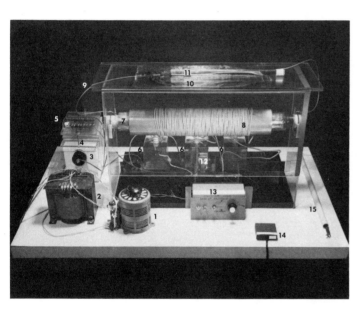

Large horizontal resonating Tesla coil (fabricated by Tim Richards after G. Breet, M.A. Tuve, and O. Dahl, *Physical Review*, 1930). This Tesla coil, also using household A.C. current, produces very high voltage and increased corona discharge for effective use with large objects. The design of this system is flexible and may be adjusted depending on the surface area of the object placed on the photographic paper or film to vary the amount of corona discharge. The windings of the primary may be decreased or increased, the capacitance may be altered by using one or all of the capacitors, and the distance between the electrode plate and the object may be increased by stacking glass or plexiglas on top of the electrode plate. This apparatus allows for control of the discharge rate, the voltage and exposure time. A footswitch or timer may be used for controlling the length of each exposure.

It is important to exercise extreme precaution with living subjects (see safety precautions for high-voltage equipment). The operator should wear ultraviolet shielding safety goggles and the room should be well ventilated. During long exposures of several minutes the operator should leave the room entirely, controlling the exposure with a timer, due to the production of ozone by this high voltage. Photo by Mary Jo Toles.

Key to elements:
1. Variable auto transformer that drives the primary of a neon transformer providing 0–5 KV, alternating current (A.C.).
2. Isolation transformer.
3. Neon transformer.
4. Full-wave rectifier stack (10 KV, P.I.V. at 1 amp) that changes the A.C. current to direct (D.C.) current.
5. Two ballast resistors to prevent spikes from returning through the wire from the spark coil and damaging the rectifier. This protects the electronic components against over-voltage.
6. Three high-voltage oil immersed can capacitors (5 to 10 KV at .1 to 1 microfarads).
7. Secondary windings of the spark coil (7,000 turns of 37 guage enamel coated copper wire covered in resin).
8. Primary windings of the spark coil (73 turns of 10 guage insulated copper wire wrapped over an insulating core).
9. Wire connecting spark coil to aluminum foil electrode plate.
10. Electrode plate covered with glass plate (this can be layered up much thicker with more sheets of glass or plexiglas if the object is large, to increase the corona discharge).
11. Plexiglas wand with wire leading to the other end of the spark coil. This wand may be placed with the wire directly in contact with the object or it may be placed off to the side away from the equipment (as with the neon transformer apparatus in photo 2). This arrangement may be used when the subject is a person. With voltage set low, the person touches the film or paper and the body acts as an antenna for the discharge. Take extra precaution when using living subjects.
12. Variable pulse motor with spark gap points.
13. Pulse speed control panel. This includes ON/OFF controls for the entire apparatus and variable control knob for the speed of the pulse motor.
14. Footswitch placed for hand controlling the exposure time.
15. Grounding wand. This is a wire connecting the metal parts of the electrical components to ground. Before touching any of the various components of the apparatus, it is important to touch all metal parts with the grounding wand to discharge any electrical potential remaining in the capacitors and thus preventing electrical shock.

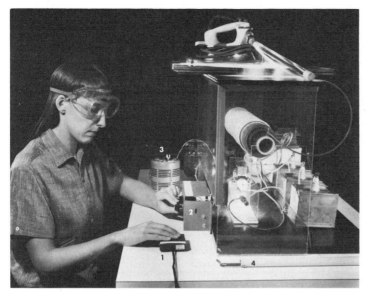

Horizontal resonating Tesla coil is switched on by hand operation of the footswitch. Note the corona discharge around the iron atop the apparatus. It is important when working in close proximity to this device to protect your eyes with ultraviolet shielding goggles.

Other than the footswitch (2), the pulse speed control panel (2), and the variable voltage transformer knob (3), DO NOT touch other parts of the apparatus while in operation. Use the grounding wand (4) to ground all metal parts of the apparatus before touching the various components while not in operation. Photo by Mary Jo Toles.

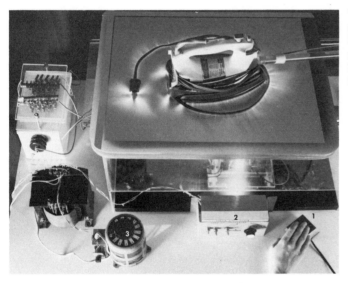

This overhead view shows the layout of the three control devices used in producing a high-voltage image. (1) is the hand operated footswitch, (2) is the pulse speed control panel, and (3) is the variable voltage transformer knob. Note the corona discharge onto the photographic paper from the iron. Photo by Mary Jo Toles.

Overhead photograph of object producing a corona discharge onto the photographic paper. The plexiglas wand with one electrode is attached to the front of the iron (1). The end of the electric cord periodically arcs a spark toward the other end of the spark coil (2). Photo by Mary Jo Toles.

A typical ground clamp attached to a radiator for grounding the high-voltage apparatus. A connection could also be made to the cold water line of an all metal plumbing fixture or to the metal face of a duplex receptacle. In all cases, if the metal has been painted, scrape the paint off to make a good metal-to-metal connection. Photo by Mary Jo Toles.

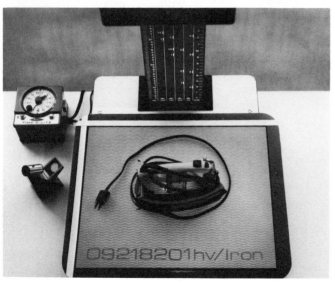

Taking care not to move the object, the top sheet of plexiglas was placed under a colorhead enlarger, projecting a prefocused image with a preset color over the object onto the photographic paper. The paper was then removed and processed normally as a color print. Photo by Mary Jo Toles.

The high-voltage photogram depicted in production here is from the series, *Domestic Reflections: Clandestine Scientific Investigations of Household Items*, © 1982, Mary Jo Toles. "The Merrimacian platen of an iron surfaces as a metaphor for moving easily through the stuff of existence, as a steam iron tames the wrinkle, the warhead courses to target."

held by human subjects. This is the minimum current in milliamperes (mA) that a subject can perceive. At high frequencies, human subjects can act as conductors for rather large currents, which at low frequencies could be dangerous or fatal, with no noticeable sensation.

Another important indicator of physiological effects of electric current is the "let-go" or muscle deactivation current. This also varies with frequency, from 19 milliamperes for frequencies up to 200 hertz (Hz), to 22 milliamperes at 1 kilohertz, and 73 milliamperes at 10 kilohertz. Currents of these magnitudes are not only very perceptible, but they can be dangerous.

HOLOGRAPHY

Finally, we come to one of the most revolutionary discoveries in this century—holography. Holography holds equally immense possibilities for the future of both science and art, and it brings to us a most sophisticated visual communications medium.

A hologram is a three-dimensional image that uses laser light and photographic film to record the light waves reflected from an object. The film is developed and then illuminated by laser light or white light. The resulting image from the hologram is three-dimensional and contains all the visual details of the original object, often looking as real as the original—until you try to reach out and touch it. The hologram is constructed only of light; it is an apparition. Because it has the same dimensional properties and characteristics as our everyday world but no substance, it can challenge and change our very concept of reality.

Holography offers an entirely new kind of vehicle for the creative ability of the artist. Once too technically complex and inaccessible for use by artists, now, as Dr. Tung H. Jeong notes, "the introduction of motion and the elimination of stringent conditions for illumination have made it possible for artists without scientific background to adopt holography as a new and exciting medium of visual communication. Thus, a new era of collaboration between scientists and artists has begun."

The following information on holography has been compiled for us by Dr. Jeong, a nuclear physicist who is Chairman of the Physics Department at Lake Forest College, in Lake Forest, Illinois. Dr. Jeong pioneered in the research and development of many of the processes used to construct various kinds of holograms. He has for years been a well-known and enthusiastic teacher of holography, both in the United States and in foreign countries. He emphasizes the "do it first" approach, believing that the understanding and curiosity to pursue a subject is generated through hands-on learning.

The inexpensive equipment mentioned by Dr. Jeong as necessary in the construction of a hologram is listed in Sources of Supply.

HOLOGRAPHY
by Tung H. Jeong, Ph.D.

Holography is a process of recording three-dimensional images on a light-sensitive medium without the use of a camera. Discovered by Dennis Gabor in 1947, it was not until the early 1960s, after the invention of the laser, that the concept was proven to be of great fundamental and practical importance. In 1971, Gabor was awarded the Nobel Prize in Physics.

The holographic process involves the optical recording of an interference pattern formed by two sets of light waves, one directly from the laser, the other scattered from an object. This brief statement is more understandable after you actually make a simple hologram. The following procedure can be done inexpensively with minimum equipment, and the results can be viewed under an ordinary light. It is called a *one-beam reflection* hologram. (A *reflection hologram* is viewed with the light source on the same side as the viewer; a *transmission hologram* is viewed with the light source behind the hologram and opposite the viewer.)

You need a helium neon (HeNe) laser, a 10× microscope lens, holographic film or

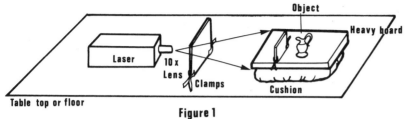

Figure 1

Figure 1.
Set up for making a one-beam reflection hologram consists of (from left to right) a helium neon laser, a 10× lens (mounted on the laser), a card for blocking the light before exposure, the photoplate, and the object. The photoplate and the object are on a rigid board supported by vibration-absorbing material (here an inflated inner tube). Illustration by Jeanne Reilly.

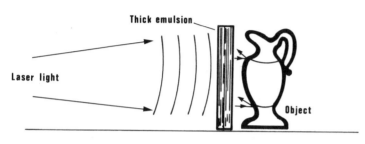

Figure 2

Figure 2. Light from the laser is spread by the lens, arriving at the photoplate, and interferes with light scattered back from the object, forming interference patterns throughout the thickness of the emulsion. Illustration by Jeanne Reilly.

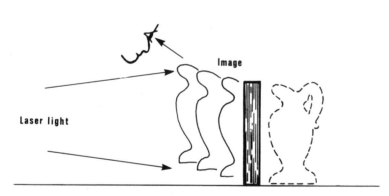

Figure 3

Figure 3. After processing, white light is used to view the finished hologram. The interference pattern inside the emulsion acts like a stack of thick films and selectively reflects a particular color from the white light to form a 3-dimensional image of the original object. Illustration by Jeanne Reilly.

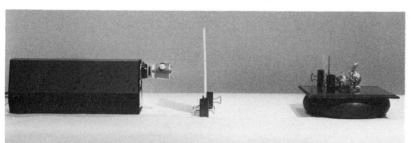

Figure 4. Photograph of reflection hologram.

plates, a sturdy platform, and some common chemicals. (These are common supplies that can be obtained from scientific and educational supply catalogs and stores without great expense. Holographic film plates and general information are available through Integraf, Box 586, Lake Forest, IL 60095.) The holographic plate is composed of a fine-grain black-and-white emulsion called Holotest 8E75HD, made of Agfa Gaevert. The platform is made by supporting a heavy board on a cushion consisting of any vibration-absorbing material, such as a small inner tube or packing foam. Select any sturdy three-dimensional object as the subject of your hologram.

Figure 1 shows the arrangement for this material on a firm surface such as a concrete floor. The light from the laser is spread out by the lens attached to it at a distance of approximately 1 meter. The object to be recorded is placed on top of the board and illuminated by the laser light. The system is ready for making a hologram.

The procedure does not require a completely darkened room. The film is fine-grained and especially red-sensitized. A green safelight can be used or a minimum amount of white light. First, the laser beam is blocked with an obstacle, such as a dark card. The holographic plate is put into position as close to the object as possible on the laser side. It can be made self-standing by the use of clamps, as shown. If film is used instead of a holographic plate, it must be sandwiched between glass plates and clamped down. Wait several minutes to allow it to settle before exposure.

The most important precaution in making any hologram is to make sure that there is no relative motion between the object and the photoplate during exposure. Thus, make certain that neither the object nor the plate will move. Placing putty on the base of the plateholder as well as the object will help insure stability.

To make the exposure, simply lift up the card quickly and allow the laser light to go through the photoplate and illuminate the object. For a 1-milliwatt laser, the exposure time varies between 1 and 10 seconds, depending on how much the light spreads. After the exposure, block the beam again and remove the plate for processing.

The processing procedure is done at room temperature, under a green safelight, using the following chemicals: pyrogallo (some catalogues list it as pyrogallic acid), sodium carbonate anhydrous, potassium dichromate, sulfuric acid, and Kodak Photo-Flo. (See Sources of Supply, and also read the section on darkroom safety in Chapter 3.)

Solution A

| Pyrogallic acid | 10 g |
| Water | 1 l |

Mix together.

Solution B

| Sodium carbonate anhydrous | 60 g |
| Distilled water | 1 l |

Mix together.

These solutions keep well if stored separately in tight opaque bottles at room temperature or below.

To develop:

1. Mix equal parts of A and B and develop the holographic plate or film in it for 1 minute with gentle agitation. (The mixture is ineffective after 10 minutes, so use only enough for the hologram being developed, and then discard.)

 This mixture yields a red or yellowish-red image. If you desire a color shift toward yellow, green, or blue, add a proportional amount of sodium sulfite, between 0 and 25 grams, to 1 liter of solution A.

2. Wash for 3 minutes in running water.

3. Bleach until clear (15 seconds to a maximum of 2 minutes) in the following solution:

Potassium dichromate	4 g
Concentrated sulfuric acid	4 ml
Distilled water	1 l

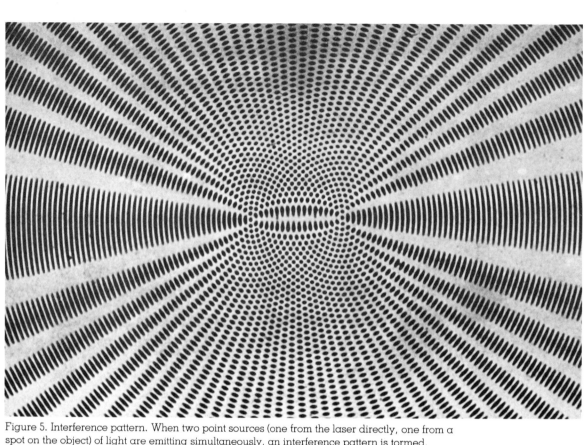

Figure 5. Interference pattern. When two point sources (one from the laser directly, one from a spot on the object) of light are emitting simultaneously, an interference pattern is formed, consisting of alternative surfaces of maximum and minimum energy density. A photoplate placed between the point sources will record the reflection hologram. Each spot on the object forms an independent set of patterns with the direct laser light. Thus, in a single exposure, all points on the object illumined by laser light will simultaneously form their individual patterns with the direct light.

(This solution can be stored indefinitely.)

4. Wash for 3 minutes in running water.
5. Soak in Photo-Flo solution for 2 minutes (follow directions on the bottle).
6. Let dry vertically (hang with clothespins). The image cannot be seen until the hologram is completely dry. The thoroughly dried hologram can be viewed with any point source of white light, such as a flashlight, a slide projector, or sunlight. In general, the sharper the shadow the light can cast, the sharper the image becomes.

How is it possible that we record a three-dimensional image in color, on black-and-white film, without the use of a camera, and view it with ordinary light? To answer this question, the reader needs to understand ideas involving color production from common objects such as soap film and oil slicks. The basic principle involved is called wave interference.

Figure 2 shows schematically what is happening. The emulsion we use is approximately .6 microns thick, almost 10 wavelengths of the laser light we use (.633 microns). Thus, it can be considered a three-dimensional recording medium. Since it is made without antihalation, during the exposure the laser light transmits through the film and illuminates the object. The scattered light from the object moves back toward the emulsion. An interference pattern is thus

formed between the oncoming light and the scattered light, forming a stationary pattern throughout the film. These patterns, in fact, are precisely the same, with the exception of dimensions, as interference patterns commonly detected by television when the signal from the broadcasting station is reflected from other structures.

The general feature of the interference pattern consists of alternating layers of surfaces with strong and weak light energy. After processing, the film emulsion resembles a boxful of layers of thin film of complicated shapes. The bleaching process renders the whole film transparent with variations inside only in the index of refraction.

Figure 3 shows the image reconstruction process. By shining a spotlight at the film, at an angle equivalent to that during the exposure, an image can be seen with the reflected light. Each layer of thin film inside the emulsion reflects light toward the viewer, reinforcing through the process of interference a particular color based on the film thickness. Whatever complex pattern was formed now breaks up the light in such a way as to recreate the three-dimensional likeness of the original subject.

We should appreciate why it is necessary to avoid all relative motion between the film and the object during exposure. Any motion would cause the interference pattern being formed to be blurred, resulting in failure.

On the other hand, if the hologram can be formed very quickly, such as with a ruby laser, the motion problem is avoided. Portraits of people can be made with the subject holding the photoplate against his or her nose. Typically, the exposure is made between 10 and 20 billionths of a second, a time too brief for anything to move sufficiently to affect the interference patterns. Because of the high power output of such lasers, eye safety must always be a great concern.

The preceding example in the construction and explanation of a single beam reflection hologram is used to illustrate the underlying procedure and principles. It's only one of many different types of holograms, most of the others being more complex both to make and to explain.

The most striking feature of any hologram is the three-dimensional image that it forms. An observer looks through a hologram as if it were a window. A three-dimensional image of an object can be observed to be on either

Figure 6. Transmission hologram. By a slight change in the set up in Figure 4, the system is ready for making a transmission hologram. Note that the change involves placing the object on the laser side of the photo plate, so that both the direct laser light and the light scattered from the object arrive at the plate from the left. Using the same exposure and processing procedure, the resulting hologram is viewed with the laser in the same configuration as when the hologram was made.

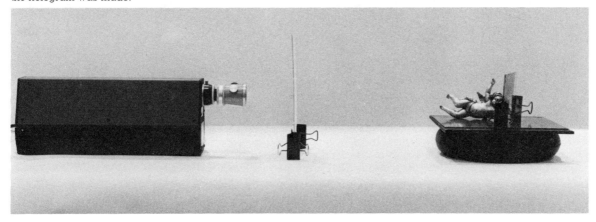

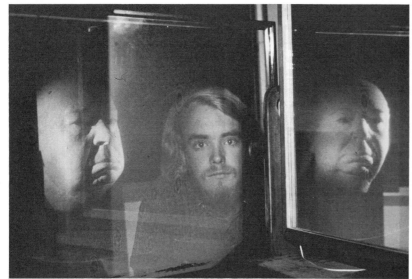

Hologram. (Alfred Hitchcock). This is a photograph of a projected 3-dimensional image of Alfred Hitchcock (at the right), a student holographer, and a mirror-image of the hologram. Photography by Tung H. Jeong, © 1969.

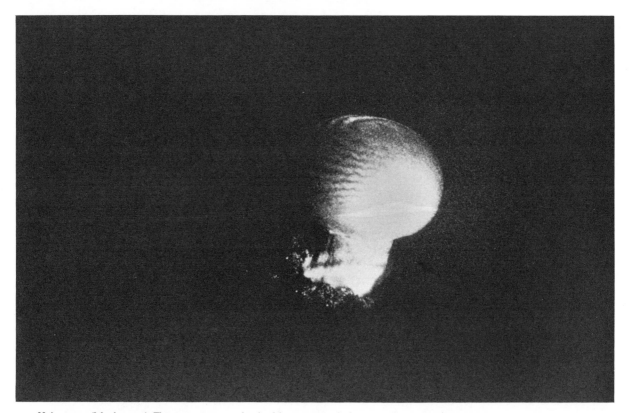

Hologram. (Mushroom): This is an image of a double-exposure hologram of a growing mushroom. The time interval between exposures is 15 seconds. The quantitative change in the mushroom is revealed in the black lines formed on the image holographically. This demonstrates a unique scientific application called holographic non-destructive testing. Hologram and photography by Tung H. Jeong, © 1968.

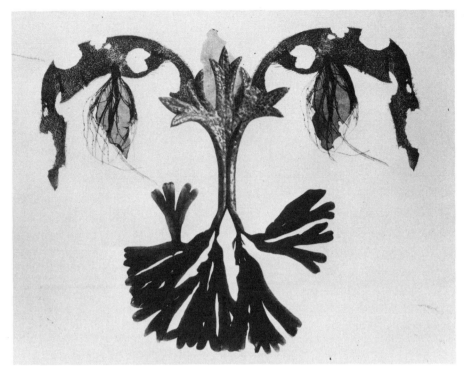

Ellen Land-Weber: from "The Natural Selection of E. Haeckel, #2," 3M Color-in-Color transfer to Arches paper, © 1979. 22½" × 28".

Mary Jo Toles: from the Semes "Recent Plant Cutbacks," © 1983. Monoprint—20" × 24" Ektaprint with 8" × 10" Polacolor ER, enlarger projection and high-voltage exposure. "I am continually exploring the visual evidence of energy affecting matter. In my laboratory of the familiar I inductively pursue an open investigation of a scene without a crime, populated with a plethora of overcharged clues."

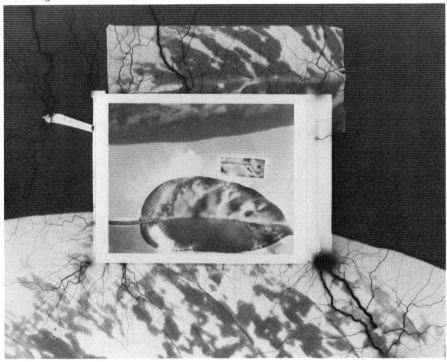

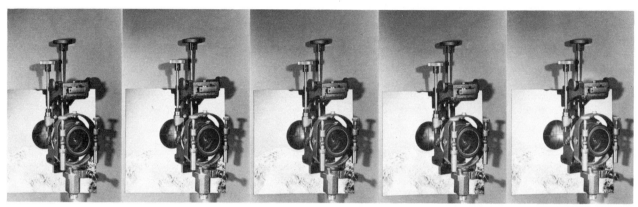

G. E. Gundlach and Grayson Marshall: "Launching into E-Space." "There are times when an artist must create a new tool to embody visions that had been denied form by the shortcomings of previously existing technologies. The Multiplex Imaging Process makes possible and practical the creation of high quality, large size, full color, three-dimensional transparencies. Because a flat print cannot convey the depth axis, this sequence of photographs records different views of a single image made by this system. It is a product of E-Space Pioneering."

side or even straddling this window. As the viewer moves his head up and down and side to side, he can look around the object. In fact, what is observed is not a psychological effect but can be confirmed by scientific instruments, such as cameras or video recorders. This means that the light arriving from the hologram into the viewer's eyes is physically the same as light emitted from the original object.

In a hologram, all parts of the film plane contain the full image of the object, so that if the film is cut into small pieces, each piece still has the full image of the object on it. This is seen most easily with transmission holograms. In photography, each area of the film contains the image of a different part of the object, and it takes the entire film frame to reconstruct the full object.

Presently, an ever increasing group of artists, scientists, and entrepreneurs are making holograms in multiple color, in motion, and in a great variety of sizes and shapes.

The chronological development of holography very much parallels that of photography. It began as a cumbersome technique, capable of recording monochromatic still images and requiring expensive equipment. Eventually it became simplified, acquired color and motion, and was—and is—practiced by people beyond the scientific community. Like photography, holography is another dimension of image-making with film and light that offers seemingly limitless opportunities for exploration.

In every art there is a science. In every science there is an art. Combined, they have formed the greatest achievements of mankind. Alden B. Dow, FAIA[4]

9

Finishing the Works

Opposite page: Margaretta K. Mitchell: "Cyclamen," photogravure, © 1982. $13\frac{1}{16}$" × $12\frac{3}{4}$". Gravure print, hand-painted "à la poupée." Photogravure unites the visual immediacy of the photographic image with the physical beauty of ink pressed onto handmade paper.

With work complete, the tendency is to be less concerned about the choices that remain. The archival considerations of how to frame and present the work are too often afterthoughts, and yet they are critical to the survival and the meaning of the work.[2]

ARCHIVAL CONSIDERATIONS

What problems may you encounter as your works age and are stored? There are two primary areas of consideration. The first is the material used in the imaging process. This area has been discussed under the various descriptions of process in Chapter 4, and a final archival process is given at the end of this chapter. The second consideration is common to all the processes: the images in most of the processes outlined in this book rest on paper bases, and the paper itself must be treated properly.

How Will the Paper be Affected?

Throughout this book, we have urged the use of fine art or handformed paper of high rag content. The matting and mounting materials should also be of this quality.

NEUTRAL PH These materials are high in rag content and may contain buffering compounds to keep the pH neutral. (Refer to Chapter 5 for a further definition of pH neutral. Also note, under Sources of Supply, that Conservation Resources International supplies unbuffered materials.) The materials used should contain few if any deposits of heavy metals, such as copper and iron, and they should be free of chemical components, such as alum (often found in sizings).

MOLD The conditions ideal for the growth of mold are 70°F and 70 percent humidity. These conditions are also adverse to most photographic processes. As a result, both the image and the paper will deteriorate if work is stored under these conditions.

FOXING Mold growth causes a condition called "foxing." *Foxing* is the chemical reaction that takes place as mold attaches to iron salts in the paper. It is a brown patch, usually in a circular area, with loose edges around a darker center dot. It may cover a large area of the piece, or be almost microscopic. And it may develop either in the artwork or in the mounting and matting materials. It ruins a print if not treated. To stop mold growth the piece must be removed from the environment causing the mold to grow. Treatment may be given with a fungicide in a professional laboratory. This only ends the growth of existing mold; it does not restore the paper or artwork. Prevention, through care in paper selection and proper storage practices, is a much better alternative.

HUMIDITY AND COCKLING Paper is hygroscopic, and therefore another culprit is moisture. Moisture allows molds to form and also may cause "cockling." *Cockling* is the ripple in the edge of the paper when too much moisture is present. A certain amount of this is caused by paper's natural expansion and contraction. If relative humidity (expressed by RH) is constant, the paper does not change, but this consistency is rare outside of museum conditions. Framing systems for paper should allow this slight dimensional change to occur unhindered. If possible, work should be stored to maintain consistent humidity.

This old photograph shows deterioration and staining of both image and mounting board.

LIGHT The fourth consideration is light. The ultraviolet rays in the spectrum (see Chapter 2) are the most detrimental to the photographic image and to the paper. Ultraviolet radiation is emitted in varying amounts by sunlight and fluorescent fixtures. It causes premature aging in the paper. The paper yellows and becomes brittle. If you think of old and yellowed newspapers, you are imagining an aged paper. Wood pulp papers, such as newsprint, are highly vulnerable to this aging process. By using rag paper, the hazard is reduced. Desirable storage conditions provide low light levels, a consistent low temperature (preferably below 60°F), and protection from airborne pollutants. When work changes due to light damage, the deterioration acts on the relationships within the work itself. The careful choices the artist made are destroyed. Therefore light level is a factor for the image as well as for the paper.

The keeping quality of color materials is a growing concern. The American National Standards Board has been formed to try to establish guidelines for evaluating stability in color photographic materials. For example, Polaroid 600 and SX-70 show great shifts in density and are prone to yellow stain forma-

tion when kept in the dark. This tendency, together with poor light-fading stability, gives them their "fugitive" reputation. Since the images are "one of a kind," these factors are critical. Kodak's current PR10 instant film also has poor light-keeping qualities, but prints using this film are more stable in the dark. They do not tend to develop image cracks under the top polyester sheet, as do SX-70 prints. Resin-coated materials are also subject to cracking.

The term "dark fading" is used to refer to chemical changes that take place in photographs that are kept in the dark. The Polaroid and Kodak materials just mentioned should be stored in the dark, and the changes may be monitored with a densitometer. This instrument reads the reflection density of the print in different colors of light. A mylar overlay is made so that the print is "read" at the same point each time. Any change in density indicates that reactions are taking place. (For example, yellowing increases the density read through the blue filter.)

Traditionally, dye transfer and Cibachrome have been used to provide greater color stability. Many new materials will appear on the market as the public becomes

more concerned. Ektaflex by Kodak is one such material. These prints are not yet as stable as Cibachrome or dye transfer, but they at least address the problem.

TEMPERATURE High temperature is detrimental to paper surfaces, and it is deadly for images. It is a primary archival concern that is only now coming under serious consideration.

The Art Institute of Chicago is one of the first museums in the country to maintain a cold storage vault for keeping color images. In addition to being indispensable for Type C prints, it is helpful for calotypes and albumen prints. Prints in the cold vault must be removed slowly for viewing. They are first moved to the black-and-white vault at 60°F, where they are kept overnight before being allowed in the study room. Douglas Severson gave us the following information on the photography storage system:

> The value of cold storage in prolonging the useful life of photographic materials is well-established. The stability of the dyes in most

Joyce Neimanas: "Ham No Rye," gelatin silver print, woven collage, colored ink, 16" × 20" © 1980. This print is from a series entitled "Designed to Deceive" dealing with illusions. In this picture, the actual photographic paper is woven and speaks directly about the photograph as a paper object. The part of the photograph that is not woven (the tablecloth) is of itself woven. "I think about the photograph as being a piece of paper that holds an illusion of an object but in itself is an object." From the collection of Jay Cooper, Phoenix, Arizona.

Preparation and conservation laboratory, The Art Institute of Chicago, Department of Photography. This laboratory was especially designed to aid in the care and restoration of the photograhic collection.

color materials is increased dramatically by reductions in storage temperatures. For instance, with Ektacolor materials, the following benefits accrue:

1. By lowering the storage temperature from 75°F to 60°F the print's life expectancy is approximately tripled.

2. By lowering the storage temperature from 75°F to 40°F the print's life expectancy is increased 20 to 30 times.

3. By lowering the storage RH from 60% to 40% the print's life expectancy is approximately doubled.

This type of care is difficult in one's home or studio. But an awareness of the effect of heat on photographs may mean such things as moving photo storage boxes to an air-conditioned area in summer and using dehumidifying equipment.

FRAMING AND PRESENTATION Paper and imagery should also be preserved through proper care in matting, mounting, and framing. Doing so helps to insure a further control over conditions.

MATTING AND MOUNTING We must begin by stating that without exception we do not advocate dry mounting techniques. In processes such as color-in-color, the entire image could be destroyed by the heat. Dry mounting also violates the basic premise of archival matting and mounting—that matting and

mounting must be reversible. All the materials used for presentation of the image must be easily removed without damage to the work. This is important because theories of proper preservation change through continuing research.

BACKING BOARDS AND HINGES The back mat should be rag museum board. These boards are available in several weights from the sources listed in the back of the book. Most of these boards are buffered. (Agents such as calcium carbonate are added during manufacture to raise the pH to further insure neutral pH.) Over time the buffering agent may migrate to the print and cause changes where contact is made. Light Impressions carries a 4-ply nonbuffered museum board which is recommended for albumen, dye transfer, and most color processes.

To insure reversibility, we use hinges to mount the work to the backing board.

The hinges are cut from sheets of mulberry paper, folded stamp album fashion, and brushed with wheat paste. The paste recipe is as follows:

Conservation Wheat Paste Recipe

1. Mix enough wheat starch (30 grams or 4 T.) with 150 ml or 5 oz. cold water to form a slurry (thin glue). Place in top of double boiler for ½ hour to hydrate starch. Stir occasionally.

198

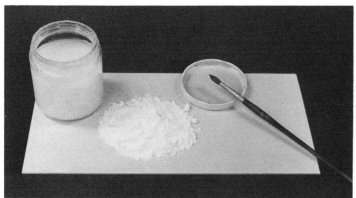

Conservation wheat paste in dry form and after mixing for use. A small red sable brush or a standard paste brush may be used to apply the wheat paste.

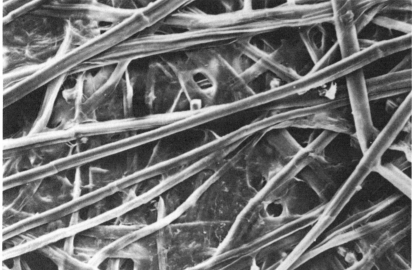

Mulberry hinge. Scanning electron micrograph magnified 370×. Courtesy of Odell T. Minick, Department of Pathology, Northwestern Memorial Hospital, Chicago, Illinois.

Linen and mulberry hinges.

Wheat paste is applied to hinge prior to placing hinge on the back of the artwork.

2. Cook over boiling water for 15 minutes, stirring constantly. It will go through several changes, becoming easier to stir at the end of the cooking.

3. Place cooked mixture in blender and process 3–5 seconds.

4. Allow paste to cool. It sets up in a semisolid mass.

5. To use, slowly add water and mix with a paste brush.

6. Store at room temperature in a covered glass jar. Discard when paste smells sour or becomes too thin (in approximately one week).

This recipe may be used for all types of hinging or mending works of art on paper.

Half of the pasted hinge is applied to the back of the artwork, and the other half is applied to the mat board. After the piece is hinged, a top mat is cut, possibly reducing the size of the image slightly. Often the print is signed and numbered in the area covered by the mat. This method prevents the signature from interfering with the image. Another possibility is to cut the top mat slightly larger than the image to allow the irregularities of the paper edge to show. This is particularly beneficial when matting images on handmade paper.

If the surface of the piece is slightly three-dimensional and would protrude from a conventional mat, it is possible to cut an underlayer. This may be done using archival corregated board from Light Impressions (see Sources of Supply). This underlayer elevates the top mat so that the image no longer protrudes.

The top mat may be hinged at the upper edge or along the side with linen tape. The purpose of this top mat is protection. When the work is stored unframed, it helps to prevent abrasion of the print surface. When framed, it keeps the glazing off the surface of the work, preventing moisture transfer.

A special note should be included here. Pressure sensitive tape should never be used in the mounting or matting procedure. These tapes may be destructive to the paper, since they cause discoloration and brittleness. They also do not allow the "reversibility" we recommend.

FRAMING

If framing is the best form of presentation for an image, there are two considerations. The first is structural. Are high-quality materials being used that protect the work under adverse conditions? Framer Sue Lindstrom

Top mat is hinged to backing board and artwork is held in place with a covered weight until mulberry hinges are dry.

A selection of sample museum board matting materials and linen-wrapped boards.

A wood frame with components: backing support of foam core and ragboard. Paper artwork is hinge-mounted without a top mat to allow paper edge complete visibility.

states: "We are not so concerned about how the work is under the best conditions; how is it under the worst conditions? If it accidentally gets wet, will pigments from mat boards transfer to images, for example?" The second consideration is that the materials used inside the frame should be of the purity discussed earlier in this chapter. Buffering compounds are present in most of the "rag" boards. You may wish to consider using materials without these agents. (See Sources of Supply.) The illustration above shows systems for layering mats and mounting materials.

Glazing

Finally, the glass, or preferably acrylic sheeting (Plexiglass or lucite), should not rest on the image. It is raised to prevent the transfer of moisture and also to prevent the image from adhering in time to the top surface.

Several manufacturers now make acrylic sheeting that absorbs ultraviolet rays (see Sources of Supply). Acrylic sheeting is also worthy of consideration because it is lightweight and does not shatter when work is shipped. It does require careful handling because it is easily scratched, but several good polishes are available to correct this. Armorall Protectant is recommended. It is sprayed on the surface, allowed to stand 24–48 hours, then buffed and polished with a soft dry cloth. (See Sources of Supply.) Acrylic sheeting also has electrostatic properties that make it less desirable for work that uses pastel or charcoal. It may cause the surface to "lift" on some machine prints. Glass should be used for these images. Avoid nonglare glass, because it is translucent rather than transparent.

Frames

The frame should hold the glass or acrylic sheeting off the surface of the work. In some cases this is done with the mat, as discussed. If not, look closely at the frame. Several are made with an interior lip to create a space between the glass and the work. In some

Sealed wood frame with foam core and mat board supports for the acrylic glazing material. This frame is particularly good for works on handmade paper that have a raised surface or slight dimensionality.

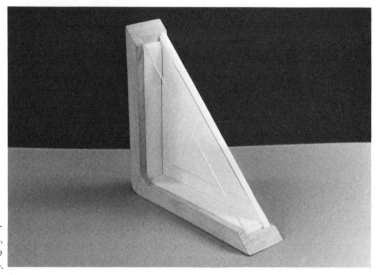

The assembled frame in a cut away sample shows the acrylic sheeting, side inserts, art paper, backing mat, and foam core in place.

cases, the framer needs to insert a *fillet*, that is, a small piece of mat board, under the rabbit of the frame. The fillet holds the glass above the mat or mounting board and creates an air space.

If the frame is wood, it should be completely treated with sealer inside and out. The best metal frames have mitered corners soldered to appear solid or continuous. The frame should be larger than the work to allow the work to breathe as changes in temperature and humidity occur. The frame may be backed with acid-free corrugated board and covered with brown paper that is coated to prevent moisture passage. Rubber bumpers are commonly installed on the back of the frame to allow for air circulation and level hanging. A piece properly sealed may develop condensation with extreme temperature changes or in direct sunlight. This condensa-

tion goes away when the conditions return to normal, and it may serve as a warning that the piece is in a bad environment.

Professional framers do not always give proper considerations to all these factors. To receive this quality, you must, in many cases, specify exactly what you want done each step of the way toward the finished job.

Framing as an Aesthetic Concern

The frame and all forms of presentation should be an extension of the image, designed to be an enhancement of the work rather than merely an embellishment.

Historic Frames

An early proponent of framing as an extension of the image was Edward Sheriff Curtis. He designed his own frames for his Indian

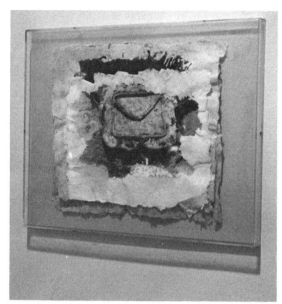

Acrylic frame with linen insert.

Edward Sheriff Curtis: "Sea Nymph," blue-toned silver print, 1930. 10″ × 13″. Courtesy of Joshua Mann Pailet, A Gallery for Fine Photography, New Orleans, Louisiana.

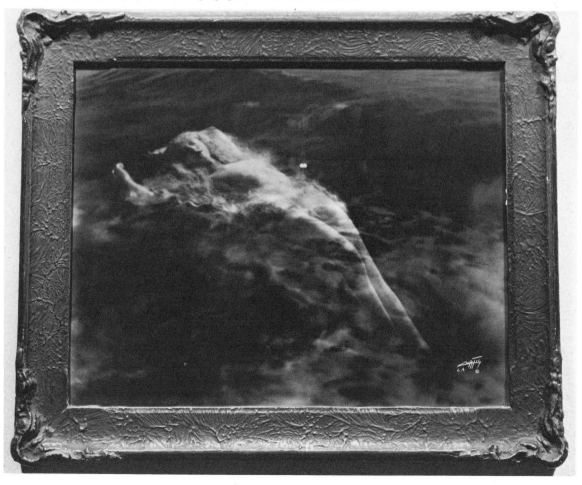

prints, and he was typical of early photographers (1900–1920) who developed their own printing processes. Many of his prints were orotone (gold-toned) photographs on glass. Later these pictures were even called "Curttones." It seems natural that, while developing this process, he also experimented with presentation. His frames, carefully finished to heighten the image, were a rich gold-brown tone to enhance the gold-toned images. He would often "proof" his images in the field, using cyanotype processes, and he even made some finished prints in this technique. When he framed blue-toned silver prints, he chose blue frames to complement the blue of the image. He also preserved his images by publishing portfolios of his work, printing photogravures on Holland paper. All these measures reflected the photographer's care and concern for the survival and presentation of the photograph.

The Frame as Environment

The frame should control the artwork's surroundings. In other words, "protect it from, for example, the patterned wallpaper against which it might someday hang" (Sue Lindstrom). The frame provides a quiet area leading into the image.

When framing is done for an entire exhibit, there is yet another consideration. In this instance, consistency of style and of size diffuse interest in the frame and increase interest in the work. Judgments made in frame selection must give preference to the total look and feel of the exhibition. The exhibit hung at the Art Institute of Chicago for the opening of the new photography gallery in 1982 is an excellent example of designing a show to minimize framing by making it consistent. It thereby maximizes the interest in individual pieces.

Contemporary Approaches to Framing

These recommendations are primarily considerations for exhibition presentations in a conventional format.

To frame images on handformed paper, we have developed a special framing system using clear acrylic boxes with an interior support structure of linen-wrapped frames. Care should be taken to obtain pre-washed linen with no sulfur in it. To mount the work in this frame, the hook tape of a Velcro strip is sewn to the linen to hold the work in place. The loop cloth of the Velcro is sewn to Pellon (an inert fabric of polyester spun webbing). The Pellon is then glued with wheat paste to the back of the piece of art work. The two Velcro strips are attached to hold the work in position in the frame. The same system may be used to attach the work directly to the

Main Gallery, The Art Institute of Chicago, Department of Photography, opening exhibition, April, 1982; "A History of Photography from Chicago Collections."

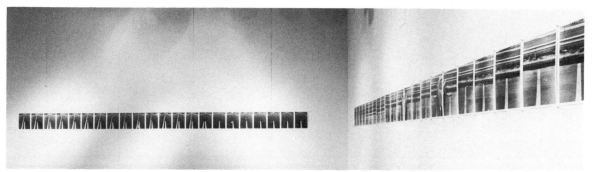

Jacqueline Rapp: "Bartlett Road" and "O'Hare Airport," silver gelatin prints, 1977. 10″ × 8″. Installation view of the gallery.

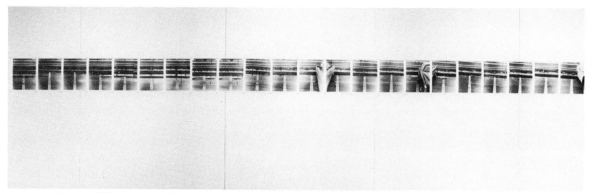

Jacqueline Rapp: "O'Hare Airport," silver gelatin prints, 1977. 10″ × 8″. Photographs are mounted to accentuate the progression of the image. Detail of installation.

gallery wall. The Velcro is simply stapled to the wall or attached with double-faced hanging material, such as 3M pressure tape. This method does not support exceedingly heavy pieces, but it has been used for works on paper up to 6′×6′. Because the paper is rag, it may hang uncovered and be relatively unaffected for the average length of time it remains in the gallery exhibition. For longer periods of time, it is advisable to use the acrylic box to prevent grime and dust from accumulating on the surface of the work.

A contemporary example of the framing and presentation system actually becoming a working part of the image is François Robert's piece. The photographs are carefully cut and positioned so that the image slowly changes as the lever at the right side of the frame is moved. This presents an interesting way for a still photograph to move in time and space.

Concerns for Storage and Presentation in Portfolios and Book Formats

Here are some archival considerations for the storage of finished but unframed artwork.

Photo boxes used for storage should be acid-free. These may be purchased from large camera stores or ordered from outlets such as Light Impressions. Again, if you wish unbuffered materials, contact Conservation Resources International for their Lig-free boxboard. Boxes may also be constructed, using rag papers. Even nonresinous wood should be avoided, as should most metal cases, unless treated with baked enamel finishes. The images should be properly matted even for storage, since the matting helps to prevent abrasion on the surface. They should be covered with acid-free tissue or polyester, such as Mylar Type D or Melinex

 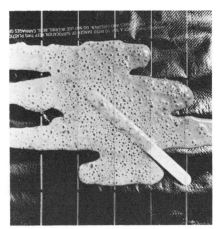

| Figure A | Figure B | Figure C |

François Robert: "Ice Cream Before, After," gelatin silver print, © 1982. Image 11" × 11", frame 23" × 23". Courtesy of Betsy Rosenfield Gallery, Chicago. This illustrates the progression of the image from "before" to "after." A tab on the side of the frame is pulled out causing the image to move from 'A' through 'B' to 'C'. All three images are within a single frame.

Type 516. Glassine should be used only if it is neutral pH (many types of glassine are acid).

Images from copy machines present special problems, because they are highly fugitive. These images must be protected from abrasion, and precautions are needed to keep the image from transferring to the surrounding materials. A double layer of glassine is placed under the image against the back mat, and mylar corners are constructed to hold the image against the mat board. A hinged top mat is modified to keep it off the image surface. A paper coated with gelatin or a neutral glassine may be placed over the surface of the image for storage. It should be kept in the dark in conditions of low humidity (30 to 50 percent). Avoid any pressure on the images, and do not store them next to each other.

In storing Van Dyke prints, unbuffered board is preferable. Keeping these prints in too neutral an environment is not advantageous. When these images are placed on buffered boards, the compounds in the board tend to migrate into the print. Cyanotypes should also be stored in a slightly acidic environment (pH in the range of 5–6). Storage in the dark retards the fading that occurs in these prints.

Barbara Crane's handsome folded paper presentation containers are constructed of rag paper and ribbon or upholstery cord. They provide a subtle tactile aesthetic support for the prints. All elements are carefully planned so that alignments of the components are meaningful. The material used in these cases is tactile, to continue the aesthetic of the print surface. Barbara Crane chose this format to involve the viewer more personally with the print. The images must be hand-held to be viewed.

Bookbinding materials and techniques may be used to create storage boxes or book format containers for images. Some of the early cyanotypes were produced as books, and in contemporary images books are regaining stature as art objects.

Keith Smith extends the book concept. He considers books as entities with intrinsic rhythms, moving from page to page and image to image with a prescribed pattern and balance.

Vicki Ragan's "dot box" came from an aesthetic question about framing and preservation. Ragan created "The Random Dot" because "it seemed to me that the standard white archival mat had become as important as the image itself. This sequence gradually alternates the photograph and the mat. In the last piece the photograph is completely gone from its original place and exists only on the mat."

206

Barbara Lazarus Metz: "Continuum," handbound book of cyanotype on paper with ultra-suede cover, © 1980. 6″ × 8″.

Collection of Barbara Crane's handmade paper folios.

Keith Smith: "A Change in Dimension," Book #2, film positives, hand applied emulsion, etching paper, colored pencil, © Summer 1967. 11″ × 14″.

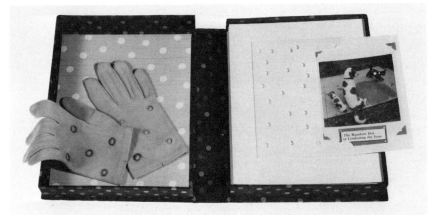

Vicki Lee Ragan: "The Random Dot," detail, 11" × 8¾".

Vicki Lee Ragan: "The Random Dot," detail, 11' × 8¾".

The box format is an excellent solution both as an extension of the image and as an archival consideration.

MUSEUM STANDARDS

With all the approaches and systems for keeping alternative process images, we wanted to find out how museums handle the pieces and whether there is a position on showing these works. One of the people we spoke with was David Travis, curator of photography for the Art Institute of Chicago. He heads one of the most advanced archives for photography in the country. The Art Institute of Chicago was one of the first major museums to build facilities to care for their photography collection, and David Travis gave us some interesting opinions on the role of the museum in caring for, collecting, and preserving works of photographic art. He stated:

The museum has a responsibility to exhibit all types of work without regard to the quality of the materials, but the museum should own only what it is prepared to care for. If a work is extremely fugitive, it should be returned to the artist after the exhibit. The museum has a responsibility, a "public trust," when it purchases work. In other words, it can only own what it can maintain. It is also important to consider that most photographic mediums are really controlled by the commercial industry rather than by the artist. In the 1850s the artist made most of his own materials, often including the photographic paper. Today photographers are somewhat helpless in dealing with archival properties because they don't have control over their materials. The problem of the artist is to do something with visual intelligence toward the material, and take care that the material will survive. The museum in turn tries to acquire works the artist wishes to be judged by, and to make those works available to the public.

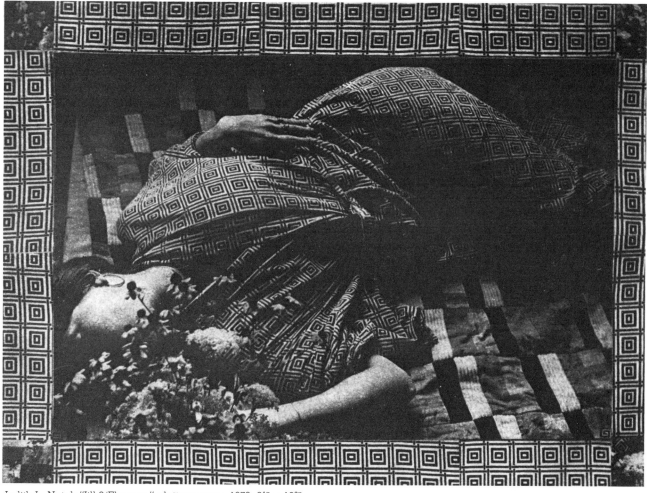

Judith L. Natal: "Jill 2/Flowers," photogravure, 1978. 9½" × 12⅜".

PHOTOGRAVURE

For artists concerned with the longevity of their image and the type of control sometimes lacking in contemporary photography, we include a final archival process designed to insure the stability of the print. This process, photogravure, would come just above carbon printing if we were to list the processes in order of archival excellence. Photogravure permits you to make any negative, or to transfer via a rephotographic means, any image in other mediums into a permanent stable photogravure print. Certain studios will help photographers produce their images in this form. For the artist with some background in printmaking, we provide the following information.

Most photogravure in commercial printing is done with a halftone screen that is etched and mounted on a cylinder for rotogravure printing. The hand method uses printmakers' asphaltum or rosin aquatint dusted onto the copper etching plate to replace the commercial half-tone screen. This produces an image in which the dot pattern is invisible without magnification and gives the final print its velvety appearance. The print has great fidelity to the tonal range of the original print. Images that emphasize the middle-range tones work best with this process.

An Outline of Process

Gravure is done with a tissue not unlike carbon printing (see Chapter 4). It can be made by applying gelatin to a strong paper as described in carbon printing. The gelatin on the surface of the paper is light-sensitized by applying potassium bichromate. After drying, the black and white positive transparency is placed in contact with the sensitized paper

Wax feet used to hold the copper plate above the bottom of the acid bath.

and exposed. The gelatin side of the paper is next placed in contact with the aquatinted copper plate, and all air bubbles are removed with a squeegee. After pressure has been applied, the plate is immersed in warm water, and the paper backing is removed. The gelatin corresponding to the black areas washes off completely and then softens in the gray areas by degrees from white (hard emulsion) through middle gray to dark (very soft emulsion). The plate is then dried.

When this process is complete, the plate is placed in successive ferric chloride baths of decreasing specific gravities (accomplished by increasing the water in the bath). The gelatin emulsion acts as an etching resist. The darks have a thinner emulsion and begin etching first, and therefore they etch deeply. The plate is removed from the etching bath as the emulsion in the highlight areas just begins to be penetrated. The plate is then washed in warm water to remove gelatin and then rubbed with alcohol to remove the rosin or with paint thinner to remove the asphaltum. The plate is next cleaned, inked, wiped, and printed, using traditional intaglio methods.

THE FILM Traditionally, low-contrast films are used for photogravure, but any high contrast orthochromatic films may be used with a low-contrast developer. Kodak Gravure Positive, Ansco Litho, Dupont Ortho Litho, or GAF Ortho Plasticopy are all satisfactory films. The last has the advantage of being somewhat resistant to scratching. You may also wish to draw directly on clear acetate to create or enhance your image. The edges of these positives should be masked.

PLATE Only copper may be used in this process. Zinc would create bubbles capable of removing the gelatin during biting in the ferric chloride. Standard engraving copper is 16 gauge and is available by mail order from Graphic Chemical (see Sources of Supply) or directly from Bridgeport Engravers Supply Co. in the cities listed under suppliers. Copper is a metal of fluctuating market value and may be quite costly. Copper plates are sometimes electroplated with steel to multiple print the image. The noncoated top surface of the plate must be meticulously cleaned with whiting and ammonia to remove all traces of grease and fingerprints. Wear gloves during this cleaning, and work in a well ventilated area. The plate is clean when water runs off the surface evenly.

AQUATINT The surface of the copper plate must now be given an even coating of powdered asphaltum in one of two ways. In one method, set the plate on the floor on a piece of cardboard. Then fill a sock with asphaltum and tap it, sending a fine powder down and dusting the plate. To guarantee fewer heavy blobs and irregularities, a more accurate system requires constructing a simple dusting box. Any covered cardboard box with dimensions of approximately 18″×18″×3′ works. Cut a trap door that can be opened up at the bottom of the box. Place a cup of powdered asphaltum in the box and shake the box in all directions. Set it down with the "door" at the bottom, and after 1 minute, slide the plate on the cardboard into the box. After a thin even deposit has formed (2–3 minutes), slide the plate out. Heat the copper plate on a hot plate set on "high" until the asphaltum melts (about 10 minutes). Allow the plate to

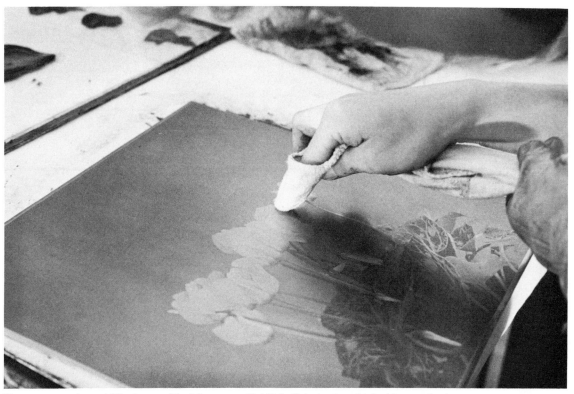

Photogravure plate of "Cyclamen," by Margaretta K. Mitchell, being hand inked in a method known as "à la poupée." Ink is carefully added to certain areas of the image. Photograph courtesy of Ed Hill Editions. Photo credit: Diana Crane.

cool, and the aquatint is complete. It is important to observe safety procedures and to wear a mask during this process.

GELATIN PAPER This paper is referred to as carbon tissue paper, gravure pigment paper, gravure carbon tissue, and/or any combination of these words. They all refer to a paper with a gelatin coating to which iron oxide has been added, giving it a reddish tint and making it easier to check the progress of the development during washing. It also limits light penetration. If purchasing this paper (see Sources of Supply), order sheets rather than rolls and take care not to crack the gelatin when handling the paper. Store it in a cool place (60°F) at low humidity (55 percent). When you are ready to use the paper, cut it ½" larger than the print. The paper is sensitized under safelight conditions by mixing 35 grams potassium dichromate in 1 liter of deionized water and cooling it to 55°F. Soak the paper in this mixture for 3 minutes, until the curl reverses. Remove the paper from this mixture and squeegee it against a ferrotype plate or Plexiglass. Dry with a fan or hair dryer on low setting (no more than 70°F). Do not use materials other than Plexiglass, because it may be impossible to remove the paper without cracking the gelatin. The dried papers should be used the same day. If storage is necessary, it must be in the dark and for no longer than three days.

EXPOSING THE PAPER The light for exposure should be rich in ultraviolet rays, such as an ultraviolet light or a sunlamp. The light should be approximately 36" above the paper or at a distance slightly greater than the diagonal measurement of the plate. The ultraviolet light

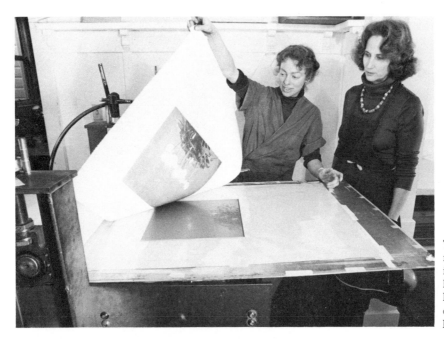

The finished print of "Cyclamen" by Margaretta K. Mitchell is lifted from the plate by printer Katie Kahn at Katherine Lincoln Press, San Francisco. Photograph courtesy of Ed Hill Editions. Photo credit: Diana Crane.

may be in the light box. Exposure times vary from 3 to 15 minutes. Position the masked film positive in tight contact with the sensitized paper, using the same orientation you wish to have in the final print. The longer the exposure, the more gelatin remains on the plate, and the fewer dark areas are in the final print. The use of Stauffer's Sensitivity Guide is helpful during exposure and etching.

TRANSFERRING THE RESIST TO THE PLATE
Begin by boiling distilled water to remove all gas bubbles. Use this water in all the following steps: Place the copper plate in a tray of warm water (80°F). While the plate is warming, place the paper resist in cool water (55°F) until the curl reverses. Remove the plate and the paper from the water baths, and gently place the paper, gelatin side down, on the copper plate. Be careful not to trap air bubbles. A squeegee may be used, but do not apply great pressure or you will make marks on the plate. Allow the paper to cool and dry for approximately 20 minutes under pressure.

DEVELOPING Slide the plate, paper side up, into a tray of warm water (100°F). If possible, this should be a stream of running water. Gently agitate the plate in the water, and the paper will loosen from the gelatin. The paper

may then be lifted slowly from the plate surface. If the paper shows any resistance, let it soak longer. After the paper has been removed, continue washing, lowering the water temperature to 95°, until the red color disappears from the plate and the wash water. Rinse the plate with a solution of 3 parts alcohol to 1 part water and then with straight alcohol. (Do this only if you used asphaltum; it will damage resin.) Set the plate on an angle to dry or use a hair dryer (not above 70°F), or dry with a fan placed two feet above the plate.

ETCHING To etch, the plate is placed in a ferric chloride bath in a plastic, glass, or enamel tray. The strength of the ferric chloride in proportion to water is given in terms of specific gravity. The most common, 48°F Baumé ferric chloride solution, may be used as a "single bath" by persons with experience in working with transparencies and tissue and controlling etching. For less experienced artists, or for those desiring a higher degree of control, the multi-bath method gives greater control. For example, a longer time in the higher Baumé bath etches the darks deeply and therefore increases contrast. The specific gravity is changed by adding distilled water as follows:

Baumé Solution	Ml of distilled water added to stock 48° Baumé ferric chloride solution
44°	148
42°	238
40°	333
38°	430

Any two or three of these may be used. A hydrometer is used to check the solutions. Note that, when water is added to the iron solution, it raises the temperature and may need to cool down overnight before it can be used. Also, after use for approximately half an hour of etching, the solution is weakened. It is advisable to attach dental wax "feet" in the margins of the plate to hold it up off the bottom of the tray. Etching is best done with the plate face down in the tray. This helps prevent pitting. The plate must be turned over often to check and control the etch. Wear gloves to check the plate and to move it from one tray to the next.

The whole process should not take more than 15–20 minutes: 4–5 minutes in the first bath (44°F Baumé), 10 minutes in the second bath (42°F Baumé) and 2–3 minutes in the third bath (38°F Baumé). As the acid etches, the shadow areas become black, and the plate should be removed before the highlight areas turn gray. Once the etching is complete, the plate is removed from the acid and gently flooded with cool water until all the ferric chloride is removed. Then the pressure and heat of the water is increased until the resist is melted from the plate.

PRINTING Printing is done using conventional intaglio methods, providing a full range of color possibilities. The inks used should be "loose": a proportion of 3 parts ink to 1 part burned plate oil is desirable. The plate is warmed and the ink applied until all areas are full. The "wipe" is done with a soft tarleton cloth. It may be desirable to buff highlight areas after the final wipe or to handwipe, using the palm of your hand. The plate is then placed on the bed of the etching press and dampened paper laid over it. Then it is run through the press. If you are using handmade papers that are unsized, it is best to dampen them, using a printer's "damp book." This damp book may be constructed by saturating blotters with a mixture of 1T formaldehyde in 1 gallon water. The mixture is applied to the blotters with a clean sponge. The papers are then interleafed with the blotters and sealed in a plastic bag overnight. After the printing is completed, the plate should be cleaned with mineral spirits.

ORIGINAL PHOTOGRAPHIC NEGATIVES
Any medium that can be rephotographed may be transferred into permanent form through this process. It is highly archival, yet it offers a wide variety of manipulative possibilities in a painterly tradition.

Margaretta Mitchell described her particular printing technique for photogravure as follows:

> To make a photogravure in color, a black and white photograph is still the first step. The color is achieved by a printing technique called "à la poupée," referring to the French word for "doll," which was used to name the cloth or paper dauber with which the colored ink is rubbed into the surface of the plate. Printers also often use their fingers or a squeegee to apply the ink. It is the use of the hands that creates the subtle painterly effects of this delicate technique. As on any intaglio plate, the best printed plate is the one appropriately wiped. Needless to say, it is necessary to have great expertise to wipe several colors on one plate and retain the desired edges or blends of color without smearing the colors one to another.

> Photogravure unites the visual immediacy of the photographic image with the physical beauty of ink pressed onto fine 100 percent rag paper. Colored photogravure printed à la poupée perfectly blends the several techniques I have pursued—painting, printmaking, and photography.

This book presents some of the techniques of the past and some of the technology of the future. It gathers many artists together in a reflective manner to look at what and who makes art. These artists teach us that photography will remain, with or without manipulation, a unique tool for personal vision.

Books listed in the Bibliography and used as source material for the text are not repeated here. However, we acknowledge the helpful information given by William Crawford in *Keepers of Light*, and the generous cooperation of the John Michael Kohler Arts Center staff, Sheboygan, Wisconsin, who provided photographs from the exhibition catalogue *The Alternative Image: An Aesthetic and Technical Exploration of Traditional Photographic Processes*.

Chapter One

1. Henri Poincaré, as quoted in a lecture by Clifford Matthews, Ph.D., December 10, 1982, at the University of Illinois, Circle Campus, Chicago.

2. Rudolph Arnheim, *Visual Thinking* (Berkeley, CA: University of California Press, 1969), p. 64.

3. William Crawford, *Keepers of Light* (Dobbs Ferry, NY: Morgan and Morgan, 1979), p. 107.

4. Crawford, p. 105.

5. Robert Heinecken, an interview with the authors on October 18, 1982, in Chicago.

6. David Hume, *Essays* (London: George Rutledge & Sons, Ltd., n.d.), p. 1969.

7. Van Deren Coke, *Sleight of Hand* (Fullerton, CA: California State University, 1982), p. 8.

8. John Ruskin, *The Lamp of Beauty*, ed. by Joan Evans (Ithaca, NY: Cornell University Press, 1980), pp. 19–20.

9. Robert Heinecken interview with the authors, October 18, 1982, in Chicago.

Chapter Two

1. Joseph Campbell, *Myths to Live By* (New York: The Viking Press, 1972), p. 135.

2. Lewis Alquist, Dr. Tung H. Jeong, Barbara Lazarus Metz, and Kathleen Thompson were particularly helpful in the development of this chapter.

Chapter Three

1. Margaretta K. Mitchell, *Recollections* (New York: The Viking Press, 1979), p. 32.

2. Aiko's Art Materials, Inc., carries Oriental papers, brushes, inks, books, and prints. Catalogues on papers and brushes are available.

3. We first became aware of the information on chemical hazards and darkroom safety through an interview with Gail Barazani. We highly recommend her book, *Safe Practices in the Arts & Crafts: A Study Guide for Artists*. Barazani referred us to Theodore Hogan because of his extensive research in occupational health.

Chapter Four

1. Igor Stravinsky, *Poetics of Music* (Cambridge, MA: Harvard University Press, 1975), pp. 26–27.

2. The following people were sources for additional technical assistance and detailed information for the processes in this chapter: Barbara Crane, Fred Endsley, Dr. Robert Green, Barbara Lazarus Metz, Jack Leblebijan, Dr. Mephie Ngoi, Katherine Pappas Parks, Nancy Rexroth, Mark Sawyer, Klaus Schnitzer, Joel Snyder, and Judith Harold Steinhauser. We also wish to acknowledge the Alden B. Dow Creativity Center, Northwood Institute, Midland, Michigan, whose generous assistance and support made possible further research into printing photographs on handmade paper.

Appendix A • Notes

3. Robert Cone at Rockford Colloid Corporation in Piermont, New York, has been an important source for our research into printing photographs on handmade paper. He is a willing consultant for questions and problems that may arise during experimentation with Liquid Light.

Chapter Five

1. Sukey Hughes, *Washi* (Tokyo: Kodansha International, 1978), p. 151.

2. The following people contributed technical information and insight to this chapter: Harold Allen, Timothy Barrett, Sherry Healy, Chuck Hilger, jonne johnson, Elaine Koretsky, Linda Sorkin, and Karen Stahlecker; also Syozo Nomura and Akinori Ohkawa at the Pulp and Paper Experimental Station, Kochi, Japan.

3. The following photographs were taken at the Dard Hunter Paper Museum, The Institute of Paper Chemistry, Appleton, Wisconsin: Pages 36, 92, 97, 102, 103, 104.

4. We especially thank Odell T. Minick, Department of Pathology, Northwestern Memorial Hospital, Chicago, who made the scanning electron micrographs.

Chapter Six

1. Robert Henri, *The Art Spirit* (Philadelphia, Penna: J. B. Lippincott, 1951), p. 66.

2. We would like to acknowledge the help of jonne johnson, who has taught courses in materials and techniques and shared with us her extensive knowledge of this subject.

Chapter Seven

1. György Doczi, *The Power of Limits* (Boulder, CO: Shambhala, 1981), p. 134.

2. Barbara Tuchman, quoted in the *New York Times*, November 2, 1980.

3. Judith O'Dell, from a quotation given to the authors specifically for this book.

4. Dane Rudhyar, *Triptych* (The Netherlands: Servire-Wassenaar, 1968), p. 54.

Chapter Eight

1. Albert Einstein, quoted in *The Dancing Wu Li Masters*, by Gary Zukav (New York: William Morrow & Co., Inc., 1979), p. 45.

2. Essential to this chapter were the contributions of: Dr. Tung H. Jeong, Tom Porett, Sonia Sheridan, Peter Thompson, and Mary Jo Toles.

3. We thank H. S. Dakin for permitting us to quote from his book, *High Voltage Photography* (San Francisco: H. S. Dakin Company, 1975).

4. The quotation attributed to Alden Dow was given to the authors specifically for this book.

Chapter Nine

1. John Szarkowski, quoted from *On Photography*, by Susan Sontag (New York: Dell Publishing Co., 1977), p. 192.

2. For special help with this chapter we are grateful to Douglas Kenyon, Sue Lindstrom of Ross Wetzel Studio, Margaretta K. Mitchell, Joshua Mann Pailet, and Robert Weinberg of Graphic Conservation Company.

Interview with Jeffrey Gilbert on the Japanese photographer, Nojima

The development of art photography and Western style modern art in Japan occupy parallel histories during the Meiji Restoration of 1868–1912 and present a unique synthesis of Eastern and Western cultural aesthetics. Yasuzo Nojima (1885–1964) was born in Urawa outside of Tokyo and in 1905 entered Keio University, where he studied photography and painting. He was a member of the first generation of Japanese intellectuals to receive a thoroughly Western-oriented education, and this in part helped to form his goal to achieve individual self-expression. This philosophy was central to the spirit of Modernism which prevailed during the Taisho Period (1912–1926). Nojima worked extensively in gum printing and bromoil from 1905 to 1932. He perfected his techniques as a member of the Tokyo Photography Study Group. From 1904 to 1909 the founders of this group introduced the bichromate, pigment, oil, and bromoil printing methods to Japan. At that time Nojima decided to create one-of-a-kind photographs that reflected his personal philosophy that the unique images expressed his self-existence. The subjects of these photographs were nudes, still lifes, and portraits. In 1932, he switched to silver prints to explore the "new objectivity" and Bauhaus ideas of Maholy-Nagy.

Throughout his career Nojima pioneered the campaign for the recognition of photography as a fine art. He established three galleries for the exhibition of photography and other modern Japanese art. In 1932 he began publishing *Koga*, a pioneering critical journal of modern photography. This journal was published with Nobuo Ina, Ihei Kimura, and Iwata Nakayama. The contributors, photographers, and critics worked together to develop the "New Vision" in Japan. Because of its selected international distribution, it also introduced the work of many modern Japanese photographers of the West.

Nojima's unique body of photographic work (together with his support of other fine art mediums) forms a foundation for the appreciation of modern Japanese art in both his own country and the West.

Advance Process & Supply Co.
400 N. Noble St.
Chicago, Il 60622
Catalog & Price List

Aiko's Art Materials Import, Inc.
714 N. Wabash
Chicago, IL 60611
Papers and Brushes

Air Photo Supply Corp.
PO Box 158 So. Station
Yonkers, NY 10705

American Institute of Conservation
National Office
Martha Morales, Ex. Sec.
3545 Williamsburg Lane NW
Washington, DC 20008
Conservation Information

Andrews, Nelson, Whitehead
7 Laight St.
New York, NY 10013
Art and Handmade Paper

Aristo Grid Lamp Products, Inc.
PO Box 769
Port Washington, LI, NY 11050
Aristo Grid Lamp Light Source

Autotype U.S.A.
501 W. Golf Rd.
Arlington Hts, IL 60005
Photographic Supplies
Photographic Dye Transfer
Materials and Dyes

Barcham Green & Co., Ltd.
(Simon Green)
Hayle Mill
Maidstone
Kent ME15 6XQ, England
Handmade Papers

Black Box Collotype Studios Inc.
4840 W. Belmont Ave.
Chicago, Il 60641
Photographic Supplies

Blue Mountain Photo Supply
Box 3085
Reading, PA 19604
Historic and Alternative Photo Processes

Bostick & Sullivan
PO Box 2155
Van Nuys, CA 91404
Platinum & Palladium, Photographic Chemicals
Paper Information

Bridgeport Engraving Supply Co.
333 State St.
Bridgeport, CN 06602
Photo-engraving Copper, Magnesium, and Zinc

R. K. Burt and Co. Ltd.
57, Union Street
London, SE. 1, England
Papers and Supplies

California Ink Co.
501 15th St.
San Francisco, CA 94103
Inks & Chemicals

Carriage House Handmade Papers
8 Evans Rd.
Brookline, MA 02146
Papermaking Supplies

Center for Occupational Hazards, Inc.
5 Beekman Street
New York, NY 10038
Publishers of Art Hazard News

Cerulean Blue, Ltd.
PO Box 21168
Seattle, WA 98111
Graphic Arts or Photo Suppliers
Dye Transfer Paper
Prepackaged Sensitizers
Inkodye, Blueprint Kit, Brown Print Kit
Fabrics for Printing

The College Art Association of America
16 E. 52nd St.
New York, NY 10022
"Safe Practices in the Arts & Crafts: A Studio Guide"
by Gail Barazani

Appendix B • Sources of Supply

D.Y.E.
3763 Durango Ave.
Los Angeles, CA 90034
Prepackaged Sensitizers
Cyanotype, Blueprint & Brown Print Kits
Prewashed Fabrics

Dawson's Book Store
535 N. Larchmont Blvd.
Los Angeles, CA 90004
Papermaking Books

Dieu Donne Press and Paper Mill
3 Crosby St.
New York, New York 10013
Handmade Papers

Eastman Kodak Co.
Rochester, NY 14604
Technical & Chemical Information
Pamphlets on Processes

Elegant Images Ltd.
3421 M. St. NW
Washington, DC 20007
Photographic Supplies
Platinum & Palladium Printing
Information and Materials

Farnsworth & Co. Papermakers
2325 Third St., No. 406
San Francisco, CA 94107
Custom Made Paper

Sam Fine
6710 N. Sheridan Rd.
Chicago, IL
Technical Expert in Kallitype & Photo Etching

Gold's Art & Frame
2918 N. Elm
Lumberton, NC 28358
Papermaking Supplies

Graphic Chemical Co.
PO Box 27
728 North Yale Ave.
Villa Park, IL 60181
Inks, Materials & Paper

Dr. Robert Green
Gallery 614
0350 Country Road 20
Corunna, IN 46730
Photographic Materials
Pigment Tissue for Carbon & Carbro Printing
Fine Selection of Final Support Papers
Gelatin Paper for Oil Printing
Manual for Tricolor Carbro Printing

Chuck Hilger
705 Pacific
Santa Cruz, CA 95060
Vacuum Tables

Holography Workshops
Lake Forest College
Lake Forest, IL 60045
Holography, Information

Hoos Photo
1745 Sherman Ave.
Evanston, IL 60201
Photography Supplies and Used Equipment

Hunter-Penrose Ltd.
7 Spa Rd.
London, SE 16, England
Etching Supplies

Image Hand Paper Mill
1333 Wood St.
Oakland, CA 94607
Paper Supplies
Internally Sized Handmade Paper

Integraf
Box 586
Lake Forest, IL 60045
Holography
Information and Supplies

Kalamazoo Handmade Paper
5947 N. 25th St.
Kalamazoo, MI 49004
Western, Japanese Handmade Papers for Conservation and Book Arts

Kirlian Equipment Co.
555 N. Broadway
Jericho, NY 11753
High-Voltage Supplies

W. H. Korn, Inc.
260 West Street
New York, NY 10013
Litho, Crayons, Pencils, Inks, & Materials

Light Impressions
PO Box 3012
Rochester, NY 14614
Kwik-Print Pigments, Kits, and Other Kwik-Print Supplies
100% Acid-Free Mounting Board for Archival Display andPhotographic Materials.
Catalog Available.

Luminos Photo Corporation
25 Wolffe St.
Yonkers, NY 10705
Photo Linen

Lee McDonald
PO Box 264
Charlestown, MA 02129
Papermaking Supplies
Papermaking fibers, processing equipment,
aequous pigments, sizings,
buffering and color retention agents
Oriental and Western Moulds
Felts. Catalog.

The Maine Photographic ReSource
2 Central Street
Rockport, Maine 04856
Specialty Store for Photographic Books,
Materials, Supplies, and Hard-to-Find
Products and Chemistries. Catalogue.

Mid-West Neon Supply
2920 W. Belmont
Chicago, IL 60618
Product Information for light sources

Miller Cardboard Corporation
75 Wooster Street
New York, NY 10012
Acid Free Matting and
Mounting Materials

Museum of Holography
11 Mercer St.
New York, NY 10013
Holography Information

New York Central Art Supply, Inc.
62 Third Ave.
New York, NY 10003
Art Materials and Supplies
Paper Samples: Catalog Available

Paperchase
213 Tottenham Court Rd.
London, W1, England
Selection of Japanese and Handmade Papers

Paper Press
340 W. Huron
Chicago, IL 60610
Handmade Paper Information & Supplies, Classes,
and Collaborative Projects

Paper Source
207 W. Superior
Chicago, IL 60610
Art and Handmade Papers

Peerless Color Laboratories
11 Diamond Pl.
Rochester, NY 14609
Transparent Water Colors

Pelouze Scale Co.
2120 Greenwood
Evanston, IL 60202
Metric Scales

Photographers Formulary, Inc.
PO Box 5105
Missoula, MT 59806
Photographic Chemicals and Supplies
Amidol Developer, Nelson's Gold Toner, Wide
Selection of Photographic Chemicals, Various
Alternative Processes Kits.

Photo Lab Index
Morgan & Morgan
Dobbs Ferry, NY 10522
Photographic Supplies
Updates on Chemicals & Old Processes

Polaroid Corporation
Industrial Marketing & Technical Assistance
575 Technology Square
Cambridge, MA 02139
Product Information

Porter's U-Spread Emulsion
Porter's Camera Store, Inc.
PO Box 628
Cedar Falls, IA 50613
Projection–Speed Emulsion

Pro Chemical & Dye
PO Box 14
Sommerset, MA 02726
Pigments & Dyes

Process Materials Corporation
301 Veterans Blvd.
Rutherford, NJ 07070
*Fine Art Papers, Mounting and
Matting Materials. Free Catalogue.*

Pyramid Artists' Materials
2107 High Cross Rd.
Urbana, IL 61801
*Artists' and Hand Papermaking Supplies,
Educational Materials. Catalog.*

Pyramid Prints and Paperworks
1601 Guilford Ave.
Baltimore, MD 21202
*Papermaking Classes, Supplies,
Collaborative Projects*

Quick-Way Color Copies
100 East Ohio
Chicago, IL 60611
Graphic Arts Photo Suppliers
Transfer Sheets for Electrostatic Transfer

R. & J Arts, Inc.
4821 South 1395 East
Salt Lake City, UT 84117
Prepackaged Sensitizers
Cyanotype Kits

Rockland Colloid Corporation
302 Piermont Ave.
Piermont, NY 10968
Prepackaged Sensitizers and Emulsions
Liquid Light Photo Emulsion & Information

Sargent-Welch Scientific Co.
7300 N. Linder Ave.
Skokie, IL 60077
Chemicals

Sargents Drug Store
23 N. Wabash Ave.
Chicago, IL 60602
Chemical Supplies

Mark Sawyer
1440 East Adams
Tucson, AZ 85719
Uranium Printing Information

Klaus Schnitzer
187 Montclaire Ave.
Montclaire, NJ 07042
Platinum & Palladium Printing Information

Screen Process Supplies
1199 E. 12th St.
Oakland, CA 94606
Prepackaged Sensitizers
Inkodye

Asao Shimura
Cannabis Press
431 Fukuhara Kasama-SH1
Ibaragi-Ken 309-15
Japan
Oriental Fiber, Moulds

Daniel Smith, Inc.
4130 1st Ave. S.
Seattle, WA 98134
Fine Papers/Complete Art Supplies

Straw Into Gold
PO Box 2904
5533 College Ave.
Oakland, CA 94518
Fibers. Catalog.

Talas
104 Fifth Ave.
New York, NY 10011
Sizing and Archival Supplies

Tamarind Institute
University of New Mexico
Albuquerque, NM 87106
Printing and Paper Information
Presses, Litho, Quarterly Review

Test Fabrics, Inc.
PO Drawer O
200 Blackford Ave.
Middlesex, NJ 08846
Prepackaged Cotton Sensitizers
Unsized Fabrics for Contact Printing

Textile Resources
PO Box 90245
Long Beach, CA 90809
Prepackaged Sensitizers
Blueprint and Brown Print kits
Prewashed Fabrics

3M Company
Graphic Preparation Systems Division
3M Center/223-2N-01
St. Paul, MN 55144
Copy Machine Materials
3M Color Key and Transfer Key Products

Transcello Inks
Advance Process Supply
400 N. Noble St.
Chicago, IL 60622
Graphic Arts or Photo Suppliers
Inks for Printing Dye-Transfer Paper

Twinrocker, Inc.
RFD 2
Brookston, IN 47923
Handmade Paper Custom-Made to Specifications
Papermaking Supplies

VWR Scientific
PO Box 7800
Rincon Annex
San Francisco, CA 94120
1972 Educator's Catalog of Laboratory Apparatus &
Chemicals

Visual Studies Workshop
31 Prince St.
Rochester, NY 14607
Pamphlets & Information on Experimental
Processes

Voith-Allis
PO Box 2337
Appleton, WI 54911
Valley Beaters

Ross Wetzel Studio
1212 Washington St.
Wilmette, IL 60091
Archival Supplies
Framing Materials, Art and Handmade Papers

The World Print Council
PO Box 26010
San Francisco, CA 94126
Publications on Papermaking

acetic acid	Mild acid (commonly found in vinegar) used to form "stop bath" to neutralize the developer. Also used to prevent bleeding of colors in dye transfer
acid	Any hydrogen compound with a pH of less than 7. This turns blue litmus paper red. In photography, acids combine with metals to form salts.
additive color	The name of the color mixing system using light. The primaries are red, green, and blue, which combine to form lighter, brighter colors and which, together, form white.
á la poupée	An intaglio printmaking term referring to the use of hand-applied color. Several colors are added simultaneously by dabbing inks onto the plate, using a soft cloth on the pad.
albumen	An egg white mixture used to form emulsion on printing paper. Widely used 1850–1890.
alkali	A compound with a pH greater than 7; it tends to feel slippery. This turns red litmus blue. Used to neutralize acid.
aquatint	A process using asphaltum to coat the surface of an etching plate to give a ground or base tone to the print.
archival	Having a quality of permanence.
asphaltum	Acid-resistant ingredient in the surface coating materials used in etching.
bichromate	(Also dichromate.) Poisonous chromium salts of ammonium, potassium, or sodium used in gum printing and as bleach baths.
bite	The "eating in" or corrosive effect of acid on the surface of a printing plate.
burnt plate oil	The heavy oil remaining when linseed oil has been reduced by ignition. Used to thin etching inks in photogravure.
calcium carbonate	A by-product in the manufacture of caustic soda used as a filler and coating agent in paper.
calotype	(Also Talbotype.) A paper negative process invented in 1840 by Fox Talbot. It shortened the exposure time significantly, and was the first successful negative-positive process in photography allowing multiple prints of the same image to be made. Use of the process was restricted by Talbot patents.

Appendix C • Glossary

camera obscura	(From the Latin for "dark room.") It reflected an upside-down image on the wall or side opposite a pinhole opening for light to enter. It became a "camera" as light-sensitive materials developed.
chiaroscuro	Italian term referring to variations in tone from light to dark. Shading.
chine collé	A process of attaching thin sheets of paper to the backing paper at the same time a print is being printed.
collodion	A glue-like transparent solution used to coat emulsion supports in the wet-plate process of the 1800s. It consisted of pyroxyline in alcohol and ether.
contact print	Print made by placing emulsion side of negative in close contact with a light-sensitive support paper. Exposed with a direct or artificial light, or with sunlight.
continuous spectrum	Light with measurable quantities of all wave lengths of visible color. Sunlight and tungsten bulbs emit this light.
contrast	In a black-and-white photograph, differences in brilliance from one area to another make the image visible. "Contrasty" indicates extreme differences.
daguerreotype	Process invented by Louis Daguerre in mid-1800s using vapors from heated mercury to register an image on a copper plate coated with polished silver.
density	Characteristic of an area of image silver that absorbs (or prevents transmission of) light.
densitometer	Instrument for measuring silver deposits; that is, density of developed images.
dark reaction	A progressive hardening of light-sensitive materials in the absence of light.
dichromate	See bichromate
dimensional stability	A quality in paper that prevents shrinking or stretching.
emulsion	A mixture of silver halides (or a silver salt suspension) in a viscous medium, often gelatin. Generally refers to any light-sensitive medium used to coat photographic films or paper.
ferric	The presence of iron.
ferrotype	Processing of iron in the plates of the tintype. Now a procedure of squeegeeing photographic prints, emulsion side against a polished metal surface, to impart a gloss.

foxing	The brown stain in paper caused by the reaction of the micro-organisms to iron contained in the paper.
frilling	The wrinkling or detaching of the emulsion from the support during processing. Masking the edge during exposure helps to prevent this.
gelatin	A medium or binder of complex protein used as an emulsion vehicle and as a sizing agent.
halides	Compounds of halogens (fluorine, chlorine, iodine, and bromine) with electropositive elements. These elements mixed with silver and other metallic salts form the light-sensitive compounds for most photographic emulsions.
hygroscopic	Water-retaining.
lithography	Printing process using special materials that are treated chemically to accept ink on the surface of stone or metal. Non-image areas are treated to accept water or remain clear.
masking	The blocking of the edge or parts of the image with opaque materials, such as tape or paint.
matte	A dull or nonglossy surface.
negative	Any material on which the subject tones are reversed. Used to make a positive image that appears as the original.
opaque	Unable to transmit light. Also, finely ground tempera used to mask certain areas.
orthochromatic	Materials sensitive to all but red-orange light.
pH	A scale of value between acid and alkaline from 0–14: 7 is neutral; less than 7 is acidic; greater than 7 is alkaline.
positive	An image in which the tones match those of the object depicted.
primary color	The pigments or light that cannot be obtained by mixing.
photogravure	A printing process using a plate on which a photographic image has been produced with carbon tissue.
photogram	The print made by placing objects or patterns directly on light-sensitive materials and exposing to light.
Pi System	A method which utilizes a specially sized handmade paper for photographic printing techniques.
pigment	Finely ground coloring materials.

register	The alignment of images either to keep edges and objects on top of each other or in a prescribed pattern.
saturation	The intensity or purity of color (brilliance versus softness). Also a solution in which no more of a particular chemical may be added.
separation	The use of three negatives to show values of red, green, and blue. Obtained by photographing the subject through filters of those colors.
sumi	Black Chinese ink.
test strip	A paper or support treated with emulsion, used to check varying exposures for particular negatives.
toner	Chemical used to change the color of the image, either prior to or after development.
translucent	The quality of being neither opaque nor clear.
ultraviolet	The bands of light of short wavelength on the upper side of the visible spectrum, beyond visible violet light.
wet plate	Process in which sensitized plates are both exposed and developed while wet. Usually refers to the collodion process.

PAPERMAKING TERMS

abaca	A strong bast fiber from the Philippines, whose leaf stalks are used to make Manila hemp. Used for Eastern and Western sheet forming; takes Oriental dyes well. Also the name of the plant.
alpha-cellulose	A state or condition for pulps.
bast fiber	A fiber that comes from the inner stalk of the plant, primarily used in Oriental sheet forming. Fibers such as kozo, gampi, ramie, and flax are bast fiber.
beating	Macerating the fibers to collapse the fiber walls and increase the bonding surfaces.
bleaching	Whitening the fiber by use of the sun in Oriental processing or chlorine-based chemicals in Western papermaking. The use of bleach may weaken the fiber in the paper.
calendering	The use of metal rollers and heat to impart a smooth surface and even weight to paper.
casting	The use of forms or moulds into which pulp is placed to create three-dimensional paper sculpture.

cellulose	The carbohydrate component in fibers.
chain lines	The pattern (in the finished sheet) or slight watermark left by the structure of the screen. On a laid mould, the wire running vertically up the surface holding the horizontal wires in place and keeping even spacing.
chiri	Bits of black bark and injured fiber, picked and discarded in the Oriental papermaking process. Also paper formed from these scraps.
cold press	Partially pressed paper that retains the rough, pebbly surface of the felt.
couch	(Pronounced "cooch.") The action of transferring a freshly formed sheet of handmade paper to a felt or blanket, thus removing it from the screen surface of the mould.
deckle	The wooden frame that fits over the mould to contain the pulp as the sheet is formed. In Western papermaking, the deckle is separate from the mould. In Oriental papermaking, it is hinged to the mould.
deckle edge	The feathered, uneven edge on a sheet of untrimmed paper. Formed by a slight slippage of the pulp under and against the deckle in the formation process.
emboss	To impart a design or pattern in the paper surface. Achieved by pressing paper against a low relief object, usually by using an etching press.
external sizing	Sizing materials applied to the finished paper surface (see sizing).
felt	The heavy sheet of woven fabric, usually wool, upon which the paper is couched. In Western papermaking, felts are layered between sheets of paper prior to pressing.
felt side	The pattern left by the felt on one side of the paper as it is processed commercially.
fibrilation	The roughening of the fiber walls to increase bonding with water in papermaking.
filler or load	Clays or minerals added to the pulp during beating that fill in spaces between the fibers to create a smoother, more opaque surface. Common fillers are clays, calcium carbonate, and titanium dioxide.
flax	The bast fiber from which linen is made. Long, tough fiber producing strong paper with good sheen.
formation	The distribution of fiber in the finished sheet. Checked by holding the sheet up to the light. It is controlled through proper beating and the action of the mould in the vat as the sheet is formed.

formation aid	The mucilage-type substance used in Oriental papermaking to control distribution of fiber and drainage of water from the mould during the forming of the sheet. Traditionally tororo-aoi root was used. Okra is a common substitute, and PNS is a synthetic equivalent.
fune	Japanese papermaking vat (translated, it means "boat").
furnish	The combination of materials added to the vat—pulp, sizings or fillers, dye or coloring agents. The furnish determines the type of paper produced.
gampi	The bast fiber shrub (generally uncultivated) characterized by long, fine, strong, glossy fibers.
gelatin	A colorless protein derived from processing animal tissue. Excellent sizing for paper. Renders paper water-resistant, controlling "bleeding" of color in painting and printmaking. May be used with pulp in the vat or brushed on the finished sheet. Renders paper more reflective for photographic processing.
glassine or glazed paper	A shiny, semitransparent paper produced by calendering with highly polished heated rollers. Special acid-free glassine is available for archival photographic storage.
half-stuff	Partially beaten fiber, generally cotton, ready for the beater. Sold dry to supply papermakers. Generally longer fiber than linters.
hankusa	Oriental term meaning "half-fiber, half-pulp paper."
hemi cellulose	The strongest bending cells of cellulose. More susceptible to deterioration from atmospheric pollutants and chemicals.
hemp	High cellulose fiber for papermaking. Produces strong, lustrous paper.
hog	A machine for agitating pulp in the vat. Sometimes mechanical, it has comb-like blades that keep fibers evenly distributed. Called a *mase* or *zaburi* in Oriental papermaking.
Hollander	The machine used for beating fiber into pulp. Invented in Holland in the eighteenth century to replace the stamping machines. Consists of a cylindrical blade and bedplate mechanism mounted on one side of an oval vat. Fiber and water circulate around the vat and are thrown in contact with the blades that gradually macerate the fiber into pulp. The shortening of fiber that occurs makes it somewhat less desirable than stamping or hand beating.
hot press	Paper calendered to produce a smooth surface.
hydropulper	The machine used to process primarily linter cotton fiber for papermaking. The power-driven agitator hydrates the cellulose to increase bonding. Blenders are simple hydropulpers.

internal sizing	Sizing added to the pulp during beating. May also refer to sizing added to the vat prior to sheet formation.
jute	Indian fiber popular with European papermakers in the late eighteenth century to supplement the diminishing supply of cotton and flax. Makes durable paper and may be used unprocessed for texture.
kamisuki	Papermaking in Japan.
keta	Hinged wooden frame in Japanese papermaking that holds a loose screen or *su*, sandwiched between the upper and lower sections. The upper frame may have handles and is comparable to the deckle in Western papermaking.
kozo	Variety of papermaking mulberries producing strong, long fiber paper with good sheen.
laid paper	Paper retaining the pattern of the laid mould surface. These are long parallel strands of wire covering the surface of the mould. They produce an even pattern of linear marks visible when paper is held.
laid mould	Wooden frame mould with wire surface. Individual wires are strung across and held in place and slightly separated by chain lines (see laid paper). The first moulds used by Western papermakers were of this type.
laminated	Paper formed by couching one sheet on top of another without placing felt between. One sheet bonds to the next when pressed.
lignin	Found in the cellulose structure of plants. Considered undesirable because it resists bonding and is attacked by deteriorating substances. Cotton has no lignin.
linter	Short fiber left on the seed when cotton is ginned. The fiber is retrieved and processed into blotter-like sheets and sold to the paper industry.
load	See *filler*.
mitsumata	Bast fiber. One of the three fibers primarily used in Japanese papermaking. Produces fine grain, soft, absorbant paper.
mould	Basic tool in papermaking. The wooden structure that supports the screen surface on which the paper is formed.
nagashi-zuki	Means "discharge papermaking." Japanese process of sloshing the excess pulp from the screen surface to gradually build up layers of fiber until a desired thickness is achieved. This action is made possible by the use of neri or other formation aids.
neri	Term for different types of vegetable base formation aids. The most common is tororo-aoi.

papyrus	The writing substance formed by laying slices of the stalk at right angles to each other and pounding with a mallet to bind them into "paper." This surface is not true paper because no water bath is used in the process of forming the sheet, but it is one of the oldest writing surfaces similar to paper.
PNS	A synthetic formation aid.
post	A stack or pile of wet-formed paper sheets interleafed with felt in preparation for pressing to remove excess water.
pulp	The papermaking material in wet state ready to be used to form paper. It is produced mechanically by introducing fiber into a beating or mixing apparatus or chemically with the addition of agents, which break down and separate the fibers. The pulp is then diluted for adding to the vat.
quire	A measure of 24 sheets of paper.
ream	A larger measure for paper sheets (20 quires), or 480–500 sheets.
retting	The process of decaying fibers by placing them in contact with moisture. This begins to separate the fiber from its core.
rice paper	An incorrect name for Oriental paper. Originally translucent paper made by slicing the pith of the Arabic papyrifera tree.
seed hair	Short fiber left clinging to the seed as cotton is processed. Commonly used to produce linters for papermaking.
sha	Fabric, usually silk, placed over the su to create woven paper and lessen the pattern of the su in the finished sheet.
sizing	Water-resistant materials such as gelatin, starch, glue, and the like, that are added to the paper in its pulp stage or after drying to fill in the interstices between fibers and to control wetting or bleeding of inks and dyes.
slurry or stock	The mixture of pulp and water in the vat. The ratio of pulp to water in the slurry helps to determine the thickness of the finished sheet.
stamper	Machine used in early papermaking to pound fibers into pulp. It operated by pounding a hammerhead device into a trough or bucket-like container. Stampers were often powered by water wheels. Contemporary versions are used to process bast fiber and are electrically driven.
stuff	The material used in papermaking—the fiber used to produce the paper.
su	The loose screen surface of a Japanese mould made of thin strips of bamboo with silk chain lines.

sugeta	Japanese papermaking mould. In total, a combination of the keta or framework and of the su or loose screen.
tamezuke	The original method of papermaking by a single scoop of the mould into the fiber without the use of formation aid. Now considered "Western" papermaking.
tororo-aoi	Roots of this plant are crushed to produce the formation aid for Japanese papermaking. (See neri.)
vacuum forming	The use of a closed chamber to remove water from the pulp. This achieves an embossed or semi-sculptured sheet when objects are placed under the surface of the pulp. Many special effects may be obtained by using vacuum forming equipment.
vat	Container or tub used to hold the slurry (pulp and water) for dipping the mould and deckle to form the sheet of handmade paper.
waterleaf	The newly formed sheet before it is pressed; also, paper that is unsized.
washi	Japanese paper.
watermark	A semi-transparent area of the finished sheet, which, when held to the light, reveals a pattern, word, or special mark. Often the mark of the particular mill that produced the paper, such as Fabriano. May be a linear pattern or chiaroscuro using shaded areas to create portraits or scenes.
wove	Refers to both the mould and the finished paper. The surface of the mould has intersecting wires in a screen mesh pattern, which in turn produces a smooth surface sheet of paper with no linear pattern. (See laid.)

WEIGHTS AND MEASURES—CONVERSION TABLES

In American photographic practice, solids are weighed by either the Avoirdupois or the metric system, and liquids are measured correspondingly by U.S. liquid or metric measure. The following tables give the equivalent values required for converting quantities from one system to the other.

Avoirdupois to Metric Weight				
Pounds	Ounces	Grains	Grams	Kilograms
1	16	7000	453.6	0.4536
0.0625	1	437.5	28.35	0.02835
		1	0.0648	
	0.03527	15.43	1	0.001
2.205	35.27	15430	1000	1

U.S. Liquid to Metric Measure				
Gallons	Quarts	Ounces (Fluid)	Milli-liters	Liters
1	4	128	3785.	3.785
0.25	1	32	946.3	0.9463
		1	29.57	0.02957
		0.125	3.697	0.003697
		0.03381	1	0.001
0.2642	1.057	33.81	1000	1

CONVERSION FACTORS

Ounces per 32 fluid ounces multiplied by 29.96 = grams per liter

Pounds per 32 fluid ounces multiplied by 479.3 = grams per liter

Grams per liter multiplied by 0.03338 = ounces per 32 fluid ounces

Grams per liter multiplied by 0.002086 = pounds per 32 fluid ounces

Grams per liter approximately equals ounces per 30 quarts

Grams per liter approximately equals pounds per 120 gallons

Ounces (fluid) per 32 ounces multiplied by 31.25 = milliliters per liter

Milliliters per liter multiplied by 0.032 = ounces (fluid) per 32 ounces

centimeters × .3937 = inches

inches × 2.5400 = centimeters

Appendix D • Tables

APPROXIMATE HOUSEHOLD MEASURES

U.S. Equivalents	Metric	
1 teaspoon	⅙	fluid ounce
	5	milliliters
	75–100	drops
1 tablespoon	½	fluid ounce
	14½	milliliters
	3	teaspoons
1 cup	8	fluid ounces
	237	milliliters
	48	teaspoons
	16	tablespoons
1 pint	16	fluid ounces
	473	milliliters
	96	teaspoons
	32	tablespoons
	2	cups
1 quart	32	fluid ounces
	948	milliliters
	192	teaspoons
	64	tablespoons

Adams, Ansel. *Polaroid Land Photography*. New York: New York Graphic Society, 1978.

Allen, Harold. *Father Ravalli's Missions*. Chicago: The School of the Art Institute of Chicago, 1972.

Anderson, Harold H., editor. *Creativity and Its Cultivation*. New York & Evanston: Harper & Row, Publishers, 1959.

Arnheim, Rudolf. *Visual Thinking*. Los Angeles: University of California Press, 1969.

Arnow, Jan. *Handbook of Alternative Photographic Processes*. New York: Van Nostrand Reinhold Co., 1982.

The Art Gallery Visual Arts Center. *Sleight of Hand*. Fullerton: California State University (November 5–December 9, 1982).

Barazani, Gail Coningsby. *Safe Practices in the Arts & Crafts: A Studio Guide*. New York: The College Art Association of America, 1978.

Barzun, Jacques. *Darwin, Marx, Wagner*. Garden City, New York: Doubleday Anchor Book, 1958.

Bell, Lilian A. *Plant Fibers for Papermaking*. McMinnville, Oregon: Liliaceae Press, 1981.

Bentov, Itzhak. *Stalking the Wild Pendulum*. New York: E. P. Dutton, 1979.

Brigadier, Anne. *Collage: A Complete Guide for Artists*. New York: Watson-Guptill Publications, 1970.

Campbell, Joseph. *Myths to Live By*. New York: The Viking Press, 1972.

Cox, Meg. "Photographers Who Want Color Prints That Last Say Carbon-Pigment Process Stands Test of Time," *The Wall Street Journal* (July 1, 1981), p. 44.

Crane, Barbara. *Barbara Crane Photographs 1948–1980*. Tucson, Arizona: Center for Creative Photography/University of Arizona, 1981.

Crawford, William. *Keepers of Light*. New York: Morgan & Morgan, 1979.

Dakin, H. S. *High-Voltage Photography*, 2nd ed. San Francisco: H. S. Dakin Company, 1975.

Davis, Phil. *Photography*. Dubuque, Iowa: William C. Brown Co., 1972.

Doczi, Gyorgy. *The Power of Limits*. Boulder & London: Shambhala, 1981.

Eastman Kodak Co. *Darkroom Dataguide*. Rochester, NY: Eastman Kodak Co., 1974.

Fredrick, Peter. *Creative Sunprinting*. London: Focal Press, 1980.

Gardner, Helen. *Art Through the Ages*. New York: Harcourt, Brace & Co., 1948.

Gassen, Arnold. *Handbook for Contemporary Photography*, 2nd ed. Athens, Ohio: Handbook Publishing Co., 1971.

Gassen, Arnold. *A Chronology of Photography*. Athens, Ohio: Handbook Publishing Company, 1972.

Gerritsen, Frans. *Theory and Practice of Color*. London: MacMillan, Inc., 1975.

Green, Dr. Robert. *Carbro, Carbon; Monochrom, Trichrome*, 2nd rev. ed. Fort Wayne, Indiana: Gallery 614, 1977.

Hawley, Gessner G. *The Condensed Chemical Dictionary*, 9th ed. New York: Van Nostrand Reinhold Company, 1977.

Heller, Jules. *Papermaking*. New York: Watson-Guptill Publications, 1978.

Hughes, Sukey. *Washi: The World of Japanese Paper*. Tokyo, New York, & San Francisco: Kodansha International, 1978.

Hume, David. *Essays*. London: George Rutledge & Sons, Ltd., n.d., pp. 165–182.

Imberdis, S. J. Translated by Eric Laughton. *Papyrus of the Craft of Paper*. Bird & Bull Press, 1961. (Original Edition, 1693)

Johnston, Mark. "Altered Images," *Artweek* (November 27, 1982), p. 12.

Jones, Darryl, "Carbon, Carbro Printing Processes Reviewed," *Arts Insight* (November 1981), pp. 11, 12.

Koretsky, Elaine and Toale, Bernard, Directors. *International Conference of Handpapermakers*. Carriage House Press, 1981, p. 90.

Krippner, S., and Rubin, D. *Galaxies of Life, the Human Aura in Acupuncture and Kirlian Photography*. New York: Gordon and Breach, 1973.

Life Library of Photography. *The Camera*. New York: Time-Life Books, 1970.

Appendix E • Bibliography

Loach, Roberta. *Visual Dialog*. Los Angeles: Visual Dialog Inc., 1978.

Long, Paulette, Editor. *Paper Art & Technology*. San Francisco: World Print Council, 1979.

Mason, John. *Papermaking as an Artistic Craft*. Leichester, England: Twelve by Eight, 1963.

Massey, Robert. *Formulas for Painters*. New York: Watson-Guptill Publications, 1979.

Mayer, Ralph. *The Artist's Handbook of Materials and Techniques*. New York: The Viking Press, 1959.

McCann, Michael. *Health Hazards Manual for Artists*, rev. ed. New York: The Foundation for the Community of Artists, 1975.

McCray, Marilyn. *Electroworks*. Rochester, NY: The George Eastman House, 1979.

Mitchell, Margaretta K. *Recollections*. New York: The Viking Press, 1979.

Nettles, Bea. *Breaking the Rules: A Photo Media Cookbook*. Rochester, NY: Light Impressions Corporation, 1977.

Newhall, Beaumont. *The History of Photography*. New York: The Museum of Modern Art, 1964.

Newman, Thelma, R. *Innovative Printmaking*. New York: Crown Publishers, 1977.

Nickle, Robert. *Robert Nickle Collages*. Chicago: The Art Institute of Chicago, 1978.

Ostrander, S. & Schroeder, L. *Psychic Discoveries Behind the Iron Curtain*. New York: Bantam Books, 1971.

Ostrander, S. & Schroeder, L. *Handbook of PSI Discoveries*. New York: G. P. Putnam Sons, 1974.

Reilly, James M. *Albumen and Salted Paper Book*. Rochester, New York: Light Impressions Corporation, 1980.

Rexroth, Nancy. *The Platinotype*. Yellow Springs, Ohio: Violet Press, 1977.

Rose, Barbara. *American Art Since 1900*. New York: Praeger Publishers, 1975.

Rudhyar, Dane. *The Planetarization of Consciousness*. New York: Harper & Row, 1970.

Rudhyar, Dane. *Triptych*. The Netherlands: Servire-Wassenaar, 1968.

Ruskin, John. *The Lamp of Beauty*, Joan Evans, ed. Ithaca, New York: Cornell University Press, 1980 (Chapter 1).

Saff, Donald and Sacilotto, Deli. *Printmaking*. New York: Holt, Rinehart & Winston, 1978.

Saint Germain. *Studies in Alchemy*. Los Angeles: Summit University Press, 1979.

Sarjeant, Peter T., Ph.D. *Hand Papermaking Manual*. Covington, Virginia: Paper Make, 1974.

Scharf, David. *Magnifications*. New York: Schocken Books, 1977.

Scopick, David. *The Gum Bichromate Book*. Rochester, New York: Light Impressions Corporation, 1978.

Sheridan, Sonia Landy. *Energized Artscience*. Saint Paul: Industrial Graphics Division, 3M, 1978.

Smith, W. Eugene and Smith, Aileen M. *Minamata*. New York: Holt, Reinhart & Winston, 1975.

Sondheim, Alan. *Individuals: Post-Movement Art in America*. New York: E. P. Dutton & Co., Inc., 1977.

Sontag, Susan. *On Photography*. New York: Dell Publishing Co., 1977.

Stecker, Paul G., ed. *Merck Index: An Encyclopedia of Chemicals and Drugs*. Rahway, New Jersey: Merck and Company, 1968.

Stravinsky, Igor. *Poetics of Music*. Cambridge, Massachusetts and London, England: Harvard University Press, 1975.

Strong, Donald E. *The Classical World*. New York: McGraw-Hill Book Co., 1965.

Studley, Vance. *The Art & Craft of Handmade Paper*. New York: Van Nostrand Reinhold Co., 1977.

Swedlund, Charles. *Photography: A Handbook of History, Materials and Processes*. New York: Holt, Rinehart & Winston, 1974.

Szarkowski, John. *Mirrors and Windows*. New York: The Museum of Modern Art, 1978.

Terry, Walter. *How to Look at Dance*. New York: William Morrow & Co., 1982.

Tesla, N. *Lectures, Patents, Articles.* Reogard, Yugoslavia: Swallow Publications, 1964.

Toale, Bernard. *The Art of Papermaking.* Worcester, MA: Davis Publication, Inc., 1983.

Tolstoy, Leo. *What is Art? and Essays on Art.* London: Oxford University Press, 1975.

Travis, David. *Photography in Chicago Collections.* Chicago: The Art Institute of Chicago, 1982.

Tuchman, Barbara. *New York Times Magazine* (November 2, 1980).

Wade, Kent E. *Alternative Photographic Processes.* New York: Morgan & Morgan, 1978.

Wilson, Helena Chapellin. "Basic Gumbichromate Printing," *Darkroom Techniques* (June 1981), pp. 40–44.

Zukav, Gary. *The Dancing Wu Li Masters.* New York: William Morrow & Co. Inc., 1979.

Index